The Renaissance of Gravure
The Art of S. W. Hayter

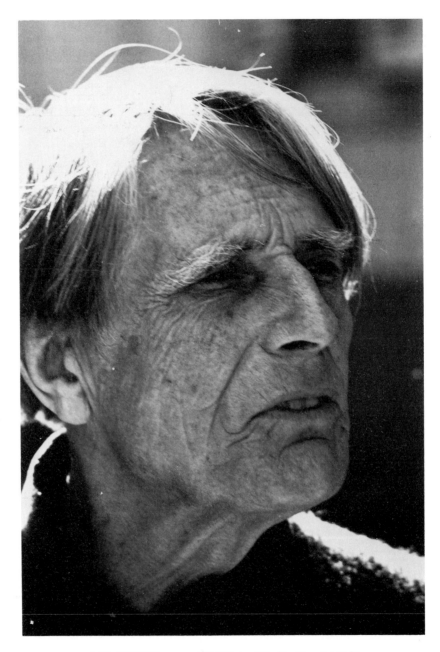

S.W. HAYTER, 1901–88 (*Michael Parkin Fine Art Ltd.*)

The Renaissance of Gravure
The Art of S. W. Hayter

(incorporating the catalogue of the
retrospective exhibition at the Ashmolean Museum, Oxford,
11 October–27 November 1988)

EDITED BY

P. M. S. HACKER

CLARENDON PRESS · OXFORD
1988

Oxford University Press, Walton Street, Oxford OX2 6DP

Oxford New York Toronto
Delhi Bombay Calcutta Madras Karachi
Petaling Jaya Singapore Hong Kong Tokyo
Nairobi Dar es Salaam Cape Town
Melbourne Auckland
and associated companies in
Berlin Ibadan

Oxford is a trade mark of Oxford University Press

Published in the United States
by Oxford University Press, New York

British Library Cataloguing in Publication Data
The Renaissance of gravure: the art of
S. W. Hayter: incorporating the catalogue
of the retrospective exhibition at the
Ashmolean Museum, Oxford, 11 October–
27 November 1988.
1. English prints. Hayter, Stanley William,
1901–. Catalogues, indexes
I. Hacker, P.M.S. (Peter Michael Stephan)
796.92'4
ISBN 0-19-952113 1
ISBN 0-19-952111-5 (pbk.)

Library of Congress Cataloging in Publication Data
Data available

Printed in Great Britain by
Butler and Tanner Ltd., Frome

Acknowledgements

We are grateful to Dr Peter Hacker of St John's College, whose indefatigable enthusiasm, in both initiating and organizing the exhibition—and editing this volume—has outstripped even the most energetic of his collaborators. The exhibition arrangements have been supervised by Dr Nicholas Penny, Keeper of the Department of Western Art. Both he and Dr Hacker have received crucial help from Anne Stevens, whose experience of working with the modern prints and, as a volunteer, helping to organize exhibitions in the Department of Western Art has been invaluable. In addition to helping to select and carry prints back from Paris, she played a large part, together with Judith Chantry, in restoring, mounting, and hanging them. But, above all, we are indebted to Stanley William Hayter himself for agreeing to this exhibition, for making so many loans, and for devoting so much time and trouble to its realization. Désirée Moorhead, together with Peter Black and Eddie Mullins, have given invaluable assistance with the catalogue and Robert Douwma has helped in numerous vital ways: organizing transport, advising on hanging, providing frames, making possible the poster, and giving advice at every stage. Unusual demands for photographs have been met with the usual efficiency and expertise by Noelle Brown of the Department of Western Art and Michael Dudley of the Museum's photographic service. We are also indebted to Jean Lodge of the Ruskin School for the preparation of the special showcase devoted to technique, and to Jack Shirreff for printing the poster. Finally we must thank the institutions and private individuals who have kindly agreed to lend prints to this exhibition.

CHRISTOPHER WHITE
Director of the Ashmolean Museum, Oxford

Contents

List of Plates

Colour

Black and White

I
Introduction

―――

PETER HACKER

From its inception in fifteenth-century Italy and Germany, gravure—the printing of an image from a groove in a resistant material—enjoyed only a little more than a hundred years of genuine creativity. Thereafter it progressively degenerated into a largely reproductive medium. Printmakers made copies of paintings, or—if they originated the image—sought to emulate the drawn pencil line rather than to develop the expressive potentialities of the projected burin line or to utilize creatively the multiple planes available in a worked metal plate. The sculptural qualities of gravure were neglected and, despite important exceptions in each century, the making of intaglio prints lapsed into, at best, a minor art. It was not until the invention of photographic means of reproduction that the conditions existed for the revitalization of gravure as a medium capable of original expression. Conditions create opportunities, but men must seize them. Something of a revival occurred in England in the late nineteenth and early twentieth centuries, but it was largely backward-looking. A genuine renaissance requires not merely technical competence, but a grasp of hitherto unrealized possibilities of expression, as well as original ideas that are of significance to the age. This did not come about until the 1930s in France, and a decade later in the USA. It was due, above all, to the passion, conviction, and creativity of Stanley William Hayter.

When Hayter went to Paris in 1926, he was, in his painting, already in the process of parting company with the imitation of nature. During his three years in Iran (1922–5) he had experimented with Cubism and had passed through the natural progression of its analytic, synthetic, and constructive phases. Like Kandinsky before him he had arrived at the abiding conviction that a work of art, irrespective of whether it is figurative or not, must possess a reality of its own. It must not owe it to some extraneous object which it reproduces or copies, but must be self-sufficient. Within the first months of his arrival in Paris, he was lucky to make friends not only with such artists as Balthus, Calder, Anthony Gross, Giac-

ometti, Masson, and Miró, but also with the finest burinist of the day—Joseph Hecht, who taught him engraving. Impressed by the neglected possibilities of gravure, and convinced that the best way of realizing them was in a workshop in which artists would work together and exchange ideas, Hayter established what later became known as Atelier 17. (This anodyne name was chosen in 1933 to avoid any suggestion of one man imposing his image on his 'followers' or of founding a 'school'.)

Over the next sixty years, first in Paris (1927–39), then in New York (1940–50), and then again in Paris (1950 to the present), almost every major twentieth-century artist interested in gravure came to work with Hayter. Modern American printmaking literally dates from 1940, when the Atelier was set up at the New School for Social Research in New York, achieving nation-wide recognition with the 'Hayter and Studio 17' exhibition at the Museum of Modern Art in 1944. Hundreds of artists of dozens of nationalities did not merely learn new techniques at the Atelier, but acquired a transformed vision of the potentialities of the medium and a new conception of creative gravure. Through them, the influence of Atelier 17 and its founder has spread all over the world. Herbert Read observed in 1949 that 'the art of gravure, before the foundation of Atelier 17, was an art that had never realized half its potentialities. Hayter and his pupils have discovered new processes and new possibilities in existing processes; they have added new "values" to the art—values of texture, of dimension, one might even say of colour.'[1] When Read was writing, the last clause was largely metaphorical. In the intervening years, Hayter has transformed the metaphor into a reality. Just how true Read's remark is today, after the revolution in simultaneous colour printing initiated by Hayter, the exploration of colour 'interference', the introduction of fluorescent colours in intaglio and transparent colours applied with hard and soft rollers, can be seen in the scintillating images Hayter has made in the last four decades.

Hayter's early Paris prints show him rapidly acquiring mastery of the burin, and gradually realizing how to exploit its potentialities. The early sequence of urban scenes culminates in the 1930 portfolio *Paysages urbains* (**101–2**), in which vigorous line and inventiveness are combined in a series of 'double images' of landscapes superimposed upon city views. One space is seen through another, and the fascination with ambiguity which was to characterize so much of his later work is already visible.

Although many of his friends belonged to the Surrealist movement, Hayter did not exhibit with the Surrealists until some time after the second Surrealist manifesto. The first, with its emphasis upon oneiric (dream) material, did not strike him as valid. But his interest in free association, dissociation, decomposing and reconstructing reality, visual metaphor and simile shows him to be moving on parallel

[1] H. Read, Preface to S. W. Hayter's *New Ways of Gravure* (London and New York, 1949).

tracks. This is evident in his illustrations to George Reavey's *Faust's Metamorphoses* (**103**) and in *Apocalypse* (**105–6**), for which Georges Hugnet wrote a Surrealist text on the prints.

By 1932, Hayter was moving further away from figurative representation (*Amants* (**10**) and *Meurtre* (**11**)), although neither then nor at any later time did he accept any sharp distinction between figurative and abstract art. He refused an invitation from Arp and Miró to become a founding member of 'Abstraction-creation' for this very reason. Even something as 'abstract' as a Mondrian, he insists, can be seen as an architectural groundplan, and it is futile to try to block the disposition of our visual imagination to impose content on prima-facie abstract forms. By this time he had become convinced of the importance of 'automatism' or 'unconscious' figuration. The sources of the image-making faculty can be uniquely tapped by discarding conscious control. Hence he was attracted by the second Surrealist manifesto (1929), with its emphasis on automatism.

1934 was a watershed. The Atelier put on its first collective exhibition, in both Paris and London, and won considerable acclaim. Hayter made *Œdipe* (**12**), *Érotisme compensé* (**13**), and *Viol de Lucrèce* (**14**), which could be said to be his first pure Surrealist works. In these the vigour of automatist engraving is evident, and what became known as Hayter's 'whiplash' burin line, with its characteristic ferocity and mobility, can be seen. Here too is the 'raised white line', introducing a plane in front of the image that can be used to increase its depth, giving focal points or trajectories outside it. In these images he began to use to full effect soft-ground texturing to create a background of spatial webs and shadows. The mythological titles given to many of the prints of this period reflect his belief that the sources of myth and of automatist creation are importantly related. The primal urges, fears, and prohibitions that are articulated in myth find expression in the strange and powerful Surrealist imagery of those prints. It is, of course, no coincidence that Hayter had ready widely in Freudian psychoanalytic theory.

Combat (**17**), made in 1936, is the largest plate he made in the thirties, and a high point of achievement. In it he concentrated all his skills and insight, his pent-up energies, and horror of war, to create an image of mortal strife that reaches back to Renaissance pictures of battling warriors (Pollaiuolo, Uccello, and Leonardo) and anticipates Picasso's *Guernica*. Equally powerful, although less complex, images, combining specificity of figure with Surrealist mode, characterize many of the prints of the following three years, especially the *Numancia* series commissioned by Vollard and the portfolio *Facile Proie*.

The early American prints, done on a small scale, are further developments of ideas visible in *Facile Proie*, explorations of mythological motifs (*Minotaur* (**34**), *Centauresse* (**38**)), and of everyday objects—sometimes constructed with great charm (*Mirror* (**27**), *La Bêche* (**33**)). Between 1943 (*Laocoön*) (**37**), *Tarantelle* (**40**))

and 1945 (*Amazon* (**43**)), he moved on to a new plane. The images, still in his distinctive Surrealist idiom, are very much larger. The burin work is executed on an extraordinary scale with phenomenal control. The soft-ground texturing becomes ever more subtle and sophisticated. The play of spaces is increasingly complex, as one space is literally reversed and reimposed upon an image (for example, the hand of *Cronos* (**42**) or right foot and leg in *Amazon* (**43**)), and complicated webs impart tension and torsion. It was such prints, together with those of his associates at Atelier 17, that shook the American art world in the Museum of Modern Art exhibition in New York in 1944.

He had been experimenting with simultaneous colour printing since 1930, and had made two small colour prints in the USA (*Maternity* (**25**) and *Centauresse* (**38**)). In 1946, on the occasion of the death of his first son, he made the great *Cinq Personnages* (**47**), with its tortured, grief-stricken imagery and sombre, dolorous colouring. This was both an awesome visual requiem and a landmark in the history of printmaking. Throughout the late forties, he continued to work on a large, sometimes even colossal, scale (*Tropic of Cancer* (**51**)). Though the new generation of American artists (for example, Pollock, Motherwell, Rothko) worked with him in the Atelier, and although his influence upon some of them is marked, it was only in the mid-fifties, seven years after his return to Paris, that his prints reveal that the exchange of ideas had been fruitful for him too.

The Paris prints of the early fifties continue the direction of development pursued in New York, although the colours are softer (compare *Unstable Woman* (**49**) and *Jeux d'eau* (**56**)). With *Poisson rouge* (**58**), however, Hayter made a decisive shift in subject, technique, figuration, and colour. In the remarkable series of prints made with Flowmaster pen and spattered resin varnish as impermanent and permanent resists on the plate, deeply etched, inked in intaglio, and with both soft and hard rollers, Hayter came as close as he ever would to the so-called 'Abstract Expressionists' who had worked with him in New York a decade earlier. The technique lent itself to the depiction of flow and counterflow, of flung spray and light on water, and of trajectories of objects moving through a fluid medium. It was possible to represent motion, not by depicting mere displacement over time—as the Futurists had done—but by registering acceleration and deceleration. Motion could, as it were, be transferred to the plate in two ways. First, if one throws a 'fountain' of varnish at a plate, every drop will follow a parabolic trajectory that will be imprinted on the plate, and its spattered shape will be a function of its velocity. (But, since printing reverses the etched image, to obtain an upward accelerating trajectory the plate must be rotated 90° clockwise, and corresponding adjustments must be made to preserve convexity.) Etching deeply around the spattered shapes and inking with soft and hard rollers yields striking and beautiful impressions of cascading torrents (*Cascade* (**62**), *Confluence* (**68**)), rapids, or eerie interstellar spaces

(*Night* (**64**)). Secondly, the Flowmaster ink functions as a partial acid-resist, its resistance being proportional to its density. Hence a slowly inscribed line will tend to resist the acid, whereas a rapid stroke will be bitten. Consequently, the changes in the velocity of the moving pen are precisely registered by the striations in the bitten surface of the metal, which, when inked in intaglio, supplement the effects of the unbitten spatter of the varnish.

The method employed in making these prints bears a certain family resemblance to devices used by some of the 'Abstract Expressionists', but the resultant imagery is very different. Hayter used this technique to celebrate the beauty of flowing waters, the mingling of streams, and the reflection of the sun on spray. Unlike those of the New York School, his images, though highly generalized, do not lose contact with nature. Of course, they do not copy it either, but rather create in the printed picture evocative analogues of the phenomena which move the imagination in recognition of an idea. The simultaneous multicolour printing employed in this and subsequent series of images involves significant variations from one impression to another of the same print. Consequently the differences between a pair of impressions can be as important and subtle as those between Menuhin and Heifetz renderings of the same violin sonata.

In 1965, the series of Flowmaster prints came to an abrupt halt, although Hayter's fascination with wave and water remained. For the next four years, he explored the effects of undulating fields by a variety of devices which bring his work of this period into proximity with Op Art. His interest, however, was not in optical bedazzlement, but rather in the beauty of continuously deformed fields of motion. His themes were never mere pattern, but waves, complex disturbances in rippling fields, or cross-currents moving upon deep swells (*Vague de fond* (**71**)).

Until 1969, Hayter's work, although—like that of all great artists—idiosyncratic and inimitable, can be roughly located in relation to the art of the day. But in 1969 a technical innovation led rapidly to developments of colour, form, and idea that are without precedent. The use of venilia as acid-resist, of deeply bitten areas laid bare by peeling off sharply cut pieces of the plastic, of hard- and soft-roller inking coupled with fluorescent colours[2] in intaglio opened up new possibilities of expression. Although the early venilia prints continued to develop his preoccupation with flow, he quickly achieved very different results of great delicacy (*Caribbean Sea* (**73**)), remarkable co-ordination of virtuoso burin work with the new manner of etching (*Nautilus* (**74**)), subtle mathematical intricacy and beauty (*Calculus* (**77**)), and—in one of the masterpieces of the early venilia prints—stunning colour and movement (*Claduègne* (**78**)). Here he moved in a dimension of the imagination

[2] The brilliant effects of fluorescent inks cannot be fully captured by photographic reproduction. Consequently the colour illustrations of these prints, though done to high standards, cannot adequately convey the scintillating character of the originals.

hitherto unknown—and it will doubtless take time before the art world can catch up with him and assimilate his ideas. As his colours become more brilliant and his exploration of colour effects ever bolder, new themes occur in his work. Falling through space (*Free Fall* (80)), fluttering in the breeze (*Rideau* (87–8), *Bouleau* (89)), reflections in water (*City* (82), *People* (84)), and other forms of correlated and typically ambiguous spatial orders (*Clairevoie* (79), *Voiles* (85), *Volet* (90)) are investigated in a series of images which in every way betoken a complete mastery of an original medium as well as a rich and innovative imagination.

There is, to be sure, continuity through the change. The powerful burin line is as unmistakably 'Hayter' as ever, the delight in spatial ambiguity and multiplicity persists, and, although the imagery can no longer be usefully dubbed 'Surrealist', he continued and still continues to insist upon the 'pure sources' (as Mallarmé put it) of unconscious creation. Scrutinizing the prints he has made and examining their several states may incline one to think that there is a contradiction between theory and practice in this matter. Hayter is a highly intellectual, indeed cerebral, artist. The effects he achieves are typically very carefully thought out—the complex structures he creates, often involving non-Euclidean spaces, Riemannian geometry, 'exploding' spaces (as in convex mirror reflections), are obviously not sheer uncontrolled spontaneity. But there is no contradiction here. From early in his career he realized the significance of the fact that making a print, unlike painting, is not a linear operation, although it is a consecutive one. Bursts of creative work on the plate are followed by the printing of a state proof in which the results are visible for examination. This makes gravure singularly appropriate for a fruitful interplay of unconscious creation and analytic reflection in a process of 'controlled spontaneity', an expression which in this context is in no sense self-contradictory. Each state offers possibilities for further development, and a comparison of several states (which is not possible in painting) brings to light directions of development which can be exploited in the next phase. Decisions have to be made on the basis of analysis, although it is a crucial aspect of Hayter's conception that one should *not* know clearly where one is going. If one already knows exactly what it is going to look like, he has observed, why bother making it! The creative process should be one of exploration of consequences. One must learn to seize upon the *unforeseen* results of one's operations, and make something significant of them. Creation in gravure involves a developing process of phased interaction with the plate, in which the outcome, though produced through the artist's intense and reflective involvement, should not have been predictable even by him.

The prints of the mid-seventies manifest a return to a more figurative mode than in the previous decade, a tendency which is likewise evident in the *livres d'artiste* to which he contributed again after a hiatus of more than three decades. *Still*, made for Samuel Beckett's text, uses the new venilia etching technique in three coloured

images beautifully attuned to the tranquil prose poem of his friend (112). In 1978/9 he made the illustrations for the poem of another old friend, Brian Coffey. In the *Death of Hektor* he returns to the mythological themes that had so fascinated him in the thirties and forties, but handles them in a very different way (113). The archaic forms he employs in this sequence of prints capture the brutal world of mythical antiquity, and his ferocious burin lines echo Coffey's harsh, bitter poetry. In 1982/3 he illustrated a volume of Éluard's love poems, published together with translations by Coffey. The nine engravings combine simplicity of line with an evocative richness that parallels Éluard's Surrealist verse. The three accompanying lithographs (not a medium of which Hayter is overfond) add brilliant colour to this finely produced book (114–17).

In his ninth decade, far from inspiration flagging, Hayter turned to a new motif and—in some of the prints—a more literal mode of representation. A sequence of meditations upon his studio combines ingenious invention (*Indoor Swimmer* (94)), mystery (*Masque* (95)), and self-reflection (*Figure* (93)), culminating in the profound and moving *Pendu* (98). In 1985, at the age of 84, he made one of the most dramatic colour prints of all—*Fastnet* (99). Though the number of plates he now produces is diminishing (and the number of paintings is increasing), their power and originality is as great as ever.

I hope I may be excused for concluding on a personal note. It has been a great privilege for me, an academic philosopher, to get to know Bill Hayter, to talk extensively with him, and to learn from him. Attracted immediately by his art, not least because in his striving after the essence of things he is surely as Platonist an artist as any can be, I only gradually came to understand it. But the effort has been immensely rewarding, transforming the way I look at works of gravure, and indeed at visual imagery in general. This volume of essays, published on occasion of the Ashmolean Museum's retrospective exhibition of his prints, introduces the work of one of the finest artists of the century to a new generation of his countrymen, for there has not been an opportunity to see a retrospective display of Hayter's work on this scale in Britain since the Victoria and Albert Museum's exhibition in 1967. The last word goes to a young English engraver to whom I showed some of Hayter's recent prints. He bent over them in silence for some minutes, then raised his head in astonishment and exclaimed, 'He is the master-magician of them all'.

St John's College
Oxford

January 1988

While this volume was in preparation, news came from Paris that Stanley William Hayter had died suddenly at his home on 4 May 1988.

2

Hayter: The Years of Surrealism

———

GRAHAM REYNOLDS

The French expression 'peintre-graveur' is a more exact and revealing description than the English equivalent 'painter-etcher' for the artist who communicates his images through the medium of printmaking. It emphasizes that the productions of the *peintre-graveur* are original creations, such as those by Dürer, Rembrandt, Ruisdael, and other Old Masters, about whom the term was used by, amongst others, Adam Bartsch. It focuses our attention on the fact that these artists were in the first instance painters. In addition the French phrase avoids the restrictive definition of the English translation, which appears to limit their activity. In fact the *peintre-graveur* is free to employ any of the vast range of graphic techniques: line engraving, drypoint, mezzotint, aquatint, lithography, screenprinting, no less than etching. And because he is a painter he will feel the need to expand the frontiers of whatever media he uses, so that they can provide a more adequate communication for the wealth of his ideas.

S. W. Hayter is a classic exemplar of the *peintre-graveur* so defined. He practises printmaking as a method of expression distinct from his painting; it reacts upon and is affected by his painting, but is a domain with rules of its own and is a separate avenue of creation. But because he is a painter he has constantly striven to enlarge the confines of conventional methods. This exhibition demonstrates how over sixty years he has been searching to break the fetters of tradition; the title of his book *New Ways of Gravure*, first published in 1949, is a concise summary of that endeavour. His production shows a progress from the simple engraved or etched line to the introduction of textures, to the use of reserved white areas in black-and-white prints, and eventually towards the achievement of the ambition of most *peintre-graveurs*, the introduction of colour, by processes gradually refined till this could be accomplished from one plate alone.

When in 1925 Hayter decided to leave the oil industry and devote his life to art it was natural for him to choose Paris as the place in which to settle. The École de

Paris, now long defunct, was then a reality. In the twenties it was the meeting-point for ideas and the ground for their cross-fertilization. Survivors of earlier battles over Post-impressionism, Fauvism, Cubism, were challenged by the newer waves of Purism, Futurism, Dada, Orphism, Abstract Art. Among the artists with whom Hayter felt himself in tune were Hans Arp, a founder of Dada, André Masson, and Alexander Calder, who had recently created his circus of bent-wire figures and animals. These affinities of mind made it natural that he should be led into association with the Surrealists. Surrealism was primarily a literary movement in its origins, and the art which is categorized under the label of Surrealist is not of homogeneous composition. It ranges from the abstract graphism of André Masson to the academically expressed fantasies of Magritte, Dali, and Delvaux. Its strength lay in its encouragement of the forces of imagination, fed by dreams and the resources of the subconscious mind.

Anthony Gross was a friend of Hayter's from his earliest days in Paris, when they were both students at the Académie Julian. He has given a vivid account of the atmosphere of the times. 'In Paris to exhibit in a group exhibition meant a free fight. It was only the best fighter who became elected and, once chosen, another fight developed to be properly placed.'[1] He adds that Hayter was greatly respected for his fighting qualities. Nowhere was pugnacity more necessary than in the Surrealist group. Hayter showed with them in Paris in 1933, and in London in 1936. The second event gave the British their first real opportunity to see the mature work of this *émigré* descendant of Queen Victoria's portrait and history painter in a wider context. Amongst the works he showed then, in the New Burlington Galleries, were six of the present exhibits; the *Grand Cheval* (9), *Œdipe* (12), *Viol de Lucrèce* (14), *Cheiromancy* (16), *Pâques* (18), and *Maculate Conception* (19). But his association with the Surrealists lay in personal friendships and a correspondence of ideas, rather than formal membership. The group was constantly being shaken by ideological disputes, by accusations of deviation and heresy, and by expulsions. These differences became most acute when its leader André Breton associated it with the Communist Party. It was never clear how the activities of the group would hasten the coming of the dictatorship of the proletariat, nor how such a result would advance the understanding of the arcane and hermetic art of the Surrealists. A sympathetic historian of the movement, Patrick Waldberg, has written, 'One can say with complete objectivity that the surrealists were quite ineffectual in their various political stands'.[2] None the less, politics were an intensely divisive factor. Breton, who became a friend and admirer of Trotsky, was outraged when Paul Éluard joined the orthodox Communists. Not only did he expel him from the movement; he outlawed anyone who remained in touch with him. These events

[1] Anthony Gross, in *For Stanley William Hayter on his 80th birthday* (Oxford Gallery, 1981).
[2] Patrick Waldberg, *Surrealism* (London and New York, 1965), p. 18.

lie behind the guarded statement Hayter makes in *New Ways of Gravure*: 'For personal reasons I am no longer an active member of the Surrealist Group'.[3] He has explained the circumstances more fully to me in a recent letter:

The break with Breton (referred to in Paul Éluard's letters) was about the expulsion of Paul who was accused of malignant Stalinism. Breton thereon issued a fiat that no good surrealist must speak to him again.

I said quite simply that in my book my friends were my friends *whatever* they might do, and so I should continue to see Paul. And furthermore if this did *not* please, as surrealist I had always travelled in third class, and left the train at every stop.

Thus no open and bourgeois quarrel took place but probably I gave more offence than if we had had one of these performances—because I obviously did not take these attitudes seriously. As a result, in all subsequent publications or revisions my name was scrupulously eliminated from all official surrealist documents.

In fact, Breton's vendetta did falter once. He had referred to Hayter in a catalogue introduction *Art of this Century* for Peggy Guggenheim in 1941. This was translated as *Genèse et perspective artistiques de surréalisme* in 1945, and issued again, revised and corrected, in 1965, shortly before Breton's death. To the end therefore he believed that 'C'est également l'automatisme qui préside à la vision ... aiguisée jusqu'aux dernières ramifications de la nervure chez Hayter'. This lapidary phrase exactly defines the relations between Hayter and the Surrealists: he has written: 'the source of the material in all my works is unconscious or automatic'.[4]

The use of the resources of the subliminal mind, without conscious or logical direction, was the first and remained the most important differentiating charactistic of Surrealism. In 1922 Breton defined the term 'dans un sens précis. Par lui [surréalisme] nous avons convenu de désigner un certain automatisme psychique qui correspond assez bien à l'état de rêve.'[5] At the time this definition was pronounced its application was literary. It was stimulated by the recent publication of the volume *Les Champs magnétiques*, written in collaboration by Breton and Phillippe Soupault, which is regarded as the first automatic text and the first manifestation of Surrealism. The extension of the method to drawing was natural and swift. Automatic drawings by André Masson appeared in almost every number of the magazine *La Révolution surréaliste* from its beginnings in 1924 till Masson's expulsion from the group in 1928.

Hayter has made a regular and systematic practice of automatic drawing. These exercises have a direct bearing on his work as a printmaker. It is evident that such unconscious drawings are likely to be linear; they are the results of a sort of planchette or Ouija-board put into direct contact with the ideas which lie below

[3] S. W. Hayter, *New Ways of Gravure* (New York, 1981), p. 132.
[4] Ibid.
[5] André Breton, quoted in G. Hugnet's introduction to *La Petite Anthologie Poétique du Surréalisme* (Paris, 1934), p. 10.

conscious recall. Hayter has reflected deeply about the significance of the line, from its origins as the means by which man first orientated himself in the external world. In particular he distinguishes between the drawn line, which is not hidden by the draughtsman's hand, and is a visible record of the immediate past, and the engraved line, which is hidden by the hand which traces it on the plate, and explores the future. However complex the constituent factors of the prints in this exhibition, many enriched with colour and texture, it is evident that in them the line, subtle, sensitive, and expressive, is the dominant feature.

There is no more appropriate instrument for exploring the full possibilities of the line than the burin, employed in line engraving. When he first studied in Paris, at the Académie Julian, Hayter had the good fortune to meet Joseph Hecht, who had almost single-handedly rescued line engraving from being a merely reproductive process. His admiration for Hecht's prints and his study of his methods led him to the mastery so abundantly revealed in his own engravings. But it is evident that a completed print, in which the application of a rigid technique is partly inspirational and partly mechanical, cannot be achieved solely by surrender to unconscious direction. Hayter has described the interplay between these forces in his account, in *New Ways of Gravure*, of the execution of the plate *Cinq Personnages* (**47**). He writes:

The impulse to make an image is definite, but no particular image is sought consciously … if the source of material for such a work is irrational, its development and execution have to be strictly logical, not with the mechanical logic of imitation, but in accordance with a sort of system of consequences having its own logic. At the different stages of development of the work, a choice is exercised, but with extreme precaution against the application of pedestrian common sense when inspiration flags. As Paul Klee says, 'To continue *merely* automatically is as much a sin against the creative spirit as to start work without true inspiration.'[6]

The earlier engravings in the exhibition show the steps by which Hayter achieved this balance between unconscious and conscious creation. There is already in the *Paysages urbains* of 1930 (**101, 102**) an uneasy relation between the landscapes, the figures, and reality; conventional perspective and composition are jettisoned, and the people and horses are virtuoso exercises in the use of pure line. There is a sense of shock about the body of a naked man lying in the street outside the wall of Père Lachaise, in another print of this series, which reveals the difference between the imagination at work here and that seen in such contemporary painters of the urban scene as Utrillo and Dunoyer de Segonzac.

The *livre d'artiste* has long played a prominent role in French publishing, and the literary affiliations of the Surrealists invested it with a particular attraction for them; it was a field in which word and image could be linked together. Hayter has

[6] Hayter, *New Ways of Gravure*, p. 132.

worked with many of the leading Surrealist authors, including Éluard, Hugnet, and Aragon. His first venture into this mode of publication was his set of illustrations to *Faust's Metamorphoses* (103), by George Reavey, who is associated in S. Putnam's introduction with Samuel Beckett amongst the most promising young followers of James Joyce. In the following year, 1932, he collaborated in two different ways with the poet Georges Hugnet. In *Ombres portées* (104) he provides illustrations to Hugnet's poems, drawing on his intimate knowledge of the Mediterranean for the seascapes, and on Italian themes for the plate of a dead athlete which accompanies a dramatic poem about the death of the Emperor Commodus. In *Apocalypse*, of the same year, the roles of author and artist are reversed. Hayter conceived the six engravings in the set and Hugnet composed, as an introduction to them, a text which extracts from the images their extraterrestrial and apocalyptic meaning. His commentary on the deserted scene of earthquake and destruction (106) follows quite literally the artist's conception. The house struck by the cataclysm has walls of playing cards; a broken bust has fallen on the sand in front of the nearer fissure. The text for the monumental hand (105) emphasizes an idea which has a special significance for the artist, that of the three-dimensional trace left by his grip on a plastic substance. Hayter has had this void within a space cast as a sculptural form (120, 121). In the print the complicated distinctions between the interior solid and the exterior, gripping, hand are conveyed with a remarkable clarity and complete control of burin engraving.

It was natural for Hayter's illustrations for these *livres d'artiste* to be executed with fairly limited resources, and to be dependent on line and a restrained use of tonal devices. The circumstances which called them into being also ensured that they had a definite narrative content. But when Hayter interrogated the deeper sources of inspiration for subject-matter, and when he wanted to expand the graphic vocabulary of his printmaking, he was bound to enlarge upon these comparatively simple means. Although, in his own words, only a third-class passenger with the Surrealists, he had gathered his own group around him in his determination to explore the possibilities of enlarging the frontiers of printmaking. And so the little nucleus which has become world famous as 'Atelier 17' was founded in 1927. Again we can turn to Anthony Gross for an eyewitness account of its original reception: 'When Bill opened his school in Paris we all criticised him, saying that it was difficult enough to *arrive* in painting or printmaking by oneself without a roomful of pupils tacked on behind. He argued that he preferred to advance as a team than to arrive at a lone success.'[7] And so the informal working group was established which at one time or another brought into its orbit such diverse artists as Picasso, Miró, Tanguy, Giacometti, Dominguez, Masson, and many, many others. To quote Gross again: 'he based his methods on those he employed as a chemist.

[7] Anthony Gross, in *For Stanley William Hayter on his 80th birthday*.

He had to experiment with every idea, note the results and eliminate many, until he found the correct solution.'[8] In the course of these exercises he developed 'the throw of the lasso', the engraved arabesque which returns to its point of departure. By channelling deeply into his copper plate he produced void areas which, uninked, were printed as embossed white areas above the general level of the paper. Above all, he reintroduced the use of soft-ground etching for the introduction of tonal textures into his images.

The use of these new techniques is seen emerging in *Meurtre* (11), *Œdipe* (12), and *Viol de Lucrèce* (14), prints made in 1933 and 1934. The ideas for these explorations of classical myth arose during the artist's trance-like investigation of the thoughts lying below the surface of his conscious mental processes. As new inventions they called for an advance in technique, and the new technique expressed the new conception. No one who lived through the thirties will be surprised that many of the concepts retrieved by the process of automatic drawing turned out to be violent or despairing. It was hardly necessary in those times to interrogate the subconscious or dip into dreams to become aware of a sense of creeping menace and forthcoming doom. Yet these concepts emerged with even greater force when they were given the authority of unconscious recall. Amongst the images of violence that of the horse was one of the most powerful. This motif, neutral enough when it emerged as a reminiscence of Newmarket in the *Croquis au burin* (8), and given monumental presence in *Grand Cheval* (9), is the focus of battle and the horror of war in *Combat* (17). The complicated spatial geometry of this mêlée of horsemen and horses, expressed mainly through the variations in thickness of the swirling burin line, conveys the agony and fury of wounding and death.

Combat was engraved in 1936, the year in which the Spanish Civil War broke out. This struggle gave a focus to the feelings of menace and foreboding which had been building up during the thirties. Spain had been a kindly and stimulating host to many of the artists then working in Paris, Hayter and Gross amongst them. Although the political problems of the anti-Franco forces became inextricably confused between the Stalinists and the Trotskyites, there was at the outset no hesitation about the support given by the Left in other countries to the Republican government. To the Surrealists in particular the war was a gross violation of their sympathies and ideals. The images of violence in poetry and art proliferated and became more explicit. The excoriated horse was an emotionally charged symbol of the sufferings of Spain.

Measures of support for the Republicans came from many countries and in many forms. Amongst them were the two portfolios initiated by Hayter: *Solidarité* (103) and *Fraternity* (111). They are the most impressive group activity manifested by artists associated with Atelier 17, which published them. Here we find Picasso,

[8] Ibid.

Kandinsky, Hecht, joining more constant associates of the studio such as Masson, Miró, Buckland Wright, and, of course, Hayter himself. His own plate for *Solidarité* brings into the open another image of violence which was then constantly present in people's minds, air attack on civilians. Paul Éluard's verse comments upon the crashed airplane seen in this presentation of disaster:

> On s'habitue à tout
> Sauf à ces oiseaux de plomb
> Sauf à leur haine de ce qui brille
> Sauf à leur céder la place.

Unfortunately what would have been an even more monumental testimony to the scars left by the Spanish Civil War remained incomplete, a truncated torso. Ambroise Vollard, the greatest publisher of *éditions de luxe* with original prints, commissioned Hayter in 1937 to make a series of large engravings to illustrate the text of Cervantes's play *Numancia*. The completion of this project was frustrated by Vollard's death at the age of 72 in 1939. He had displayed his customary instinct in choosing the subject and the illustrator. The subject of Cervantes' play could hardly have been more apposite or more attuned to the feelings of the artist. Numancia is a hill fortress on the upper Douro in northern Spain which played a heroic part in resisting the conquest of Spain by Rome till its fall in 133 BC. It resisted a succession of sieges until Scipio Aemilianus reduced it by starvation. Cervantes' tragedy is an eloquent and musical lament for the sufferings and fate of the defenders, and a tribute to its historic fame. He takes the duration of the siege to have been sixteen years, and says that the fortress was defended by 3,000 people against an invading army of 80,000. The river Douro, which Hayter took as one of his subjects, enters as one of the allegorical characters in the play, to prophesy the inevitable defeat of the defence but its undying fame. The set was not completed, and the text was not issued with the existing plates in volume form. Published as separate engravings, they bring out the horror and despair of the play, and the parallel with the worsening situation of the Republicans from 1937 till 1939. Since they were intended as illustrations, they revert in technique to the less complex tones and linear rhythms of the earlier *livres d'artiste* in which Hayter had been engaged. The *Paysage anthropophage* (**21**) relates to one of the culminating horrors in the action, when, desperate with famine, the inhabitants of Numancia resolve to consume the flesh of their Roman prisoners:

> Y para entretener por alguna hora
> La hambre, que ya roe nuestros huesos,
> Haréis descuartizar luego á la hora
> Esos tristes romanos que están presos,
> Y sin del chico al grande hacer mejora,

Repártanse entre todos, que con esos
Será nuestra comida celebrada
Por extraña, cruel, necesitada.[9]

This expedient fails to stave off defeat; the inhabitants die by their own hand, and the Romans enter a citadel in which no one is left alive—a lake of blood.

The intimations of disaster embodied in this series of engravings were only too amply fulfilled when the German army launched its full assault on France in 1940. The attack from the air which enters into the imagery became a present and pressing reality. Atelier 17 was deserted, and its associates dispersed. But it was soon resurrected through Hayter's energies when he lived in New York from 1940.

The events of these years were in the highest degree disruptive and unsettling. But they did not interrupt the process of internal development which had been established in Hayter's printmaking over the 1930s. Setting up a new working companionship for Atelier 17 in New York also brought together a fresh wave of enthusiasts to contribute the momentum of their ideas, as well as reuniting exiles from the earlier days of the studio, such as Calder, Masson, Miró, Peterdi, and Tanguy. In these wartime years figures often formed the dominant theme of Hayter's prints. The subject is frequently one of the chief actors in the more violent and destructive Greek myths, as in *Laocoön* (37) and *Cronos* (42). In other engravings of this period the plate is dominated by the presence of a menacing, matriarchal female figure, as in *Amazon* (45). It is as though the anxieties of the 1930s have taken a more definite character, through being embodied in these myths. As Goya wrote, introducing *Los caprichos*, 'El sueño de la razón produce monstruos': the sleep of reason produces monsters.

As can be seen in the first state of *Amazon* (44), these densely tonal compositions are held together by the taut whiplash of a burin line, which defines the outlines and the spaces. This armature is overlaid by a series of soft-ground textures, which increase in sophistication, for instance in the moiré effect created by the impressed layers of silk in *Tarantelle* (40) and *Amazon* (43).

This increasingly pervasive use of texture and the prevalence of tonal variations over the whole of these plates paved the way for, indeed virtually called for, the introduction of colour. For many years Hayter and his associates had been seeking a method of printing a many-coloured engraving from a single plate in one

[9] Meanwhile to stay but for a single hour
The hunger which devours us as its prey
Cause that these wretched Romans in our power
Be slain and quartered without more delay,
And then distributed from hut to tower
To all both great and small, this very day.
So shall our banquet through the country ring
A cruel, strange and necessary thing!

(From the translation of *Numancia* by James Y. Gibson, 1885.)

operation. The modest beginnings of successful achievement are seen in the plates *Maternité* of 1940 (**25**) and *Centauresse* of 1943 (**38**). The climax of these earlier methods was reached in the large *Cinq Personnages* (**47**) in 1946. The detailed log of the making of this print which Hayter gives in *New Ways of Gravure* reveals the care with which he worked out, through experiment, the best sequence of three colours to achieve the desired multichromatic result. He also records the fascinating fact that the artist, working with three assistants who helped with the colour screens, printed the final series of fifty colour prints in three sessions, amounting to twenty-six hours' working time.

Impressive as the results of this method were, yet another stage had to be passed before Hayter could fulfil his ambition of simplifying the production of colour prints even more, by confining it to one operation. As he said to Georges Limbour, 'Cela est de la paresse bien comprise.... Pour s'épargner un peu de mal, et la difficulté ennuyeuse des repérages, on fait pendant dix-sept ans, des recherches assidues.'[10] The final resolution of this principle of the conservation of energy was reached in *Poisson rouge* (**58**) of 1957, where it is combined with another technical innovation, the use of the Flowmaster pen to act as an impermanent acid-resist during the stage of etching the metal plate.

The discovery and perfection of these new technical devices enabled Hayter to explore a totally new realm of visual imagery. Just as in the 1930s the imperative urge to express images emerging from the subconscious led to the development of soft-ground textures in the prints, so the capacity to embody all the colour on an engraving in one printing opened the way to a change of direction and a flood of novel images.

Hayter returned to Paris for good in 1950, and reopened Atelier 17 there. The move did not at first, any more than his previous *déménagement* to the United States, lead to any discontinuity in his progress. Plates such as *Pegasus* (**52**) of 1951 and *Winged Figures* of 1952 (**54**) are as much inhabited by an overpowering figural presence as the *Tarantelle* and *Amazon* of the previous decade. Then, suddenly, the movement of water came to replace these figures in his mind. The beginnings of this new concern can be traced to his holiday house in the French countryside, watered by the stream *L'Escoutay* (**53**). The preoccupation continues through *Jeux d'eau* (**56**) and *La Noyée* (**57**), and reaches its first complete expression through the deployment of his newest technical discoveries in *Poisson rouge* (**58**), of which Alexander Dunbar has written, 'On one level [it] is adapting automatism to the permanence of print; on another, it freezes in a coloured instant the frenzy of a fish's passage through water.'[11] It recalls the subaqueous luminosity of the marine

[10] George Limbour, *Hayter*, La Musée de Poche (Paris, 1962), pp. 46–7.
[11] Alexander Dunbar, introduction to catalogue *Stanley William Hayter: Prints 1931–81* (The Pier Arts Centre, Scotland, 1981).

life which haunts the Great Barrier Reef. At the same time the splatter-dash effect created by the Flowmaster resist has evident parallels with the contemporary movements of tachisme and action painting.

Hayter has continued to work out the effects of wind and wave patterns in his paintings as well as in his prints. Their interest gains strength from many levels in his personality. As a keen fisherman he is well aware of those long spells of observant indolence which being near water induces. As a scientist he is interested in the interference patterns set up by the movements of waves. His knowledge of the regulated beauty of mathematical curves is embodied in his cover design for Louis Leithold's *Calculus* (77). He makes an association between intersecting curves and the interlinked melodic lines of one of his favourite composers, Georg Philipp Telemann. And because the intersections of light reflected from waves, ripples, and the movement of water can be rendered in linear terms, they are accessible to recall through the processes of automatic drawing. His engravings of the 1960s are worlds apart from those of the 1930s, but they have this strand in common. Hayter has constantly kept the way open for such creative developments throughout his long career, and by doing so has shown that he is truly a *peintre-graveur*.

3

S. W. Hayter and Atelier 17 in America 1940–1955

DAVID COHEN

During the Second World War, New York played host to scores of European artists and intellectuals, S. W. Hayter among them. For some, exile was a disruption, but Hayter's career accelerated rapidly during his decade in America. His work of this period bears the fruit of experimentation in the creative potential in printmaking, with increasingly ambitious techniques (such as simultaneous colour printing) complementing powerful, arresting imagery. His influence as printmaker was no longer confined to a small avant-garde circle, as he began to influence the whole course of printmaking, both in America and internationally. The leading teachers and practitioners of the next generation found their way into Atelier 17, and, through publications and exhibitions, his ideas reached an audience even greater than the swelling ranks of his workshop. In America, his impact went beyond the field of printmaking, for Hayter played an important role in the emergence of Abstract Expressionism. Some of the members of this school worked with Hayter, and were influenced by his example in the theory and practice of 'automatism' (the creative tapping of unconscious sources), which was a central feature in Hayter's aesthetic. As theorist, artist, and printmaker, Hayter began to occupy a truly significant historical position.

The worsening situation in France led Hayter to close Atelier 17 in 1939, only months after the group's seventh and most successful exhibition, at the Galerie de Beaune. He left first for England, working for a short while on camouflage techniques.[1] Then in May 1940 he arrived in the United States, and spent the

[1] Hayter collaborated with two fellow Surrealists, Julian Trevelyan, a former assistant at Atelier 17, and Roland Penrose. Penrose went on to write an instruction manual on camouflage for the Home Guard (see R. Penrose, *Scrap Book, 1900–1981* (London, 1981), p. 130), while Hayter's research was taken up by an American defence contractor.

summer teaching in San Francisco, where the Museum of Fine Arts gave him his first American one-man show. In the autumn he returned to New York, where he had secured a teaching position at the New School for Social Research. His course, entitled 'Atelier 17', slowly developed into a vibrant group not limited to the enrolled students of the New School. In order to attract a mixed group of newcomers and established artists, Hayter encouraged painters and sculptors who had not done any printmaking before to try their hand, as he had in Paris in the 1930s. Many friends and colleagues from Paris found their way to the Atelier, including Masson, Chagall, Dali, Calder, Ernst, Miró, Lipchitz, and Tanguy. This in turn encouraged the participation of Americans who were keen to meet the exiles.

Atelier 17 remained at the New School until 1945, when Hayter set up independently in a loft in Greenwich Village. At the New School he enjoyed a sense of financial security new to him after the precarious years in Paris, but he began to find the bureaucracy and regulations intrusive. However, his association with the School was beneficial to both his personal development and the spread of his reputation. When he joined in 1940, under the directorship of Clara Meyer, the School attracted top-class academics and instructors, among both European exiles and Americans. Hayter's colleagues in the Fine Arts faculty included Stuart Davis, Amadée Ozènfant, Meyer Schapiro, Seymour Lipton, José de Creeft, and Berenice Abbott. At this time, W. H. Auden, Claude Lévi-Strauss, and Erich Fromm were also teaching at the School. Hayter was particularly interested in the work of the School's eminent psychologists Ernst Kris and Max Wertheimer, and this interest is perhaps reflected in his own writings of the time. (Hayter had studied Freud and Jung at King's College, London, and had even contemplated giving up chemistry in favour of psychology.) At the New School he collaborated with Wertheimer in exploring phenomena of perception as they related to mirror images (Wertheimer was a *Gestalt* psychologist), and he taught Rudolf Arnheim (with whom he has formed a lifelong friendship), when he led Wertheimer's course one semester.

In 1944 the fortunes of the Atelier began to soar when the Museum of Modern Art staged the exhibition 'Hayter and Studio 17'.[2] An exhibition of over sixty prints by thirty-one artists, including Masson, Miró, Calder, Chagall, Lipchitz, Adler, Mayo, Ubac, and of course Hayter himself, spanned the late 1930s and early 1940s. A whole issue of MOMA's Bulletin was devoted to the Atelier, and contained essays by Hayter and James Johnson Sweeney, one of the most important American critics and supporters of Modern Art. After the exhibition had shown in New York for three months, the Museum circulated it throughout the country, and, after the War, the State Department sent it on a two-year tour of South America.

Hayter was often invited to lecture at important venues following the path of the exhibition (for instance the Art Institute of Chicago), which further increased his

[2] The exhibition was organized by Monroe Wheeler.

influence. In the 1940s he began to publish articles with some frequency, and his first book, *New Ways of Gravure*, appeared in 1949. This important text, addressed primarily to practitioners, probably had as wide an influence as anything Hayter has done elsewhere, and it is read and used to this day. His other book, *About Prints*, (1962), is directed more to collectors and art lovers, but this should not obscure the fact that *New Ways* is far more than a practical manual: its insights into the history of the craft, and the author's theory of art, are vital to an understanding of Hayter's importance.

His reputation grew, as a painter as well as a printmaker, with one-man shows every year, in New York and elsewhere in the United States.[3] Hayter visited Paris as soon as he could in 1946, and was determined to live there again, and to re-establish Atelier 17, despite his growing success as an artist in America. He finally left New York in 1950, leaving the American branch of Atelier 17 to carry on until 1955. The Paris branch is, of course, active to this day.

Although, like Hayter, the majority of exiled artists and poets returned to Europe, Paris never regained its pre-War position as the Mecca of the arts. Since the success of Abstract Expressionism (or 'the triumph of American painting', as one of its historians puts it[4]), the world's artists have turned to New York for the guidance and inspiration they had for a century found in Paris. Considering Hayter's connections with the future Abstract Expressionists (he was roughly the same age as Gorky and Rothko), it is interesting to speculate what shape his career would have taken had he stayed in New York.

Some of the major figures of the New York School worked with Hayter at Atelier 17, including Jackson Pollock, Willem de Kooning, Mark Rothko, Dorothy Dehner, Louise Nevelson, William Baziotes, and Robert Motherwell. Furthermore, Hayter was closely identified with the Abstract Expressionists by contemporary critics and curators. Sidney Janis, in *Abstract and Surrealist Art in America*, reproduces a Hayter alongside a Gorky;[5] Hayter's statement in *Possibilities* appeared next to one by Pollock;[6] Jackson Pollock's first press mention reckoned one of his paintings 'to resemble Hayter in general whirling figures;[7] and in 1948 Robert Coates, the influential critic of the *New Yorker*, unhesitatingly treated Hayter as one of the new Abstract Expressionists.[8]

[3] Mortimer Brandt Gallery, New York, 1945; Hugo Gallery, New York, 1946; Durand Ruel Gallery, New York, 1947; Museum of Fine Arts, Santa Barbara, 1948; Gumps, San Francisco, 1948; Palette Gallery, St Louis, 1949; Atelier Gallery, Chicago, 1949; Perspective Gallery, New York, 1950.

[4] Irving Sandler, *The Triumph of American Painting: A History of Abstract Expressionism* (New York, 1970).

[5] Sidney Janis, *Abstract and Surrealist Art in America* (New York, 1944). The painting by Hayter is *Ophelia* (1936), now in the Tate Collection, London.

[6] 'Of the Means', by Hayter and 'My Painting', by Pollock, *Possibilities*, 1 (1947–8).

[7] James Lane, 'Passing Shows', in *Art News* 41/1 (1942), p. 29, review of an exhibition of European Masters and Young Americans at McMillen Inc. organized by John D. Graham. Graham, a friend of Hayter's from the 1920s in Paris, sent several Americans to Hayter in the 1930s, including David Smith, who visited Paris in 1935.

[8] Robert M. Coates, 'New Ideas', in *New Yorker*, 23/46 (1948), p. 44 (review of Durand Ruel show of that year).

In order to place Hayter's work and influence within an art historical perspective, it is important to recognize the tensions that existed in the Paris avant-garde in the pre-war years and the diffused and synthesized manner in which these came to influence the situation in New York. The 1930s had been marked by bitter conflicts between two factions: Abstract artists, who pursued the formal experiments of Cubism, De Stijl, and Russian Constructivism, and Surrealists, an altogether more romantic, literary, and subversive group. Although Hayter exhibited with the Surrealists, his artistic approach derives in certain key respects from the wider Modern Movement, sometimes in opposition to the Surrealist attitude. For instance, as we shall see, he incorporates the idea of 'truth to material', insisting on originality in the use of intaglio printing and respect for the integrity of the plate, features which show more of an affinity with Abstraction than with Surrealism. Also, Atelier 17 in Paris was strictly non-sectarian in its appeal. For various historical reasons, the American reception of Modern Art tended to obscure divisions,[9] and thus a movement like Abstract Expressionism could take formal solutions from one group and merge them with ideas from another (as the movement's rather awkward name implies!). From the Surrealists, the Abstract Expressionists borrowed and modified their interest in myth, the unconscious, and automatist practice.

Coincidentally, therefore, Hayter and the New York avant-garde held an ecumenical view of Modernism. Thus, in an essay on Kandinsky, Hayter could compare one of this artist's works with a Miró:

That the content of idea of the two paintings is completely different is another matter; this means of course that they are two different painters with distinct motives. But it is sufficient for our purpose if we have shown that these artists use the common universal language of modern art.[10]

One of the quirks in the Abstract Expressionists' assimilation of Modernism is that they were indebted to artists like Picasso, Kandinsky, and Klee not just for their general education in Modernism, but also for the very notion of automatism, which is supposed to come from Surrealism. Kandinsky and Klee were major formative influences for the Abstract Expressionists, and Hayter's writings on these artists

'Hayter is a member of a small but increasingly important group of contemporary American painters that includes such men as Robert Motherwell, Jackson Pollock, Hans Hofmann, William Baziotes and Arshile Gorky.... They are alike in that their method is rooted in the abstract and overlaid by Expressionist coloration and compositional freedom, and since Hayter was, in a sense, one of the founders of the movement, I think his work may fairly be considered typical.' Quoted Joann Moser, *Atelier 17* (Elvehjem Art Centre, University of Wisconsin, Madison, 1977), p. 44.

[9] See R. C. Hobbs, G. Levin, *Abstract Expressionism: The Formative Years* (New York, 1978); and J. Weschler, *Surrealism and American Art, 1931–1947* (New Brunswick, 1977). The American avant-garde of the 1930s was small and isolated, and was therefore less sectarian than in Paris; the Museum of Modern Art encouraged a formalist, synthetic reading of Modernism; and the unity in exile of hitherto rival figures (Mondrian, Leger, Breton, Tanguy, Ernst, and Chagall exhibiting in Pierre Matisse's 1941 'Art in Exile') compounded rather than checked this process.

[10] 'The Language of Kandinksy', in W. Kandinsky, *Concerning the Spiritual in Art* (New York, 1947), pp. 15–18.

emphasize the role of automatism in their painting. His essay 'The Language of Kandinsky' appeared in an English translation of Kandinsky's *Concerning the Spiritual in Art* in the series 'Documents of Modern Art', whose general editor was the future Abstract Expressionist Robert Motherwell. Hayter was able to draw upon personal friendship with Kandinsky, having worked with him on the *Fraternity* portfolio (1938), and no doubt he would have imparted his enthusiasm orally to interested young Americans working at Atelier 17.

In the 1940s Hayter wrote several articles in which he developed the theory of automatism, and described how it affected his experience as a printmaker. These include 'Line and Space of the Imagination' (1944); 'The Convention of Line' (1945); and 'The Interdependence of Idea and Technique in Gravure' (1949). Avant-garde Americans would have encountered his ideas in journals such as *View* and *Tiger's Eye* (both sympathetic to Surrealism), *Magazine of Art*, and the single-issue *Possibilities*, which was edited by Motherwell and was very important in the history of Abstract Expressionism (see Chapter 10, pp. 113–14).

Hayter's ideas in these articles rely on a reading of the collective unconscious similar to that found in Herbert Read or John Graham, laying special emphasis on the role of primordial, 'racial' experiences in the making of art. 'The Convention of Line', for example, explores the way in which the carving of line was one of the first activities of primitive man, and speculates as to how 'our savage ancestor' chanced upon the idea of line. Because there are few examples of lines in nature— hair, lightning, a twig, or a crack closed enough for thickness to be irrelevant—he probably discovered it by noticing marks left in the sand, or by tracing a direction with his finger. Hayter suggests, in other words, that line has its primordial roots in the processes of record and exploration. The decorative use of line, the magical intentions of denoting animals, the development of hieroglyphs, all demonstrate how line is a convention; therefore its use, right up to the present, draws upon a reserve of forces locked in the recesses of the collective unconscious.

Hayter's sympathy with the idea of the 'collective unconscious' was one of the factors which would have made him sympathetic to the future Abstract Expressionists, who readily assimilated Jung. Also, as Dore Ashton puts it, 'Jung found a more ready climate than Freud for his aesthetic views in the United States, where there was a puritanical reluctance to grant the libido total creative monopoly.'[11] Because Breton and the French Surrealists discounted Jung, while canonizing Freud, the Americans would have been more sympathetic to Hayter's conception of the unconscious. There were also other respects in which Hayter and the Americans shared differences with mainstream Surrealism. As we shall demonstrate in the following paragraphs, Hayter refused to bow to the literary, anti-artistic strand in Surrealism, and he shared with several rebel Surrealists (Matta, Gordon Onslow-

[11] Dore Ashton, *The Life and Times of the New York School* (Bath, 1972), p. 123.

Ford, Wolfgang Paalen) a particular contempt for the illusionistic pseudo-automatism of Dali. Rightly or wrongly, the Americans perceived Dali as an inevitable product of Surrealist orthodoxy.[12]

The rebel Surrealists actively mobilized the young Americans in a belligerent movement dedicated to a renewed and invigorated automatism. Onslow-Ford organized a series of Surrealist exhibitions at the New School, which included Hayter but excluded Dali and Magritte.[13] Matta set up a short-lived Automatist group in 1941 which included Motherwell, de Kooning, and Pollock. Paalen, in his review *DYN*, attacked Dali and proposed the biomorphism of Tanguy as the true automatist alternative. Hayter is clearly connected with this sort of position, in both his own work and his associations. The *Brunidor Portfolio*, published by Curt Valentin in 1947, included lithographs by Lam and Matta, and etchings made at Atelier 17 by Tanguy, Ernst, Hayter, Seligmann, and Miró.

Another aspect of French Surrealism that alienated the Americans was the authoritarian leadership of André Breton. He had been dubbed by one of his critics 'the Pope of Surrealism'. By the time Hayter arrived in America, he had severed formal relations with the Surrealist group because he sided with Paul Éluard in the latter's bitter disputes with Breton. Of course, almost every Surrealist painter or poet at some point in their career fell out with the leadership of this wild and boisterous group, but it is especially significant to realize the essentially ambiguous relationship between Surrealism and painting in general.

Max Ernst, André Masson, and Man Ray, the first artists to be involved with what was predominantly a literary movement, had had to fight to establish the very possibility of a Surrealist art. Some of their poet-friends believed that automatism depended on instantaneous juxtapositions of words and was therefore incompatible with plastic representation.[14] These three artists reconciled the conflict between unconscious spontaneity and artistic creativity with the invention of new techniques. Ernst discovered collage and frottage, Man Ray experimented with types of photography that incorporated chance, and Masson practised what he called 'écriture automatique', or automatic handwriting. Hayter's printmaking

[12] Although Breton fell out with Dali, and dubbed him 'Avida Dollars' (an anagram of his name), the causes of his derision were Dali's commercialism and politics, rather than the nature of his automatism. The 'occultation' of the Surealist movement in the 1940s served further to distance Surrealism from the New York School.

[13] Gordon Onslow-Ford was invited to the United States by Kay Sage, wife of Tanguy and organizer of the Society for the Preservation of European Culture. The 1941 lectures 'Surrealist Art in Exile' were accompanied by exhibitions organized jointly with Howard Putzel at the New School, and featured work by Arp, Brauner, De Chirico, Delvaux, Dominguez, Ernst, Frances, Hayter, Magritte, Matta, Miró, Moore, Onslow-Ford, Paalen, Seligmann, and Tanguy.

[14] Max Morise and Pierre Naville, in the first and third numbers of *La Révolution surréaliste* respectively. Breton's book, *Le Surréalisme et la peinture* (Paris, 1928), while rebuffing Morise and Naville, in some ways reinforced their arguments. The very title, Surrealism *and* painting, rather than Surrealist painting, was interpreted by some with suspicion. See J. Pierre, *André Breton et la peinture* (Paris, 1987).

activities need to be understood within this context of reaching 'beyond painting',[15] while at the same time asserting the autonomy of artistic practice. Through Atelier 17, his writings, and his association with the Abstract Expressionists, Hayter was a crucial agent in the spread of this philosophy, a bridge between European and American Modernist art practice. In his own prints more particularly, and in his brilliant use of the burin, Hayter would explore a unique interrelationship between automatism and line.

Before proceeding to Hayter's prints of the 1940s, we should conclude our discussion of his influence on the Abstract Expressionists by mentioning his collaboration with their star Jackson Pollock. Several scholars have recognized that the months Pollock spent at Atelier 17 in 1944–5 were a turning-point in his career, for from this period date his first successful 'drip' paintings.[16] Pollock is considered to have 'broken the ice' with his automatic, gestural application of paint, creating labyrinths of continuous, free-flowing line. At Atelier 17, which he attended in a bid to improve on self-discipline, Pollock worked on eleven plates in engraving and drypoint, the most difficult intaglio methods.[17] Undoubtedly he found this work frustrating, as the images are rather strained, but the rare tenacity with which he worked the plates suggests that the very struggle was teaching him something. Under Hayter's close guidance, Pollock was discovering the special individual quality of line. According to Bernice Rose,

Before entering Hayter's shop Pollock's line was semi-automatic ... [his] images were a priori.... In the prints (and the drawings connected with them) we begin to see a more truly independent random, automatic line.[18]

Hayter introduced Pollock to the automatic prints André Masson had made at Atelier 17 in 1941. The American was already attracted to Masson because of his violent, subterranean imagery, but in these etchings, especially *Rapt*, he was brought closer to the phenomenon of unconscious drawing, and the abstract potential of pure line. Hayter would also have shown Pollock his own automatist prints of the 1930s.

The obstinacy of the engraving tools would have driven home to Pollock the absolute need for physical control before it is possible to practise automatism. He

[15] *Beyond Painting*, title of Max Ernst's book in the Documents of Modern Art series (New York, 1948), including earlier texts *Inspiration to Order* (1932), and *Au delà de la peinture* (1936); see W. Spies, *Max Ernst: Loplop* (London, 1983), for background to these texts and useful discussion on the subject of Surrealism and painting.

[16] Bernice Rose, *Jackson Pollock: Drawing into Painting* (Museum of Modern Art, New York, 1980); Stephen Long, *Abstract Expressionist Prints* (Associated American Artists, New York, 1986); Lois Fischener-Rathus, 'Pollock at Atelier 17', *Print Collectors' Newsletter* (Jan./Feb. 1974).

[17] J. J. Sweeney, preface to *Jackson Pollock: Paintings and Drawings* (Art of this Century, New York, 1943). 'Art of this Century' was the gallery run by Peggy Guggenheim, who gave Pollock his first one-man show. On the technical demands of drypoint, see *New Ways of Gravure* (rev. edn, New York, 1981), p. 37.

[18] Rose, *Jackson Pollock*, p. 15.

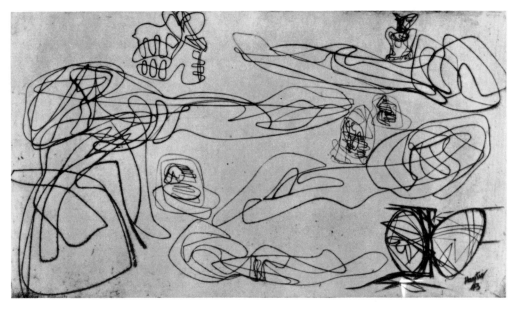

Burin Studies (1943)

achieved this with astounding genius in his paintings. If the Atelier's task was to help artists pioneer new means of expression and reach 'beyond painting', Pollock was inspired to do so within the medium of paint itself.[19] Incidentally, Atelier 17 may have provided the inspiration for Pollock's drip technique. Hayter installed a compound pendulum in the Atelier to facilitate experimentation in chance cyclical motion. Oscillation was used by Hayter and Max Ernst in their paintings of the early 1940s, and although there are other equally plausible sources, we may agree with Stephen Long's catalogue *Abstract Expressionist Prints*, that 'without Hayter and the hundreds of surrealist-inspired "drip" experiments of Atelier 17, Pollock might not have arrived at his historic breakthrough when he did'.[20]

Hayter brought to his own prints of the 1940s an unrivalled mastery of the engraver's burin. Indeed, he claims to be able to 'doodle' straight on to a plate, as in *Burin Studies* (1943), where effortlessly spontaneous linear motifs fill the composition. There is a small human or animal form in the top right-hand corner, an insect, perhaps, in bottom right, and a pair of teeth towards the left, but the sprawling webs of line that fill the rest of the composition are quite abstract. If *Burin Studies* were a drawing, it would have to have beeen scribbled in a few moments; but anyone who has tried to work an engraver's burin will known how essential

[19] B. H. Friedman, *Jackson Pollock: Energy Made Visible* (New York, 1972), p. 74.
[20] Long, *Abstract Expressionist Prints* (Associated American Artists, New York, 1986). Other sources of the 'drip', or pouring, technique include the experimental workshop of David Siquieros, group experiments with Baziotes and Kamrowski, and Hofmann's pouring exercises.

it is to preserve a steady hand, especially when negotiating turns, and avoiding any cross-over of lines. (Notice the way none of the motifs overlaps.) The absolute ease with which Hayter can bring forth organic shapes is miraculous. But he insists that the images are automatic, and offers as his proof the very fluency of the lines. Whenever there is self-conscious interference, he claims, kinks always disfigure the lines.[21]

Hayter has produced 'Burin Studies' regularly through his career (this exhibition includes one dated 1929–32 (**8**)), so that they form a sort of occasional journal. From such studies as these, or from images 'released' as drawings which he allows to mellow slowly in the imagination, he develops his other images. There is a constant interaction between these unconscious doodles and his manipulation of them. Of course, the final compositions are usually figurative, and pertain to literal or mythological subjects, which means that at a vital stage selectivity and discernment come into play. Also, as Hayter readily admits, after years of experience the engraver's hand and eye act instinctively.

Thus, if the source of material for such a work is irrational, its development and execution have to be strictly logical, not with the mechanical logic of imitation, but in accordance with a sort of system of consequences having its own logic.[22]

Despite the technical complexity of his prints in the 1940s, escalating with the introduction of simultaneous colour printing, the engraved burin line remains the pivotal component in his work. The linear element has always dominated Hayter's work, even when it has had to compete with layers of soft-ground embellishments, cuttings at the plate, or applications of colour. The early states of *Amazon* and *Tarantelle* demonstrate the primacy of the engraved line.

It is striking that, while Hayter moved away from Breton and the organized Surrealist group, the Surrealistic content of his art intensified. His work of the 1940s is characterized by the sort of violent, threatening, psychologically disturbing imagery to be found in Picasso, Masson, or Matta, all artists associated with Atelier 17, of course. Hayter's small, uncharacteristically sketch-like etching *Minotaur* was executed in 1941, the same year that André Masson—working at the Atelier 17—made his *Rêve d'un futur désert*, a superbly automatist etching of an ominous landscape whose caves and pot-holes share the Surrealist obsession with the underworld. *Minotaure* was the title of a French art review with which the Surrealists were associated, and the mythical bull-headed creature was a familiar symbol in the work of Picasso, used to evoke sexual or, in the case of *Guernica* (1938), political, violence.[23] Picasso's enduring influence on Hayter's figuration is still evident in the 1940s,

[21] Hayter in private conversation with this author, Apr. 1987.
[22] *New Ways of Gravure*, p. 132.
[23] Rosamund Frost states that Hayter contributed several unsigned drawings to *Minotaure*. Frost, 'The Chemically Pure in Art: W. Hayter, B.Sc. Surrealist', in *Art News* 40/7 (1941), p. 13.

and the themes of violence and terror which dominate his work in this period date back to the prints he did after his visit to Spain at the beginning of the Civil War, for instance *Facile Proie* (1938) (**108–10**), and the *Numancia* series (**21–4**).

Prints such as *Cruelty of Insects* (1942) (**35**) and *Prestige of the Insect* (1943) (**36**) explore further the themes of Man's cruelty to Man, indifference to suffering, and the mechanical processes of killing. Insects personify human foibles in a way that recalls the opening sequence of Luis Buñel's Surrealist film, *L'Âge d'or*. In *Cronos* (1944) (**42**) the prostrate figure of the god clasps his sprawling victim-daughter at the end of an erect, muscular arm, about to consume her gluttonously, in the way people eat asparagus or *langoustine*, holding the food above their mouth. He supports his reclining body with the palm of his hand pressed flat against a disc placed prominently at the front of the composition. In other works, Hayter depicts his own hand, or incorporates his hand print within soft ground, perhaps to signify himself. The first plate in which he utilized the impression of his own palm was, significantly perhaps, *Oedipus* (1934) (**12**). In common with all the Surrealists, Hayter's use of myth was firmly rooted in psychological preoccupations, and never prompted by neo-classical sentiment. The political evocation of cannibalism in *Cronos* obviously recalls Goya's hideous image, but also ties in with Salvador Dali's image *Autumnal Cannibalism*, despite Hayter's disregard for Dali's 'critical-paranoia' and simulated automatism.

Trapped figures and threatening females are recurrent images in Hayter's work in the 1940s. In *Terror* (1943) (**39**) the woman with hands clasped above her head can be read equally as the personification of terror or its victim. *Terror* masterfully exploits a variety of burin work; deep, thick lines around her right breast end in an abrupt manner, and burr has been left to give a rugged feel, while the hands are depicted with delicate, unobtrusive marks. The trunk of the woman's body is an open, twisting construction within which thin shading lines resemble the string inside an abstract sculpture. It is encircled by dark lines which meet at her chest. The illusion of internal space lends the figure an awesome, skeletal look, which is echoed in the skull-like head and gaping jaw.

The power of this tall, domineering figure enclosed within a tight space derives to a certain extent from the unusual shape of the plate: this in turn was dictated by the scarcity of metal in the early years of the War. The limits of material, if anything, prompt rather than impede creativity in the artist; they force him to respect his material, and search for his image within it, enhancing its automatism in the process. The raised whites which embellish the print (the cross shape on the chest, the kidney shape repeated at the foot of the composition, the circle near the torso, the eye) emphasize the reality of the picture surface, trapping the figure within it.

This idea is pursued in *Tarantelle* (1943) (**40**) and *Amazon* (1945) (**43**). Obviously,

Hayter was lucky enough to come across a better supply of plates, for he returns to a large scale with a vengeance. His *Apocalypse* series (1932) was also marked for its scale, and *Tropic of Cancer* (1949) (**51**) is the largest of all his prints. Since this period many of Hayter's paintings have also been on a large scale, prompting comparison with the Abstract Expressionists.

Tarantelle departs from *Terror* in its more adventurous use of soft-ground moiré textures. In *Terror*, the soft ground is limited to the areas surrounding the figure; the mass of the body is denoted by wiped, uninked intaglio surface, while the inked lines skirt around it; released from descriptive functions, they are used exclusively in an expressive way. In *Tarantelle* the contrast between shape and line is achieved by a more complex interplay between the textured shapes that shadow the figure and the engraved lines buried beneath them. The dancing figure is probably the artist himself, judging from the prominent hand and the masculinity of the limbs.

In *Amazon* the threatening, violent female returns, and some of the elements used in *Tarantelle* are further refined. The overlapping shapes in the earlier print are rather ambiguous in the depths they create, whereas in *Amazon* there is a more defined contrast between the close-knit fabric which creates the darker shade and the more open lace which curls around the figure like a tornado. The raised whites in *Amazon* are less tentative. Against the black shadows they seem to hang like pieces of a Calder mobile. The engraved lines are more emphatic and selective. In *Tarantelle* the intricate burin work recalls much earlier and at times pictorial uses, and although the workmanship is very fine (especially where he conveys the contorted muscles in the arm), *Amazon* established a more effective dialogue between the linear and planar dimensions.

One of the most striking features of *Amazon* is the way groups of perfectly straight tense lines appear from outside the plate, converge, and part again. In contrast to the sensual treatment of the woman's shoulder, elbow, legs, and breast, her distorted head is a menacing, Picassoid shell (recalling the *Seated Bather* (1930)), from which bunches of taut strings emanate. The Amazonian warrior seems to be struggling against these, which are at once a part of her and attacking her. Perhaps we are to read them like the contours in a Munch painting, expressing the internal, psychological anxiety of the figure. Certainly, the motif of converging lines isolating or threatening a central figure can be found in several other artists with whom Hayter was in contact in this period, namely Lam, Onslow-Ford, and Matta. Comparison of Matta's painting *Doubts Pilgrim* (1946) and Hayter's canvas *Ceres* of the same year exhibits a similar way of trapping a figure within a maze of thick lines and colour. Other prints of the period in which this visual idea is pursued include *Unstable Woman* (1947) (**49**), *Ceres* (1948) (**50**), and *Tropic of Cancer* (1949) (**51**).

Hayter's best-known print of his American decade is *Cinq Personnages* (1946)

(47), which owes its fame to its seminal position within the technical history of gravure, as the first example of a large intaglio plate printed in more than one colour in a single operation. The personal background to *Cinq Personnages*, related in the catalogue notes (p. 84), concerns the death of Hayter's son David, the only child of his first marriage. Something of this tragic situation is present in *Cinq Personnages*. The violent and terrifying image recalls Hayter's crowded Civil War compositions of the 1930s (*Combat* (1936)), breaking with the tendency of prints in the 1940s to concentrate on a single figure. Circuits of lines cut across and interconnect the component parts of the image, and lines are also used in the Munchian, contoured way analysed in the earlier prints. The choice of colours, orange, red-violet, and blue-green, also accentuates the intensity of the work. Hayter learnt in his paintings of this period how it was possible to create what he calls 'a psychological unity' with tones created by overlaying a few colours rather than with a wider palette; the tones in *Cinq Personnages* are perhaps deliberately sickly, which would relate them to the paintings of Matta. As effective as the coloured area is the large expanse of uninked plate in the middle left of the print. It is here that the totemic fifth character is perched; the simple, light burin line with which it is denoted contrasting sharply with the sprawling body on the right of the composition. This dying figure is made up of complex overlays of ink and tones, burin work, raised whites, and a crossroads of deliberately shaky, coloured lines. As a very personal meditation on a theme of grief and death, *Cinq Personnages* anticipates haunted private images such as *Masque* (1981) (95) and *Pendu* (1983) (98).

Hayter's experiments in colour printing would have a major impact on the course of printmaking in the twentieth century, as well as on his own career. His first colour print was also the first print he made in America, *Maternity*, which was achieved by first making a screenprint, and then passing it through the intaglio press. In *Centauresse* (1943) (38) Hayter successfully combined four oil colours on a single plate by using stencil cut-outs; red, yellow, green, and blue oils were applied over an initial inking of violet-red in intaglio: the only transparency which could modify the colours. Although Atelier 17 had developed clever ways of avoiding misregistration, Hayter was anxious to conduct all the inking and colouring in a single process, as well as to achieve the maximum integration of tone. In *Cinq Personnages* Hayter fixed pigmented silkscreen material on to the plate, replacing the stencils of *Centauresse*, and with his three chosen inks, two of which were transparent, he was able to effect eight different tones. These techniques of simultaneous colour printing exploit the fact that inks of different viscosities and appropriate molecular structures do not mix, and can be laid down one on top of the other in transparent films to obtain different colours and tones, depending on the permutations of the superimposed inks.

Various members of Atelier 17 experimented with Hayter through the 1940s and into the next decade (in Paris) to perfect the system of simultaneous colour printing. A major development of Hayter's earlier colour experiments with Anthony Gross in the 1930s occurred from 1946 onwards, when rollers were used to deposit inks one on top of the other. Hayter did not use this technique in his own work until the early 1950s (*Pegasus* (**52**) and *L'Escoutay* (**53**)). By the mid-1950s he had begun using a soft roller to lay colour of lower viscosity over colour already applied to the surface of the plate, thus penetrating to the already inked intaglio (*Guerriers* (1953) and *La Noyée* (1955) (**57**)). When he began experimenting with impermanent resists and deep bite (Flowmaster technique), he realized the tremendous potential of this method of simultaneous inking for extensively and deeply etched plates. The developing techniques led Hayter to think of the whole plate simultaneously in terms of the reception of colour. As *La Raie* (**61**) demonstrates, however, with its raised white burin line protruding from the deep etched space beneath it, colour was not allowed to usurp the supremacy of line in his work.

The complex process by which *Cinq Personnages* was printed is described in Chapter 11 of *New Ways of Gravure*. Hayter reveals more than just technical information in these paragraphs, however, and seems to anticipate in his comments the critical and aesthetic issues colour printing have raised. He opens the chapter with a 'sort of confession of faith', and writes,

Although, for personal reasons, I am no longer a member of the Surrealist group, the source of the material in all my works is unconscious, or automatic; that is to say an image is made without deliberate intention or direction.[24]

It is significant that he should assert this at such a juncture, for he realized that in many minds the technical complexity of colour printing is incompatible with automatism. Hayter has suffered in his career from his reputation as the 'technical wizard' of printmaking, which has prevented people from appreciating the content of his prints.

He expounds his ideas on the compatibility of automatism and printmaking in his essay 'The Interdependence of Idea and Technique in Gravure' (1949).[25] Starting from a theoretical position which rejects determinist distinctions between thought and execution, Hayter insists on interaction between conscious awareness and unconscious influence (automatism), suggesting that 'the succession is cyclic rather than narrative'. He concedes that intaglio printing is remote and indirect as a means of expression, due to oppositions between plate and print, not only because the impression is a mirror image of the worked plate, but because the incised lines print into moulded relief. (The inward to outward inversion in both cases is, Hayter

[24] *New Ways of Gravure*, p. 132.
[25] Originally published as 'Les Relations entre l'idée et la technique', in *Juin* (July 1946); then in *Tiger's Eye*, 1/8 (1949), p. 17, in a section of printmaker's statements entitled 'The Ides of Art'.

observes, of great topological interest; it is, for example, the only way that an upward helix can be inverted to a downward one.) This very remoteness, however, establishes the conditions in which automatic, unconscious work can take place. The detachment of the work on the plate from the results at the press free the artist's movements from an immediate formal awareness of their effects. The image comes out of the dark, as it were, in intervals marked by the pulling of proofs. 'The effect known as "creation" is clearly favoured by these moments of flux,' creation being something that can only truly come about during artistic expression. These 'fluid moments in the elaboration of the work' can be more intense than the inception, and the possibilities of departure are many rather than few. 'The artist can feel his work growing in power and expression or dissolving—even disintegrating; the choice, largely I think unconscious, determines the life or death of the image.'[26]

Hayter's statement that 'the rhythm of the work is very rapid as if an outside force had taken possession of the engraver' comes significantly at the moment of the birth of Abstract Expressionism, and recalls Pollock's legendary words, 'when I am "in" my painting, I'm not aware of what I'm doing'.[27] Looking forward to some of Hayter's prints of the 1950s and 1960s, particularly those made with a permanent and impermanent acid-resist (the Flowmaster series), it is possible to see the reciprocal influence of Jackson Pollock. However, Hayter's Flowmaster prints differ fundamentally from Pollock's gestural abstractions because of their subject-matter, for whereas Pollock only sought to 'experience' chance and gesture, Hayter's scientific imagination prompted him to understand them as well. Prints like *Cascade* (1955) (**62**), *Night Sea* (1962) (**65**), and *Confluence* (1964) (**68**) reveal Hayter's fascination with the natural phenomena of movement, water, and light, which have remained major preoccupations throughout his career. Hayter is wary of the dangers of Formalism, of allowing fancy techniques to overcome vision and purpose, as has happened with many of the young artists who have come to work with him in Paris since 1955. Although some critics have levelled the accusation at Hayter himself,[28] his own work achieves a sense of balance, and often of interaction, between the subject and its mode of expression.

[26] Cf. Max Ernst, *Beyond Painting*: 'The "author" is disclosed as being a mere spectator of the birth of the work, for, either indifferently or in the greatest excitement, he merely watches it undergo the successive phases of its development.'

[27] Jackson Pollock, 'My Painting', in *Possibilities* (the article that appeared next to 'Of the Means', see n. 6). Cf. also, 'I have no fears about making changes, destroying the image etc. because the painting has a life of its own' (Pollock), and 'Development may take place again at the introduction of a new and contradictory system which can later grow to the point of supplanting the primary image' (Hayter).

[28] e.g. Pat Gilmour, *Arts Review* (Oct. 1973), p. 709: 'The proof of the early state [of *Unstable Woman*] showing only burin engraving, has an exquisite crispness of line ... but the final state superimposes natty netting textures, disastrous colour flats, and absolutely irrelevant blind embossing, utterly cancelling out the infinitely more profound imaginative vision intuited in a spontaneous line.' Gilmour was the founder-curator of the Tate Gallery's print collection. *Unstable Woman*, however, won the Purchase Prize at the Brooklyn Museum Annual Print Exhibition in 1948.

The speed with which Atelier 17 developed new methods of colour etching in the late 1940s and early 1950s vindicates Hayter's twin demands for experimentation and the collective organization of the workshop. The Surrealistic sense of chance, accident, and play which often informed experimental practices of Atelier 17 can be seen at their wildest in the work of Miró and Ernst, who both worked there in the 1940s. Miró produced stunning and original etchings when he visited New York in 1947, through the wilful and spontaneous use of nails and horseshoes as etching tools, and undisciplined etching practices, while Ernst had already in the 1930s discovered open etching by accident after forgetting that he had left a plate in an acid bath overnight! Sue Fuller, a young, unknown artist who worked at the Atelier in New York, shows how the Americans could also respond in this spirit. Her experimentation with familiar sugarlift techniques, using syrup, was taken up by Masson in his print *Improvisation* (1943), while in her own soft-ground etchings she incorporated the entire contents of a sewing kit in a way that recalls the collages of Hannah Höch. Hayter was able to bring to his own experimentation the added dimension of a trained, scientific mind.[29]

Because it was founded expressly for the purpose of experiment, the structure as well as the aims of Atelier 17 was fundamentally different from the norm. The traditional hierarchy of apprenticeship was abolished, printing for other artists was seldom undertaken, and everybody was expected to do their own dirty work, such as pulling editions, numbering and dating, and cleaning up. In his approach to administration, as with 'education'—if one dare use the word in connection with Hayter—we can see the application of the principles of anarchism and Zen.

The Museum of Modern Art exhibition in 1944 revolutionized American attitudes towards 'Artists' Prints'. In the early 1940s, Hayter recalls, 'you could not give away what we called a modern print', but by the end of the decade American artists had begun to take printmaking seriously. The ranks of Atelier 17 swelled with artists from around the country as the MOMA exhibition toured, and with ex-servicemen taking advantage of the GI Bill. With the post-war economic boom, universities began to establish print studios as part of their expansion programmes, and many of these came to be staffed by people who had worked with Hayter. (For instance, Gabor Peterdi ran the department at Yale, Karl Schrag at Columbia, Karl Kasten at Berkeley, Mauricio Lasansky at Iowa, and Fred Becker at Washington University, St Louis.[30])

The dispersal of the more dynamic members of the group may partially account for the demise of the New York Atelier 17 after Hayter returned to Paris in 1950.

[29] As a trained scientist turned artist Hayter belongs to a select club, alongside Calder and Gabo.

[30] For an extensive account of the influence of Hayter and Atelier 17 on American printmaking, see Joann Moser, *Atelier 17*, pp. 17–19 and 45–7. See also Una E. Johnson, *American Prints and Printmakers* (New York, 1980), ch. 2.

Starting with Karl Schrag and ending with Leo Katz, the Atelier went through a quick succession of directors, and dwindled in popularity, despite imaginative new courses and ventures such as *21 Etchings and Poems*.[31] In 1955 the Atelier finally closed, a sad experience which deterred Hayter from his plans to open a branch in London that year, for despite the situation in New York, the Paris Atelier was thriving. The truth of the matter is, perhaps, that the warmth and enthusiasm of Atelier 17 are indivisible from its founder. In the words of James Kleege (who was director of the Atelier in 1951), 'In reality, the Atelier 17 was wherever Bill Hayter was.'[32]

[31] Hayter teamed up with the poet Jacques-Henri Levesque. Exploiting Hayter's research with Ruthven Todd and Joan Miró into the printing techniques of Blake, *21 Etchings and Poems* featured the poets' own handwriting in each plate in a unique collaboration.

[32] Quoted by Moser, *Atelier 17*, p. 11.

4
The Great Colour Prints 1969–1987

PETER HACKER

Hayter's art makes stringent demands upon the viewer. Though his images have an immediate, sometimes indeed stunning, impact they are often difficult to assimilate and to understand. Typically they make their deepest impression only after prolonged scrutiny and reflection. For these prints, and the effects which they achieve, are rarely simple. They involve a rich orchestration of space, motion, rhythm, texture, and colour. Each of these in turn is multivalent.

The representation of space has fascinated Hayter since the beginning of his career. What concerns him is less physical than subjective perceptual space and the spaces of the imagination, containing essential mutation, ambiguity, and distortion. One of his primary means of creating such spaces is not geometrical perspective, but rather planar webs (as in theatrical drops). This is singularly appropriate to gravure, for minute differences in the planes of the etched and engraved plate can open up great depths in the printed image (*Caribbean Sea* (**73**), *Free fall* (**80**), *Claduègne* (**78**)). The space of the imagination is not limited to Euclidean structures, and Hayter's explorations reach into curved spaces, 'exploding' spaces as visible in convex mirrors (*Serre* (**91**), *Convex Mirror*), and hence reversal of inward and outward direction, topological twists in space, and endless forms of ambiguity of recession, relief, dominant and subordinate plane.

Texturing the plate by impressing materials (crumpled paper, silk, gauze, wool, and even leaves) fulfils a variety of roles. It can be used, as Hayter realized in the 1930s when he introduced these devices of soft-ground etching, to create spatial recession, to generate interpenetrating webs, 'interference', and hence moiré effects, as well as to accentuate or modify flow and rhythm (*Vague de fond* (**71**)). When combined with his technique of hard- and soft-roller simultaneous multicolour inking, it increases the possibilities and subtleties of colour modulation and hence of colour space. The sky in *Fastnet* (**99**), the rippling sands seen through a film of water in *Pendu* (**98**), the suffused light streaming across the centre of *Chute* (**86**),

or the marbling effect of the anterior bands of yellow in *Free fall* (**80**) exemplify some of these possibilities.

Hayter is equally preoccupied with the representation of motion. But he is rarely concerned simply to depict a moving *object* as such. In the magnificent series of Flowmaster prints in the late fifties and early sixties he concentrated upon flow and motion within a flow (*Cascade* (**62**), *Confluence* (**68**)) or upon the path traced out by an object within a fluid medium (*Poisson rouge* (**58**)). When figurative components reappear in his work in the seventies, the movement of an object is often captured by the motion of a field upon which it is located or the disturbance to a flow (*Requin*, *Sea Serpent*). In the mid-seventies, violent falling through space is depicted by portraying the billowing wake of an object whose character is only intimated (*Free fall* (**80**)). Here again he makes use of the unique qualities of gravure. The representation, in his images, is often a direct projection of the means of representation. The trace of his burin in the metal plate does not merely depict the movement of the object represented, but becomes one with it (*Free fall*). The etched spattering of the varnish in the Flowmaster prints *is* the spray of water depicted, and the motion of the artist's hand is directly projected on to the velocity of the flow represented. The imaginative experience of the creator working the plate is fused with the image created and immediately communicated to the perceptive viewer. Idea and technique, as Hayter ceaselessly stresses in his writings, are inseparable.

Given his interest in wave motion and in the vibration of a field against which an object or trace of an object is depicted, it is not surprising that rhythm plays a major role in many of Hayter's prints. Regular rhythm, however, does not hold the interest of the viewer, and mesmerizing effects, as, for example, in Op Art of the sixties, though they may hold the eye, numb the mind and ultimately become simply boring. Whether the rhythm of a field or of stroboscopic representation of motion in one of Hayter's prints is slow or rapid, it always varies in amplitude, frequency, or direction (*Caribbean Sea* (**73**), *North-west* (**97**)). Where he employs a series of moving bands superimposed one upon another, as in *Wind* (**81**) or *Free fall* (**80**), the displacement of one series relative to the other is progressive, unpredictable, and hence animated.

Being the inventor of simultaneous multicolour printing, Hayter has acquired an unsurpassed understanding of colour and its effects. The completion of the plate, for him, is only half the creative process. For colour is never employed merely to 'colour in' an image in accord with a preconceived idea. The interplay between the apparent relief of the image printed from the worked plate, and the colour spaces created by the relations between 'warm' and 'cold' colours, as well as the apparent depths generated by the superimposition of transparent colours one on top of the other, the tensions or harmonies produced by the adjacency of colour opposites or

complementaries, all play a vital role in the completed work (*Styx* (**83**), *Bouleau* (**89**)). It is noteworthy that although Hayter's techniques of colour printing allow numerous different coloured inks of varying viscosities to be placed simultaneously on the plate, he is intent upon achieving the maximal effect with minimal means. Sometimes employing only two different inks (*Wind* (**81**)), and rarely more than four, he creates an extraordinarily rich array of colours, sometimes of great delicacy (*Caribbean Sea* (**73**), *Pendu* (**98**), *Apparition* (**96**)), sometimes of blinding brilliance (*Claduègne* (**78**)), and at other times of great dramatic force (*Fastnet* (**99**), *Chute* (**86**)).

When scrutinizing Hayter's prints, each of these parameters should be explored. If their synthesis in the image is to be understood, one must grasp the sophisticated counterpoint which the artist has created. Anyone willing to submit himself to these demands will find that Hayter's prints have a remarkable strength. They are hard, not soft. They do not falter under scrutiny, but have a rare quality of resistance to gaze. Their interest does not diminish with familiarity, for the eye is kept continually in motion as new relationships and subtleties spring to view. The fascination of these images grows as understanding deepens.

At an age when most artists are firmly settled in style and repertoire, Hayter enjoyed an outburst of creativity and flood of original ideas. Between 1969 and 1987 he made well over a hundred prints, many of them masterpieces of modern art. Although his preoccupation with water, flow, and the reflection of light on water continued for a while, it was expressed in new forms corresponding to the different techniques which he introduced. The range of colours he used changed as he began exploring the potentialities of fluorescent inks, and his prints became increasingly brilliant. By the mid-seventies, fresh themes occurred in his work and were developed with ever greater virtuosity. It is impossible, in the compass of a short essay, to survey all of these. The following discussion will, therefore, focus upon five major motifs that were developed in this period and are well represented in this exhibition. However, much that is important has had to be omitted.

The changes in the character of Hayter's prints in 1969 coincide with his employment of a new technique of etching. He began using venilia, a self-adhesive plastic sheet, as a permanent acid-resist laid down on the metal plate. It can be cut with a knife, both in long flowing lines and in small, precisely controllable segments. The knife here is used in a way similar to the burin, inasmuch as the hand moves but little, and the plate is swung *against* the knife. As with a burin, one 'navigates' as it were, but in *two* rather than three dimensions. However, the cutting motion of the knife *following* the hand is very different from that of the burin urged forward *in front* of the hand against the resistance of metal, for one can see the wake of the trace one leaves, rather than projecting an incision before one. The expressive

potentialities of the line thus cut are distinctive and novel, differing both from the engraved line and from the bitten line of the etching needle on an acid-resist ground. The plastic cut-outs can be reimposed in varying orientations upon a partially bitten plate, or a fresh sheet can be laid down and cut to yield an indefinite variety of precise mosaic-like structures deeper within the plate. This ground makes it possible to etch deeply into the plate over large areas, while retaining crisp outlines. It is then possible to ink in intaglio in such a way that the colour will be held densely at the edges of the bitten area, offering the centre for a second colour deposited with a soft roller. If this second colour is transparent, a third one rolled on it will appear in the print as glinting through it in the centre. The unbitten surface of the plate can, of course, be inked in further colours through stencils, or with a hard roller (uniformly or in gradation).

The use of venilia is merely another technique, and the only artistic importance of technique for Hayter is the extent to which it liberates fresh movements of the imagination and releases new ideas. 'It is the importance of the idea (communicated by whatever process), and this alone, that determines the validity of the work.' Nevertheless, 'the expressive possibilities of a process in the hands of an artist who has himself devised it can give results in the category of the print as a major work far beyond any result to be expected from the ingenious adapters of other men's methods'.[1] It is evident that one of the greatest stimuli to Hayter's imagination comes from his restless exploration of new means of expression.

The sea and water prints of this period display both continuity with and change from the images of the sixties. Hayter's fascination with flow, rhythm, and the effects of light on water continues, but the new technique provides a different form of representation with distinctive expressive possibilities. By cutting interwoven undulating lines through the plastic resist it is possible to create webs of elongated trapezoid shapes. If deeply bitten, and inked in intaglio as well as with a soft roller, remarkable effects of light can be achieved. This is manifest in *Caribbean Sea* (**73**), which imparts the impression of sunlight filtering through shallow seas. Sandbanks seem to be visible through the undulating surface, although nothing here is figuratively depicted, but only suggested. The complexity of the structures by which this image is produced is noteworthy. Three different layers of wave motion are superimposed one on top of the other. The background consists of narrow bands, akin to those used in the images of the mid-sixties. Upon this a dense web of undulating soft orange trapezoid shapes moves in counterflow. Finally a darker pattern, made by impressing a wire grid underneath the plate, heaves and surges. The fascination of this delicately coloured image is due to our intuitive apprehension of the multiplicity of wave movements, one passing through or over the other.

Quite different effects were pursued the same year (1969) in *L'Harmas* (**75**), and

[1] S. W. Hayter, *About Prints* (London and New York, 1962), pp. 103 f.

explored again in the following year in *Ripple* (**76**). Here Hayter's interest was not in the broken reflections of light beneath the surface of the sea, as in *Caribbean Sea*, or on light flashing on spray as in *Swimmers* (1970), but on the rippling sunlight on an unbroken but gently moving surface. *L'Harmas* depicts the sun reflected off the waters of a swimming pool. Because the waters are contained within walls, any wave motion will bounce from side to side, generating the distinctive patterns Hayter has depicted. The interference of two such wave motions moving in opposite directions produces just those peculiar circular reflections of light visible here at the edge of the sunbaked pool. *Ripple* is a closer study of these light patterns; the shapes and sliced lines are bolder, the colours more brilliant and in stronger contrast, and the movement more dramatic.

Disturbances to wave motion are, of course, created by objects moving through an undulating medium. The very first of Hayter's venilia prints *Swimming Bird* (1969) explored this, as did *Swimmers*, made the following year. In neither case was he interested in the depiction of the object itself, but rather in the movement, the splashing of water in the light, and the breaking up of the wave pattern. However, in *Sea Serpent* (1975) and even more dramatically in *Requin* (1978), monsters of the ocean are depicted in a highly generalized manner moving within a flowing medium. *Requin* is a dramatic evocation of a shark looming out of the gloomy depths. The ground is richly textured, and the movement of the water around the dark shape suggests immense and frightening power.

Claduègne is a river in the vicinity of a holiday house Hayter owned in the Ardèche, and the print of that name (**78**), made in 1972, originated in observations of the movement of the river waters in the sunshine. But from this mundane source emerged an image of vibrant incandescent flow. With its tilted, curved horizon line, convex surface, and the bands of red and orange leaping into a darkened sky, it evokes the idea of the fiery surface of the sun rather than of any terrestrial stream. Among the studies of water, *Styx* (**83**), made in 1974, is unique in its strange patterns of movement. The streams of liquid move through each other without intermingling. The flow is slow, as if the liquid is thick and viscous. Like bands of molten lava, the shining streams of orange descend from left to right. Dark greenish-blue flows move in similar pattern across them, ascending to the right; and through both layers, emerald green concentric ripples expand languidly from bottom right upwards. The two large circles inscribed increase the spatial complexity and depth of the crossing flows.

The number of water studies diminishes after the mid-seventies as Hayter turned to new themes, but in 1985, in his eighty-fourth year, he made one of the finest sea prints of his long career. A friend of his sailed in the ill-fated Fastnet yacht race that ran into a hurricane, and hearing of this inspired the largest and most dramatic of all Hayter's colour prints (**99**). Five ghostly sails reach high into the dark sky,

low-lying mist scudding across their tops. As the eye flickers back and forth from one to the other, they appear to move from left to right on a curving trajectory, battling through mountainous seas. One may indeed take this sequence of sails to depict one yacht in progressive displacement. The horizon line is tilted, as if seen from the deck of a tossing vessel, and this destabilizes the image. For one is tempted to tilt one's head in order to secure a 'level' horizon, but is forced to resist the temptation by the logic of the picture. Fierce burin lines, inked in fluorescent orange, lie high above the ocean on the same plane as the tops of the sails, indicating the whip of the mast as the yacht is flung back and forth; other wild lines intimate broken stays flying in the wind. The surface of the ocean heaves as blind rollers race across it, and diagonal streaks suggest the lashing rain. The sky is rendered by elaborate soft-ground etching, torn pieces of gauze both animating the surface and functioning as a metaphor for the ripping canvas. Dark purple-green storm clouds cover the sky, but the horizon line glowers in angry red and orange. *Fastnet* is not a picture of an arbitrary sailing boat in a storm, but a representation of the very notion of a yacht at the mercy of a tempest—an archetypal idea given pictorial form.

Related to the sea and water prints is a superb quartet, *Lake, Caragh, City,* and *People* (1973–4). Their subject is not movement of, but reflection in, water. Hence they explore two spatial orders, one dominant and the other subordinate. *People* (**84**) depicts a densely packed crowd receding into the distance on the slopes of a hill. Above, a dark sky looms ominously. The mass of people is huddled on the seashore, their broken reflections gleaming in the water. The picture is studiedly equivocal. It depicts mankind alone in an alien and threatening world, but the brilliant colours, the bronze figures standing out sharply against the emerald green hills, belie, or at least mitigate, the minatory character of the image. *City* (**82**) makes use of a more blurred reflection to impart depth. Along the horizontal centre of the print, the city lights of Istanbul shine and glitter in the distance. The night sky, with stylized clouds scudding across it, enfolds the town. Below, the lights, domes, minarets, and modern skyscrapers are reflected in a waterfront, and the oval firmament is mirrored indistinctly in a dark sea. As in *People*, an air of loneliness is conveyed, but here too it is muted. The city seems a haven in the darkness, and the dim reflections in the water are tranquil.

In *Apparition* (**96**), made eight years later (1982), Hayter returned to the motif of reflection, in a plate that is similarly divided along a horizontal, but otherwise altogether different in spirit. The figurative component is minimal, and the emotional tone has changed. A strange reddish-black shape looms high up from the horizon of a silvery grey-blue sea into a darkened sky. A strong passage of light shines from the horizon on the left, but the reflective surface of the sea is illuminated on the right. Moreover, the shapes and linear constructions in it, though they partly

echo the strange apparition in the sky, do not mirror it. The muted colours, the powerful recession on the right that conflicts with the flat construction on the lower left, and the contradictory lighting lend the image an aura of mystery. The sense of a horizon line and of a partly lit sky and sea is so strong that expectations of further recognition are raised—and dashed. Within this identifiable framework, the eye is left to explore the curious and unfathomable imagery, seeking for a meaning that is always just beyond grasp.

The study of reflections led quite naturally to the portrayal of two different spatial orders which, unlike those of the reflection prints, are either co-ordinate or ambiguous in subordination. Three outstanding prints, in all of which the figurative component is minor, exemplify this. *Clairevoie* (**79**), made in 1974, depicts a field of dancing curvilinear black shapes against a background of yellow in gradation merging with a rich violet. This array is seen through a lattice of columns evenly distributed in the frontal plane. Segments of these columns have been deeply etched with predominantly rectilinear shapes, which hold the purple ink densely at the edges and are strongly textured in the centre, thus producing a metallic impression. It is impossible to keep both planes in focus simultaneously, and the eye switches constantly from one to the other. Further ambiguity derives from the fact that the black shapes in the hinterfield can be seen moving now in a vertical plane, now in recession. The spatial ambivalence and strong colouring hold the eye, and one is forced to move within the image, discovering fresh relationships and continuities.

Voiles (**85**), made the following year, develops a similar theme quite differently. Here the frontal series of bars, when scanned from left to right (as an image is naturally scanned), is subordinate to the field behind it. But the dark-blue bars become progressively wider until, on the far right, they are transformed into the dominant field. Behind them, lying against a lighter-blue background, is an interconnected sequence of sail-like white shapes moving in a sweeping, ascending flow in recession set off against a strong diagonal. The relationships between the white shapes within each plane, as well as the relationships between shapes in different planes, are complex, and typically broken just at the point at which one seems to have found the key to the whole. *Voiles* is a subtle and fascinating study of counterpoint in blue and white.

Volet (**90**) is yet another variation on this theme, with even more refined effects. Here there is a different kind of ambiguity between column and background, for what appear in the lower part of the print to be silvery columns in the frontal plane become, higher up, the spaces in the background visible between a second series of columns, coloured in grey, which are also apparently in the frontal plane. It is not for nothing that Hayter humorously refers to this transformation as 'the Disappearing Column Trick', for the transition, effected by means of delicate inking in gradation, is imperceptible. On each of the two sets of stripes is etched a series

of circling bands, yellow on the silver stripes and black on the grey ones. They swirl around in continuous dance, almost persuading the eye that they are unbroken, and adding further ambiguity to the planes of the image.

A further motif that emerged in the mid-seventies is that of falling through space, of wind, and of fluttering in the wind. Here Hayter characteristically strives after generality while eschewing abstraction, aiming to depict not the particularity of phenomena, but their quintessential nature. *Free fall* (**80**), made in 1974, depicts an indeterminate object plunging from the heavens into the void, rolling and pitching convulsively. The theme is not the falling object, but the falling of the object. Violent, erratic burin lines, inked in fluorescent yellow, mark its passage against an increasingly deep-blue background. Descending bands of textured yellow stripes in two planes accentuate the fall, and the billowing wake of the doomed object slices through these stripes in dramatic torsion. The slivers of brilliant yellow shining along the edges of some of the dark bands in the lower part of the print increase the sense of speed, and the midnight blue of deep space into which the object disappears arouses our primal fear of darkness and the void. *Chute* (**86**), made the following year, explores the theme of plunging downwards through space, not in the throes of destruction, but in triumph. In contrast with *Free fall*, here the colouring is warmer, the background series of bands curves supportingly rather than dropping away precipitously, and the swooping object is depicted in a generalized form, glowing in hot fluorescent orange, and leaving a red wake behind. The wedge-shaped spearheads, distributed along its front, thrust forward, and the remarkable invention of overlapping catenary curves before it suggests pulsating, accelerating motion. A warm diffuse light radiates across the centre of the image, as the orange shape dives in exultation in the azure blue sky. *Chute* is one of Hayter's *Meisterstiche*, brilliant in colouring, inventive in conception, and perfect in execution.

While both *Free fall* and *Chute* exploit the descending left–right diagonal, *Wind* (**81**) makes use of similar double-layered descending bands to portray ascent. Wind is visible only indirectly, by means of the objects it moves. Although no object is depicted in this print, the helical motion and vibrant colours combine to yield an unmistakable image of a vortex of rising air. Against a stable vertical on the left, Hayter has etched a series of swirling lines, cut with a free flowing hand through bands of venilia. The complexity of the structure defies description and could surely not have been planned. It is rather the product of a fine artistic intuition and decades of experience that make the movement of hand and mind a unity, and fuse conception and execution. Gusts and eddies ruffle across the image from left to right. A current of air rises in the centre, rolling boisterously, curling outwards and upwards with increasing speed. A squall whirls around, back across the image, circling turbulently before being sucked into the purple-blue sky in a giddy surge.

The two versions of *Rideau* (**87, 88**) are studies of a diaphanous curtain fluttering against a window, behind which a dancer is visible. The first version, coloured in brilliant greens and red, gives more emphasis to the dancing figure. But after pulling thirty impressions, Hayter reworked the plate. By cutting it down on the right, scraping extensively, and changing the colour scheme, he achieved a very different effect. The final version places more emphasis on the movement of the curtain blowing tremulously in the wind. The darker segments no longer depict only the swaying skirt of the dancer, but also suggest parts of the curtain flattened against the window. Here Hayter achieves just that multiplicity of aspect that is the hallmark of his art. For now we no longer see dancer *and* curtain, but a curtain and dancer fused. The swirl of the curtain *is* the twirling dancer, and the dancer's rapture is made manifest in the dance of the curtain.

Bouleau (**89**) is a generalized depiction of the branch of a birch tree moving in the breeze. As in previous prints, it is a picture less of a moving object than of the motion of the object—of the path it has traced over time. Below, picked out in warm yellows against the pink-mauve background, is a stroboscopic representation of a bough dancing a circuitous path in the wind. Above, and supported by the golden bough, is a series of sinusoidal shapes running rhythmically across the image at different levels, suggesting the foliage fluttering in the sunlight. The brilliant orange, glowing against the emerald green, and the golden haze that suffuses the centre of the image manifest a joyous intoxication with movement, light, and colour.

Between 1980 and 1983 a fresh theme captured Hayter's imagination. Having lived for a decade in the studio apartment he still occupies in Paris, he suddenly, as it were, saw it lucidly for the first time, with original astonishment. Preoccupied with our daily concerns, we cease to notice our mundane environment, lose any sense of its singularity, and take the familiar for granted. It needs an artist's vision and aesthetic detachment to apprehend the commonplace afresh and to transform it into an object of wonder. The first of this series of transmutations of the studio is *Ceiling* (**92**). Here, as in the other prints of the series, a strong figurative element appears. The great angled studio window is depicted in exaggerated recession, and through it is visible the adjacent building, with carefully delineated embrasures. The whole complex of window and vista is upside down, seen when looking backwards and upwards at the studio ceiling. The two quadrilaterals on the left, with a large monstera leaf and helically undulating grid, are linked to the architectural motif by the white lines that dominate the image. They increase the depth and spatial ambiguity—the right-hand stripe passing behind the window bars but in front of the studio wall. The angled white stripe, like an after-image, echoes the angular bars of the window. A classical spatial lucidity is achieved by altogether non-classical means, and the monochromatic colouring of the ceiling, walls, and

adjacent building, coupled with the inversion of the sky, lend the image an eerie quality.

Indoor Swimmer (**94**) is an ingenious invention. It depicts a huge shadowy red figure of a swimmer seen from below, moving with powerful strokes across the plane of vision. The white stripes here are distributed at varying depths in the picture plane, and function both to highlight the articulation of the torso and to accentuate the recession. Green undulating stripes above the swimmer mark the ripples on the surface of the pool. The curious grids on both sides seem to indicate the walls of the swimming pool, and it is initially with a shock, then with amusement and admiration at the invention, that one realizes that the swimming pool is the studio (a photograph of which is reproduced on p. 52). The 'grid' on the left is the angled studio window familiar from *Ceiling* and through it is visible the adjacent multilevelled building and sky.

Figure (**93**) and *Masque* (**95**) are more personal. *Masque* uses the 'Disappearing Column Trick' in conjunction with inking in gradation to depict the floor of the studio as seen from the gallery above. The delicate colours create a slightly misty magical light in the studio space, and the spiral staircase on the right is seen as if through a haze. A huge humanoid figure, reminiscent of Hayter's burin work in the early 1930s, floats above, signifying the artist's identification with the place in which he dreams, and creates what he dreams. An African mask was the inspiration for this print. Hayter saw it in a collection and was impressed with its powerful fetishist or totemic character. Inscribed here in the centre of the image, it perhaps represents the creative aspiration of the artist to infuse an image with life, to project the movements of his imagination on to an object that will possess a power of its own, capable of moving others.

Figure is unique among Hayter's prints in being a self-portrait. It depicts him silhouetted against an archway with his studio behind. The curve of the arch is completed by the concave distortion of the window bars of the studio on the upper left, and complemented by the curved space created by the enfolding stream of etched shapes. The differential inking of the silhouette and the vertical stripes animate the virile figure of the artist in repose, but poised for action.

The concave distortion of the window bars of the studio recurs in *Pendu* (**98**), a print rich in variegated refined textures, virtuoso engraving, and subtly modulated colour. Within the space enclosed by the window, a strange electric-green figure seems to dance. Wonderful passages of soft-ground etching animate the background of this mysterious print. Beyond the window bars, deep cloudy spaces recede indefinitely. On the left, the rippling sands of the seabed, as if seen from above, glint bronze in the sunlight. Between these highly textured sides of the print a narrow stripe of featureless blue lies far back in the picture plane. The eye is led into it as into the infinite spaces of the sky. Two long catenary curves meet in front of it, and

below their point of suspension is concealed the key to the mystery. Amidst a tangle of burin work, and lying across the great circle, is a precisely engraved figure of a hanged man, arms and wrists bound, feet turning inwards, and lifeless head drooping. The print is a meditation on death, which Hayter made at a time of serious illness in his eighty-second year. With its deliberate allusion to the Hanged Man of the Tarot pack—a symbol of spiritual riches and Utopian dreams alike—it

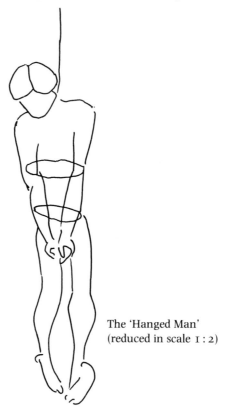

The 'Hanged Man'
(reduced in scale 1 : 2)

is neither fearful nor melancholy, but a calm recognition of mortality. The green sprite, as if balanced upon a tightrope before the studio window, may be seen as a symbol of the artist's creative spirit, as well as of the precariousness of life. The moving waters on the left recall the Heraclitean truth *panta rei*; only change and death are permanent. The deep still blue that lies behind the hanged figure intimates the peace and indifference of eternity. *Pendu* is a profound and evocative *memento mori*, comparable, both in its virtuosity and enigmatic character, to Dürer's great *vanitas* engraving *The Coat of Arms of Death.*[2]

[2] I am most grateful to Bill Hayter for numerous illuminating discussions. Charles Morgenstern and Raymond Lokker kindly commented on an earlier draft of this essay.

5
Working in Atelier 17

———

JEAN LODGE

I worked with Hayter in Atelier 17 from 1966 to 1969; the experience influenced my whole conception of art. The intensity and excitement in the Atelier came from Hayter's insistence on using controlled 'experiments', to create unforeseen images. 'If you already know what it is going to look like, there is no point in doing it.' For Hayter making pictures is a profound, sometimes amusing and always daringly imaginative 'game'. It is played on the edge of the visual unknown and may lead to startling results. 'If it looks out of balance, unbalance it even more.' He provoked me to look for movement, surprise, the unexpected . . . to take pictorial risks and to avoid predictable stability and harmony. Bill's own paintings and prints are constantly evolving, changing. In this sense he is younger in spirit than most of the artists working around him. Once he reaches a solution he always moves on to new research; art is adventure, forward-looking, driving into the unknown.

I wrote the above passage in 1981 for the Oxford Gallery publication *For Stanley Wm. Hayter on his 80th Birthday*. It provides a good introduction to this essay.

I arrived in Paris to work in Atelier 17 in October 1965 having finished the Oxford Certificate in Fine Art in painting at the Ruskin School in June. I wanted to explore the possibilities of printmaking glimpsed through *New Ways of Gravure* and *About Prints*. As an undergraduate in the States I had studied drawing with Laurence Barker, who had worked in Atelier 17; he introduced me to certain experimental drawing methods based on his experience in Hayter's workshop. I had spent the summer of 1965 in Salzburg at Kokoschka's School of Seeing, doing water-colours and enjoying the international grouping of artists and musicians there. I was stimulated and my imagination quickened by new uses of colours—very limited palettes of pure colours in superimposed transparent washes applied quickly and directly—a liberating experience after the more rational academic training I had received in Oxford. My brief sojourn at the Kokoschka School was an excellent bridge to what was to come in Paris.

I was excited about going to work with Hayter, but did not realize that working

Hayter in discussion with Julian Hayter, Jean Lodge, Lorna Taylor, and Angelica Caporaso

with him in Paris would totally change my life. Until then I had imagined going back to the States after the time in Europe, where I had come for a structured Fine Art training in a museum-based school and a closer look at our cultural roots. The projected three-month period in Atelier 17 was to be the last part of the training before returning to America to set up a painting studio.

What happened was quite different. The projected three months with Bill lengthened to over three years. During this time I decided to stay on in Paris, and in 1969 established my own printmaking workshop with Angelica Caporaso, who had also been working in Atelier 17. Our atelier is just a street away from the Rue Daguerre where we had been working with Bill. This joint workshop, where a group of artists comes regularly to make prints, is still where I do most of my work. I live in the same building and Paris XIV is where I consider my home to be, although I spend an appreciable amount of time in Oxford since becoming 'Printmaker' at the Ruskin School about ten years ago. The challenge of being part of the team that began working with the then new Bachelor of Fine Art course, and responsible for the specialization in printmaking, tempted me back to Oxford. The extraordinary resources of the University that were made available for the full-time, studio-based, three-year undergraduate course gave me the chance to develop a printmaking

workshop that would foster original experiment, maintain openness of attitude, and encourage international contacts with as many visiting artists as possible. This engagement with the University has opened rich opportunities on a scale that I would not have been able to develop privately. But I still love the freedom of my Paris atelier, where those who come are there not for a degree or because they have a grant, but because they are keenly interested in making prints in an experimental way, sharing experience, and working alongside other committed artists. Like our atelier in Paris, all over the world there are workshops, private and official, set up by artists who have worked with Hayter and continue now in their own ateliers the spirit of research, visual dialogue, and risk-taking that make printmaking a stimulating means of particular original expression. This flourishing network of international workshops and the tremendous contribution they make to contemporary printmaking are the direct result of S. W. Hayter and Atelier 17.

I shall try to relate now what being in the Atelier during the sixties was like. A typical day meant arriving at about 9 a.m. in the large wooden barn-like studio, beautifully high, light, and airy. I usually walked from old Montparnasse station. If it was winter the first thing was to help shake down and revive the fire in the big coal-burning stove near the acid baths. Then I took my place at the long newspaper-covered worktables and got on with my plates. I usually had a burin engraving and an etching on the go, working on the engraving while the other plate was in the acid or drying. Two artists would typically be 'doing colour' in the corner by the big press. We always worked in pairs, one cleaning the rollers, brushing the paper, etc., while the other did the intaglio. Often a 'nouveau' would work with an 'ancien', learning through helping, and at the end of the half-day colour-session be able to print his or her own plates, often using the colours of the 'ancien'.

Colour was very important in the Atelier. Inks of the most permanent and transparent quality were always used pure; we produced optical colours, rebel colours that broke all the rules, the vibrating indescribable colours we see when our eyes are shut or in dreams; these were the kinds of sensations we were looking for. The ideas and the techniques were one. Single-plate colour printing played an important role. The low reliefs we bit or scraped into zinc or copper were inked intaglio and with rollers of differing densities, the viscosity of the inks being all the while carefully controlled. Sometimes stencils and offset were used. All this colour work was totally different from classical multiplate separations. The rollers and reliefs created the image; technique and image were a unity. 'Resolving' the colour at the printing stage was part of the creative experiment. The result 'worked', or did not, in relation uniquely to itself, not in comparison with any preconceived or pre-existing image. One afternoon a week Krishna Reddy did a colour 'workshop'

with the newcomers, using specially made experimental plates. My own colour research at that time involved 'offsetting' woodcuts and other reliefs onto my burin plates. This meant 'collecting' the inked images from relief surfaces on to a clean soft roller and then 'depositing' them on to the intaglio-inked burin plate. This made it possible to superimpose thin films of different coloured inks of varying viscosities on to the engraved copper so that a complex colour image of many nuances was produced in one passage through the press.

At lunchtime we took our sandwiches to Odoul's café on the corner, where we had hot 'viandox' or coffee in winter and 'demies' in warm weather. One might chat with a Japanese colleague about his poetry or sculpture or with an American about paper making or theatre. There were also political discussions, often with South Americans.

Sometimes in the morning, more often during the afternoon, Bill stopped by the Atelier, perhaps to put a plate he had been working on in his painting studio into the acid or to have a black-and-white state proof made. He spoke with those whose work interested him and sometimes worked on one of his plates. We never knew just when he might come by, but as soon as Bill was physically present in the studio, there was always a kind of electrical charge in the air. He moved quickly; often he came on his way to or from playing tennis and kept up the same pace, darting around the workshop. Blue eyes alert and penetrating, he instantly took everything in. Sometimes with a quick pun or play of words, just in passing, he would open a startling new possibility in relation to a complex problem one had been struggling with for hours. When he stopped to analyse a structure in French or English, the wit and clarity of his language were further intensified by the vitality of his expressive hands ... gestures and quick diagrams on scraps of paper. Often Bill's comments finished with his provocative grin and then in a dash he would be gone. Even a visit of a quarter of an hour or twenty minutes left us transformed and energized.

On Mondays and Thursdays he always came in the late afternoon and stayed until about 8 p.m. On the other days we cleaned and cleared the Atelier at 6 p.m. On the two late days Bill looked at everyone's work, and analysed the newcomers' 'trial plates'. His vital method of 'unteaching' or 'diseducation' included warning us not to believe anything he might say. We had to try it out ourselves. He insisted that only one's personal experience could lead to any significant advance. We had to ask ourselves the questions, and answer them—the idea of 'teaching' being absurd.

Every artist who comes to work in Atelier 17 begins by doing two small exper- imental plates. It makes no difference if one has done twenty years of printmaking or never made a plate before. These two plates, one for etching, the other for engraving, were provided by Bill. They were not intended to become 'art'. They

Hayter at Atelier 17

were the means of communicating the whole conception of work at the Atelier. This involved relaxation, concentration, ways of getting clear of past work and preconceptions, and finding new, very personal ways of making lines, letting them come from within, being in a state capable of effortless action. Much of this came more easily to the Oriental 'nouveaux', many aspects of the approach being similar to yoga and other Oriental disciplines. Before being put in the acid these linear structures were begun again and again, as many times as necessary until they became personal and free. Then followed a number of states that 'transformed' the image. Rather than adding to what existed, we aimed to transform its feeling, space, orientation, and so forth.

We learned to look at and recognize what was really there in the plate, not what we wished were there or what might be there later, and to welcome the unforeseen. Another part of the game was to produce as many of these transformations as

possible with the *minimum* intervention. It would be too easy and no fun to make massive heavy moves that would obviously change the image but lack fineness and surprise. While taking these plates through many stages, we were made aware of all the possible reversals; for, of course, the printed image is always the mirror of what is on the plate. This deep involvement with ascending diagonals, with feelings of rightness or uncomfortableness, was experienced through work on these little plates—a new awareness of potential expression was awakened. Each artist's experimental plates are different, but there are clearly recognizable and definable elements that anyone with an unblinkered mind can see and agree upon. We went through unconscious counterpoints, reversals of space, and other operations that produce transformation. At the end of this experiment, which usually lasted several weeks, all the stages were pinned up and analysed. It became clear that some stages were not true transformations; they were removed, and then the whole series gone through to see what had happened. These were group sessions, including other 'nouveaux' as well as 'anciens'. We all learned a great deal from these experiments. The actual techniques employed were extremely simple, soft ground, aquatint, deep bite, engraving, etc. The exploration and discovery were not on a technical level, but rather the whole conception of how images are made and what makes them work was under review.

The introduction to engraving began with a burin being made up especially to the measure of each person's hand. Then Bill's individual introduction ... more an artist's philosophy of life than printmaking technique. The decision to incise must be made—forward-looking, leaving permanent tracks and traces, into territories where one has not yet been. The preparation involved relaxation and concentration ... free and confident, letting the sharp point advance without restraint, using the simplest possible means, being totally attentive and alert, recognizing when to stop, never overstating or carrying on into comfortable generalization. He made us understand that it doesn't matter if you 'like' the image. In fact, great care must be taken not to let oneself be seduced by likeable, familiar configurations. With the burin I learned that the undefined, the unknown, or the startling are what may reveal something significant, opening some new area of oneself, deeper than one had imagined possible.

A new way of seeing and working was revealed through our experiments with these introductory plates, guiding all subsequent work in the Atelier. Later, one came to understand certain aspects in much greater depth and to develop personal plates concentrating on those specific considerations.

Every artist who has lived through these experimental introductions has a shared experience that permits mutual understanding and discussion of each other's work. It provides exigence and precision with a clear direction that stimulates openness and generosity. It was a great feeling. You are an artist doing this job, you love it,

you are surrounded by others similarly motivated, and a positive energy and confidence reigns. The atmosphere was dynamic yet focused and precise. The problems we were working on were incredibly challenging, and those inexplicable leaps of imagination where intuition sparks were frequent and intense.

There were sessions of experimental drawing when we all concentrated on a number of propositions or problems that Bill presented. They were always new, open-ended, and intimately related to his current artistic preoccupations—sometimes complex to grasp, always producing unexpected and unpredictable results. These sessions opened up new paths. We all compared results; Bill commented, and we often went away to try out more variations late into the night.

The company was mixed. A few of the artists had been working in the Atelier for more than ten years. Others were short-term visitors—though no one came for less than three months. Sometimes artists not currently working in the Atelier joined in, and sometimes people returned when they wanted to concentrate on printmaking. They came from Berlin, Oslo, Santiago ... practising painters and sculptors. The results in our experimental sessions were quite different when tackled by a Peruvian, an Indian, an Australian, or a Frenchman. There were usually at least a dozen nationalities at any given time. The language was French because we were in Paris, but there were never a great many French artists. A lot of English was spoken too; probably the next most common language was Japanese, and then Spanish. But for many of us all of these were second languages and were sometimes used dictionary in hand and code-like. The real language of Atelier 17 was purely visual. We knew each other intimately through our visual expression and our experimentation. Mutual understanding led to a deep respect for the varied solutions different artists brought to the common problems we investigated.

The friendships I forged there are still among my dearest and deepest relationships. We all lived through this special significant and intense experience together. Those years in Atelier 17 have provided me with numerous friendly, open, generous contacts throughout the world. We see each other's works in international *biennales*; we tend to travel extensively and so keep in touch with each other. Through these friends one meets other Atelier 17 artists and so, although I worked less than four years in the workshop and that nearly twenty years ago, I feel real kinship not only with those I actually worked with, but also with those from before, those who followed, or are currently working with Bill.... An international network of generous spirit.

During the time I was working in Atelier 17, the workshop was not open on Sundays. That was the day Bill reserved for his own printing. I sometimes had the privilege of going in to help him. I learned enormously those days (and not just about printing) from the experience, comments, and conversation. Each of Bill's plates was an extraordinary example of how to produce maximum results with

Hayter in his painting studio at home

minimum means. Sometimes just one roller over a single intaglio colour produced a world of rich optical, mysterious vibrations. I was very aware those Sundays that the Atelier was really Bill's personal and private studio, that he generously welcomed us other artists in to work with him on the other days, but that it was, in fact, very much his own place.

Some Sundays there was lunch with kippers in his nearby painting studio, and he might show his recent paintings, or some gems from the Atelier's past, or collections of poems with his prints. Those Sundays were very special days for me.

Bill inspired great respect and affection ... and sometimes terror. He was intolerant of stupid behaviour. Actions that might damage any equipment or the positive working atmosphere provoked real explosions. I remember his wrath the day a 'zebra', or was it a 'monkey', put a coin through the small etching press, stamping out a perfect circle in all three blankets (fortunately not marking the cylinder). None of us present forget the veritable dance of fury. Waste was another thing that he did not tolerate. We all paid a small monthly fee and he provided proofing paper, black ink, grounds, resins, solvents, etc. There was a 'massier' system; several 'anciens' did not pay fees but were responsible for the day-to-day running of the studio. Cleaning, caretaking, and shopping (for consumables) were shared by all.

At that time it was possible to live on very little in Paris, to give a few English lessons or do a couple of hours *au pair* work a day in exchange for a 'chambre de bonne' ... occasionally to sell a few prints. We were free to give ourselves totally to our work, to being in Atelier 17. It was very satisfying; there was time to be with friends and colleagues in the evenings, time for galleries and exhibitions at the weekends. There were few expenses, few outside responsibilities, and lots of confidence and total commitment.

The very process of questioning and experiencing for oneself encouraged in the Atelier leads inevitably to the point at which it becomes necessary to leave and to continue one's own path outside. Bill makes it clear that one can always come back to work if and when one desires, and 'anciens' are welcome to drop in and to join in experimental drawing sessions. As for others before me, so too the time came for me. I saw that to continue full personal development meant that I had to create my own place. The influence of Hayter was great, it touched the kinds of images I made, the way I thought about them and about the way all art works. It was time to move away from that influence and try my own wings. I moved just a street away and started with another 'ancien' a printmaking workshop, using more of the principles of Atelier 17 than I was at the time aware. In the new studio I thought my prints and paintings were totally me; I began using some techniques not common in Atelier 17, but, looking back on them, they were highly derivative from Hayter. They reflected my deep personal involvement in problems that he had originated. I was dismayed and irritated when galleries took one look at my portfolio

and recognized Atelier 17. At that time this seemed so unfair and generalized. Sometimes they were interested in the work, other times not, but the initial response was invariably 'Atelier 17'.

Gradually pre-Atelier 17 ideas began to reappear, transformed, seen, and felt in a different way. I saw similar evolution in the work of friends and colleagues who had left the studio at about the same time. It took, in most cases, several years of research, of questioning, of applying methods of exploration developed with Bill, to bring out very personal and intimate visual forms and feelings. Working with Bill has tremendous influence, not because he ever tells one to make images look any particular way (other than 'unexpected'), but because we were all so truly engrossed in the 'automatic' and in the precise visual phenomena thus produced that for a while we worked rather like scientists in a new area of discovery.

Now, nearly twenty years later, the influence is assimilated and has become part of me and my work. I notice that it plays an important part in how I teach or 'do not teach'. I try to provoke the student/young artist to seek ways of using the techniques involved to produce images different from anything he or she might have imagined or done before. I never suggest what image to make but try to give the basic means and to create a working atmosphere of freedom and controlled experiment that can lead to original discovery.

Occasionally I am surprised to recognize in works by my students things that look very 'Atelier 17', in the sense that those gallery people used the term about my work in the early seventies. When I see this I realize that I continue to function on certain lines of action developed with Hayter and that I communicate these to my students, who, not yet having found themselves as artists, produce unconsciously works similar to ones I made twenty years ago. This does not bother me; they are learning as I did, and with time those who have something personal as well as original to say will express it; the others do not matter. This I learned in the Atelier; there is no point in trying to 'teach' anyone to be creative. They are or they are not; 'teaching' is useless at that level. What I do in the Bullingdon Road printmaking workshop and in my Paris atelier is to provide an atmosphere that stimulates seeking, investigation, research . . . questioning that will turn up methods for arriving at clear visual solutions. I try to offer a place of dialogue and freedom, including the freedom to fail, where end results are not always artistically successful prints but where the potentiality involved is constantly being stretched and expanded . . . where there is no complacency.

I remember Bill's saying once that most artists are full of potential and promise at 25 but how wonderful it was to feel himself full of potential in his sixties . . . a promising artist. He seemed younger than most of us at that time, dynamic, questioning, exploring, and open. Now I am aware that working always surrounded by young artists is a contributing factor. I realize it through my own constant

contact with young people and through the effect that sharing ideas with them has.

It is hard to put into words exactly what made working in Atelier 17 with Hayter so special. We were all drawn there not to learn a printing technique, but to participate in group research and experiment, seeking ways to create images vital to the present. We were part of a workshop where the excitement of discovery and shared experience charges the working environment constantly. Along the way prints were made and new printmaking techniques were invented, but these were not, and are not, the heart of the activity with Hayter in Atelier 17. It is more visual expression, questioning, discovering, understanding how images work on human beings, how what we see affects what we feel. All the innovative techniques are devised so as better to explore what really matters. It is something about a way of life, of giving, of being an artist . . . of accepting oneself.

Oxford
February 1988

6

Line and Colour: Hayter and Means of Expression

———

PETER BLACK

Hayter matured as an artist during a general upheaval in painting, with a number of movements making radical departures from traditional representation. One of the most important influences on painters of this period was photography, a new medium which brought about a sudden proliferation of reproductions of works of art and greatly increased the ease with which artists could refer to visual sources, including works of art. There were also a number of new scientific and technological developments which provided new ways of seeing things: by means of the microscope the minute could now for the first time be represented on a scale that the human could comprehend. Then there were new instruments which could provide analogue images of invisible phenomena. The oscilloscope, for example, provided a new way to quantify and thereby represent such things as sounds. Photography and the mass media were just beginning to publish these things, which were important influences on painters of Hayter's generation. The familiar example of one of these new types of image is that of frozen movement, but they include objects generally of the scientist's researches.[1]

The art of other periods and cultures was now accessible in a way it never had been before—classical and Renaissance art had lost their virtual monopoly as influences on painting. Hayter expresses his reaction to the art of his father's generation by saying, 'There had to be something better than this'—'Modern painting had to take account of advances in thought that had taken place.' Many artists of Hayter's generation, such as Wadsworth or Tunnard, can be identified by their references to particular new sights in the world, for instance radio masts or

[1] For examples of images inspired by new technological and scientific developments see Wolfgang Paalen, 'The New Image', *DYN*, 1 (Apr.–May 1942).

radar dishes. The German Expressionists, on the other hand, had abandoned objective reality in favour of images drawn from the artist's inner world. At the same time, in Munich, Paris, and elsewhere in Europe abstract painters searched for new forms to give to familiar subjects. For these artists there was no part of traditional image making that could not be called into question.

Hayter rarely acknowledges any direct influences: ancient cave paintings impressed him both as images with magical affective power and because they provided instances of engraving many thousands of years old. Piranesi's experiments with imaginary spaces prefigured the paintings of Hayter's older contemporaries, Kandinsky in particular, but the theme had wide currency in the early twentieth century. Other elements in Hayter's work such as the expressive use of line, particularly the burin line, and the making of images with a symbolical power like that of cave painting were the inspiration of Joseph Hecht, who taught him how to use the burin.

In the engraved work there is an affinity between Hayter's soft-ground textures—etched impressions of the texture of any flexible material pressed on to the plate surface—and collage, first used by Derain, then soon after by Ernst, Picasso, and others, to assemble real objects on the canvas together with paint. In a similar way, Ernst had earlier used frottage to combine within a single image the surfaces of a number of apparently unrelated objects from the real world. Another example is Hayter's burin line, with which he makes a figure not by outlining or shading but by the description of several aspects at once in a continuous movement around and within the figure's space. Hayter's practice is rather like Alexander Calder's in both his abstract and figurative wire mobiles, which create a similar effect in three-dimensional space. Hayter's use of natural phenomena, especially after the mid-1950s, not as part of the landscape but as self-contained images, is related to scientific illustration, which had contributed an important new range of natural images. Kandinsky had made similar investigations of scientific illustration, some of which he reproduced in *Point and Line to Plane*.[2] Klee is another artist who was using organic line forms. These things were current, as Hayter would say.

What these artists share in their work is that they made images of the kind that Merlyn Evans called presentational rather than representational. They are things in themselves; an important part of their value is that they introduce the viewer to some new category of beauty. Hayter was at the centre of this group of artists, who were responsible severally and collectively for important general developments in the area of expression. Spontaneity of technique was something familiar enough, but during Hayter's formative years many artists began experimenting with spontaneous ways of finding subject-matter. Certain modern painters were dedicated to automatism, allowing ideas to surface from the subconscious during the process of

[2] Wassily Kandinsky, *Point and Line to Plane* (New York, 1979). See the section on Line in Nature; pp. 103–9.

the work's creation. Hayter has had much in common with this approach, which characterized in particular the work of the Surrealists. The differences too are important. Hayter's approach has always had an affinity with that of a scientist: the making of an image is seen as akin to an experiment, a process of carefully observed steps leading, the artist hopes, towards a discovery. The emphasis is placed not on what the artist sees but on what he wants—consciously or unconsciously— to make. The process is described by Hayter in his article 'Interdependence of Idea and Technique in Gravure', which successfully confounds the common notion that painters have two faculties, one technical, the other responsible for image making.

The purpose of this essay is to examine some of Hayter's own ideas and the means he has employed to express them. Hayter is a humanist, a man of exceptional cultivation—as a glance at his titles will indicate. The images are sometimes completely abstract, but there have always been figurative subjects, though usually not in a realistic sense. Of these, some are mythological—*Laocoön* (37), for instance, or *Cronos* (42)—and some are universal, as *Femme au miroir* (1934) or *Étreinte* (20). And, with increasing frequency since the mid-1950s, there are images about natural phenomena. Some of these make general statements—pictures the subjects of which are not particular places but phenomena associated with land, sea, or sky. The simplest of these are obvious to anybody who has experienced the sea or patterns of waves. There are also, however, groups of images which require background information: images about (mainly natural) phenomena not normally part of our experience unless we are biologists: *Diatom* (1971), for example, which represents a microscopic marine organism which gives off a fluorescent light, or *Hydroides* (1963), which depicts the movement of a group of similar organisms.

All of these images are accessible to the viewer who is alert to the artist's means of expression. By expression is understood not the actual technical processes involved in making a painting or a plate but the successful handling of those processes. It is with these means that the artist conveys the qualities of the subject and they consist of such things as the manipulation of line primarily as an expression of movement, the integration of tones, and the control of colour both locally and in the colour scheme as a whole.

Hayter is known in his native country principally for his work in gravure—a medium generally considered to be of lesser importance than painting. This attitude has led to an undervaluing of his paintings, which have always occupied the major share of his time and may eventually prove his most important contribution to art. His reputation in the field of gravure, however, could hardly be higher.

All means of expression can be used equally in all media as long as the usage is appropriate to the scale and particular qualities of the medium. In the academies of painting there was, until recently, such emphasis on the qualities of paint that other perfectly useful conventions were overlooked. Line was a convention thought

well suited to drawing but, because the aim of the painter was felt to be naturalistic realism, a kind of reconstruction with paint, a convention such as line was avoided because it immediately introduces evidence of the artist's hand. Yet there is no conceivable artistic reason why one medium should have separate conventions from the others.[3] One of the things Hayter has done, following the lead, perhaps, of Van Gogh and Kandinsky, is to make line an appropriate convention in oil paint as it always has been in graphic work.[4] In Hayter's work ideas which began with burin line have evolved, on an appropriate scale, in oil and, more recently, in acrylic paintings. Similarly, the German Expressionists, whose preferred printmaking medium was woodcut, made use in oil paint of the convention of thick black line in order to give solidity without the need for fastidious modelling. This relationship of images in different media within an artist's work is of crucial importance, and nowhere more obviously so than where colour is concerned. One could say with reason that if Hayter had not been a painter, if he had been interested only in graphic means of expression, he might not have experimented with colour as an expressive tool in printmaking.

The immediately obvious differences between Hayter's prints and traditional etchings and engravings are the physical ones: following Hayter's example, engravers now make plates very much larger than connoisseurs of engraving might expect. There is similarly a marked difference in appearance, especially in colour. These two elements, size and colour, are linked, since both bright colour and large format are qualities normally associated not with etching or engraving but with painting. It is noteworthy that most examples of intaglio prints which are large or coloured tend to be imitations of oil paintings or water-colours.

Line is probably the most discussed expressive means vital to Hayter's work. There might seem to be a certain obviousness in saying of an engraver that his language includes line, but one of the principal advances that Hayter has made over traditional practice is in not using lines in systems to delineate or describe a subject tonally but creating lines which individually express something of the subject.

Lines are a natural way of depicting a subject that is known in advance, the method to which we all resort when we need to communicate visually some piece of information. As Hayter had demonstrated, however, lines can also be used to precipitate some unforeseen image. Hayter had described the experience of originating an image with the burin when he refers to the identification of artist with tool, which can happen as the burin cuts through the metal ahead of the artist's hand. The burinist who articulates his subject by means of line must navigate a course through the metal of the plate which he swings against the burin when a

[3] See Kandinsky, *Point and Line to Plane*, p. 110.
[4] e.g. *Ombre jaune* (1954), Whitechapel 1957 catalogue no. 78.

change of direction is required. Since he is always behind the tool the artist must be purposeful about direction changes, which cannot be planned at arm's length as they can with a tool which produces a drawn line. Hayter emphasizes the forgotten autographic qualities of engraving on copper with the burin, an activity traditionally and (in Hayter's early days as an artist) officially associated with copying rather than original expression. It is also the perfect tool for the artist committed to automatism, since it allows the image to form spontaneously as a result of the interaction of the individual and the medium.

The range of Hayter's expression with line is evident in the matter of scale. His lines vary enormously in thickness, from the thinnest burin line to the substantial bands of colour in *Styx* (**83**). Somewhere between lies the white line which stands out in relief, formed by channelling out a section of the plate with the scorper—as in *Oedipus* (**12**). In *About Boats* (**1957**) thick and thin lines play different roles; in *Bouleau* (**89**) the line that represents the birth tree's restricted movements is barely visible. The trace of the branches moving in the breeze has no discernible area but is represented by the division between areas of different colour.

Soft-ground textures, first used by Hayter in *Meurtre* (**11**), were one of the ways he found of roughening the plate surface to provide an area of tone. The engravers of the great nineteenth-century reproductions of popular pictures by Constable, Holman Hunt, or others knew just as many ways of producing a varied selection of tones. They needed these techniques in order to translate the particular surfaces or local colour represented in their original. Excellent as their technique was, their expression was always a reminder of the effects of some other medium. Sometimes, as in *Tarantelle* (**40**) or *Amazon* (**43**), the specific textures which Hayter employs contribute to the effect of the image. In these two images the net-like textures suggest the trapping and restraining of the figure. But Hayter's general practice has been formal: to modify the perceived space and to provide a counterpoint for the linear movements of the burin.

One means of expression not commented on by Hayter but prominent in recent prints is the imposition on the image of a regular vertical structure rather like a row of bars between the viewer and the subject, as in *Bouleau* (**89**), *Masque* (**95**), *Volet* (**90**), *Torso* (**1986**), and *Clairevoie* (**79**). These structures act as counterpoint like soft-ground textures, indeed a number of them are textured, but their regularity gives the images a particular quality which is worth describing. With a print like *Bouleau* it is clear that the structure acts as a reference, like a co-ordinate system, against which the movement of the lines can be evaluated by the viewer. This structure helps indicate the kind of movement involved—of something rooted and upright capable of a certain limited twisting through space, the depth of which is indicated by the segment-like patches of soft-ground texture.

Besides their role in describing space and movement, as in *Bouleau*, these struc-

tures have a representational role. For example the parts of the image contained within the different bands are often represented as occupying two parallel planes some distance apart. In *Volet* (**90**) these planes are evenly dissected; in *Voiles* (**85**) they intersect at an angle to the viewer. In *North-west* (**97**) there is a similar effect, but, rather than the usual interlocking of parallel vertical planes, the red patterns represent planes which have been twisted, so that they interlock in more than one dimension. Perhaps in *Masque* (**95**), besides the formal role played by the interlocking planes of gripping the figure between them so that it floats in mid-air, the alternating pattern suggests the stillest kind of rippling of the atmosphere in the artist's studio space. Whatever they are, these phenomena are not part of our experience. To say of *Volet* (**90**), which means 'shutter', that the divisions represent slats would be to provide a metaphor for an image which consists only of insubstantial elements such as movement, emptiness, and layered space.

Of all the means of expression which Hayter has exploited and adapted for his own purposes colour is the most powerful, the most difficult to use, and the hardest to talk about convincingly. But it is possible to indicate the significance of what Hayter has done in inventing a way of making intaglio plates in which colour is an essential part of forming the image. This will clarify how colour modifies and extends the range of all the other means of expression he uses.

Colour used to be the missing ingredient of prints, one of the reasons why people tended to think prints less important as works of art than paintings. While printed colour is quite different from painted colour and prints should never emulate the effects of paintings, there are effects of colour with which the expressive potential of the print has been greatly enhanced by Hayter's developments. So much so that there are now prints which can justifiably be called major works of art. There is an important group of prints the images of which would simply not emerge if the plate were printed in black and white. The choice of colour scheme is a vital part of making the print, as vital as any working of the surface.

The story of single-plate intaglio prints conceived as works of art in colour begins in the early thirties in two parts of Europe simultaneously. By a coincidence, which frees historians from the need to decide who influenced whom, two printmakers, Rolf Nesch and Stanley Hayter, quite independently made double impressions from a single plate: inked first to print from the surface, followed by an impression on top printed from the intaglio. The simultaneous colour impression followed a year or so later, using a plate of Anthony Gross's. The further developments of this technique have been chronicled by Hayter himself in *About Prints* and *New Ways of Gravure*, two of the best books ever published on the subject of prints. The exploration of colour printing is a study which continues in Paris in Atelier 17.

Hayter has always made the mechanics of the use of this wonderfully expressive tool sound simple; but they involve a vast experience of the behaviour of pigments.

The artist who sets out to make a work of art in simultaneously printed colour in a single impression can exploit within his image any of the known properties of the materials involved—the metal of his plate and his pigments. But there are tremendous difficulties which have to be overcome, which involved Hayter and others in the workshop in many years of experiment before the simultaneous colour print was possible.

Briefly, the problem is that films of colour on the surface of an intaglio-inked plate block by their physical intervention the taking of the intaglio ink by the dampened paper. The answer is the careful control of the ink media; the surface ink which comes between the intaglio ink and the paper has to be microscopically porous so that the intaglio ink can adhere to the paper through it. Control involves careful supervision of qualities of stickiness, viscosity, and porosity of the ink media, since where a number of pigments are employed the media have to be adjusted to form a series with differing degrees of viscosity.

Like the soft-ground textures and other tonal devices, colour has been used by Hayter as a means of modifying the space of an image. One way in which this is done is by colour gradation, the application of transparent colour ink to the surface of the intaglio-inked plate in a band graded from maximum pigment saturation to paper white, or some range between these two limits. This device has long been known to etchers of, for example, landscape subjects, who would wipe their plates when printing so as to leave a film of ink on the surface, darkest nearer to the top of the plate—implying by that means a denser band of air just above the horizon. In a plate with no obvious land and sky the artist can take advantage of a basic human association with this optical phenomenon to create a horizon by using a blue or other sky tone. In this way the phenomenon can be created with colour alone, without the need to work the plate.

A horizon is created by this means in, for example, *Bouleau* (**89**) and *Fastnet* (**99**). This device can also be used to evoke different reactions. One reacts with alarm to *Free fall* (**80**), for example, in which Hayter presents, by means of the inverse of the horizon configuration, the opposite: that is, the opening of a bottomless void where the person falling might hope to find the earth's surface. In *Masque* (**95**) these two are combined—a suggestion of a horizon line by means of a pink gradation, and of the bottomless void by means of a green graded over the bottom half of the image. These effects are not in this instance calculated to alarm but to create—by means of the control of colour—a phenomenon which can only be interpreted in terms of an imaginary or magical space.

The use of more than one intaglio colour has several effects. In *Serre* (**91**), for example, the black shape in the middle of the image is perceived as solid. Either side of the black—inevitably seen as a progression from left to right—the other colours give the air around this shape a particular quality. The impression of

radiated heat is engendered by the fluorescent pink (modified to orange), which seems to be stimulating the growth of plants, represented by the humid fluorescent green colour of the right portion of the plate.

A changing intaglio colour can express movement. Hayter had already made lines which pass through the plane of the plate before he started making prints in colour, but colour opened up new possibilities. In *Pendu* (**98**), for example, there are two catenary curves which link in the middle of the plate over the head of the hanged man from which the plate takes its name. As the eye follows the orange catenary through space down into the image from its most distant point in the top left corner, one can see it encounter an area of space characterized by an intense (fluorescent) green light. The remainder of the journey takes the eye across the plate down and up again into the (nearer) right half of the image; the space through which it passes changes once more, indicated by the diminished intensity of its light, a transparent (no longer a fluorescent) green by the time it has reached the right-hand edge. In *Pendu* the function of this line composed of points of light is to trace the path of a comet or some other stellar body with a cyclical movement through distant space. It unites all the different coloured areas of the plate surface in order to provide a cosmic context for the shadowy lines and figures that float across this space. These lines represent particular features of Hayter's studio, with the suggestion of a self-portrait,and the whole is given a specific location in space by the break or twist in the path described by the catenary curves. *Pendu* represents a Hans Sachs-like meditation on the insignificance of the artist's work when measured against the vastness of the cosmos.

In the early sixties, after a burst of masterly water images, Hayter produced a group of prints exploring colour themes. The particular colour creates the particular image. The mysterious and hot *Red Flow* (1963) makes an interesting contrast with *Green Shade* (1963). *Magnetic Field* (1966) and *Shoal Green* (1967) again demonstrate Hayter's power as a colourist to create completely different images simply by his control of colour on a pair of plates identical in scale and which differ very little in terms of work on the plate.

Hayter began to use fluorescent pigments in 1964. Their brightness makes them an easy choice when the need arises to represent a contrast of depth, since a fluorescent colour will inevitably advance from any surrounding transparent ink, even if it is the same colour with the same tone, something Hayter tried in 1964 with *Flowing Tide*. Hayter has experimented with the use of fluorescent pigments in every possible location on the plate: in the intaglio and on the relief. Because the effects of fluorescence are lost when the pigment is spread thinly it is usually confined to the intaglio. In this position it makes a more marked contrast than that which typically obtains between the thin film of colour applied by rollers to the plate surface and the more solid (generally opaque) colours used in the intaglio.

Fluorescent pigments are used where special brilliancy is required, as in *City* (**82**), in which the distant lights of the city are picked out in a thin band. Besides this they fulfil a special role which is a logical extension of Hayter's exploration of natural phenomena. *Helix* and *Flux* (both from 1969) are a good starting-point for appreciating this powerful addition to Hayter's means of expression. These two depict fields of fire which differ in scale and in the intensity of heat imagined by the artist.

Another exemplary use of fluorescent pigments is to be seen in *Il Commendatore* (1980), in which a fiery figure bursts on to the stage. The transparent green bands, drowned by the flash of orange, represent the darkened opera house. The most intense light radiates from the white of the paper along the double split down the centre of the picture. This represents the gateway from the infernal world through which the Commendatore steps, surrounded by a demonic flood of fluorescent colour. The stridency of the colours describes the infernal realm to which the Commendatore summons Don Giovanni.

Hayter's prints are often masterpieces of colour to which, once the images are appreciated, the colour seems absolutely necessary. *Sea Serpent* (1975), for example, depicts the movement of a serpent below the surface of eerily calm water. The shapes, which are barely visible in the murk, are black and obscure. The trace of the creature's movement is marked by the threatening red burin lines. The eerie calm of the surface, on which there are ripples but no splashes, is the result of Hayter's control of the colours used. The bands of alternating colour, blue and green, are carefully and exactly matched in tone. Both hues are made from the same phthalocyanine, a blue pigment which can be chlorinated to make the green. The harmony of colour and tone in this context creates an ominous calm, without which the image would lose some of its strength.

Tropic Stream (1962) is a plate the image of which would not exist without its particular colour scheme. Physically the zinc must be among the most heavily worked of a group of etched plates with organic subject-matter. *Tropic Stream* consists, apart from the strange frond-like obstructions arching left to right, of an expanding flow rapidly descending from top left to bottom right. The black intaglio colour lurks at the bottom of the plate around the crystal textures of the zinc excavated by etching and scraping. This suggests a bed of smooth pebbles at the bottom of a shallow stream over which water rushes. Further qualities of this landscape are brought out by the symbolic use of colour. These are principally the opposing forces of growth and decay, represented by the soft-roller green pigment and the hard-roller brown which colours the fronds over the stream. The inspired touch lies in the final application of colour from the hard roller in the other direction. This deposits the warm purple on some of the high ground of the plate, leaving a hint of perfumed flowers fed by the water of the stream.

Hayter's work is characterized by a restless searching for new expression and new means with which to create it. He is an artist with an unusual openness of mind, without which his many artistic and technical discoveries could not have been made. His work has evolved continuously in the various media he has used with the conventions of each informing images in the others. Abstract line and systems of line have, contrary to the prejudices of early twentieth-century academic painters, been used to create subjects out of paint. Hayter's spattering of paint on to canvas from a distance led him to make similar images in a series of etchings from 1957 onwards. Most important of all are his developments in the use of printed colour, which were unrelated to any contemporary events in printmaking but were the product of a painter's search to determine whether prints could be made with an expressive range comparable to that of painting.

7
Hayter's Paintings and their Imagery

———

BRYAN ROBERTSON

The art of S. W. Hayter soars like a fantastic bird across the general context of English art in the twentieth century: powerful, unpredictable, and finally too exotic and glittering for national assimilation, a brilliantly coloured and shaped parakeet or iridescent humming-bird, incongruous in the company of thrushes and owls. The analogy is not far fetched. Hayter's art does tend to seem foreign, like something from a hotter climate, when set beside the typical English art of any decade since the twenties—although, lamentably, his work also tends to be omitted altogether from official surveys of English art in the twentieth century assembled in England. He has worked abroad too long; the ranks close. Educated memories are in short supply. But in its obvious stature, Hayter's achievement since 1926, when he first settled in Paris, has to be assessed at the same level as those of his fellow Englishmen and near-contemporaries—Moore, Burra, Pasmore, and Sutherland, for instance— if he is to be seen at all within an English spectrum. His original contribution to the international Surrealist movement in the thirties and his equally personal discoveries as a distinct forerunner of the Abstract Expressionism which found itself in the US in the forties and fifties have immense consequence in the evolutionary complexity of English art.

But essentially, Hayter's art stands on its own, detached from a specifically English terrain, to be seen and understood as part of the great international movement which flowered in Paris in the twenties and thirties with Surrealism as much as abstraction as one of its principal facets. If Hayter has to have a context, this is his creative world as well as his city.

He should also be allowed New York, since he moved there in 1940 (like the innovatory action in art) and worked there throughout the forties, printing Pollock's first tentative engravings and having an impact through his own work, notably in its fresh element of speed in whiplash line, on Pollock and other American artists. Hayter did not fully develop this specific element as an isolated theme with variations

until the fifties and early sixties. But if Ernst, Miró, Tanguy, and Masson as well as Picasso are credited among various sources for the early work of the American Abstract Expressionists, Hayter must clearly be included in that company and more centrally than any other artist after Picasso and Miró.

Hayter's own imaginative world has been established from the outset through imagery expressed in paintings as well as engravings. His creation of Atelier 17 and the worldwide acceptance that he has established for the autonomy of printmaking as a legitimate vehicle for imaginative exploration—to replace its previous confinement as a semi-mechanical copying process—is a fact of life for which all artists are thankful. Refusing the labels of 'school' or 'teacher', Hayter has always treated other artists as equals even when they are inexperienced, and he developed the idea of working together in free association. The 'atelier' concept gave birth to the contemporary idea of a workshop, a democratic, non-hierarchical place for work, visual exploration, and the exchange of ideas.

But all this is a by-product of Hayter's main concern as an artist. He made paintings and drawings before he made an engraving; he has drawn and painted ever since. Hayter's gift for twentieth-century art is in his imagery, expressed as spectacularly through painting as through printmaking and, in painting, on a scale that graphic art cannot attain: a crucial fact, easily overlooked. It is right to honour Hayter's transformation of printmaking and to pay tribute to his generosity to fellow artists in sharing technical innovation, but wrong to label him as a printmaker or a graphic artist in isolation. Three-quarters of Hayter's mature work exists as paintings: the second crucial fact which should never be forgotten. He is an artist who draws and engraves as well as paints, that is all. We do not circumscribe Goya as a printmaker.

If I seem unduly insistent about Hayter's work as a painter, known to all who really know and care for the best art of the twentieth century, it is because in the past Hayter has occasionally suffered from neglect as a painter by critics and officials who like to stick simplified labels on easily categorized commodities. For them, it was hard to accept two decades ago that an artist recognized everywhere as the greatest printmaker of our century should be an equally accomplished painter. What is surely plain now is that you cannot exist inside a vacuum of technical virtuosity, however dazzling. You must first have an image for this virtuosity to bring to life. Those who refer admiringly to Hayter as a great technician avoid the issue.

Hayter's imagery is original, utterly personal to him, surprisingly consistent within its own sequence of changes or shifts in focus, with anticipatory signs of formal pursuits in early work taken up and developed twenty or even thirty years later—and with an emphasis sometimes in recent, late work which equally can refer back to ideas first broached more tentatively in the late twenties or thirties.

Hayter's imagery is compact, dense, energetic, bristling with belief in itself, blatantly passionate, and obsessive in its intensity. Above all, it is credible. You may not always know at once what the argument is, but you sense immediately its force and the vigour of its registration, its authority, on canvas or paper.

Delacroix was heart-warmingly right when he said that before it is anything a painting must be a feast for the eye. It is also true, in my experience, that an artist of true importance makes a world of his own that is so convincing, so real on its own terms—however fantastic they may seem in relation to our own ordinary, everyday, verifiable reality—that you feel able to enter that world and move about in it, inhabit it in a sense, with the same ease with which you enter and explore the world of *La Chartreuse de Parme*, *The Tempest*, or *The Waste Land*. In painting, the variable reality of this believable world can extend from the haunted and stressful pubescence of Balthus, enacted in formal drawing-rooms known to us all, to the biomorphically poetic encounters of Miró phrased in fantastic cartoon-like terms (*Ubu au Baléares*, for example) that are quite new to us. Hayter's world is nearly always as abstract as that of Miró—like Balthus, his friend and colleague over several decades—and has its inner spring of motivation firmly inside the basic tenets of twentieth-century poetry and painting.

The world invented by Hayter comes from a fusion between his innate personality and even his physical nature, and the awareness of violence, tragedy, irony, and a new understanding of sexuality, time, history, mythology, and ancient roots and origins common to all serious artists and writers in this century. Hayter has always liked to swim, play tennis, and sail in boats. He is fascinated by water and the life of ports and harbours. He is a very active participant in life, a man of action rather than a contemplative, and not much of a passive onlooker. He is directly involved with whatever is around him. Most importantly, he is little interested in landscape as an extended, grand panoramic view but concentrates at once on the specific characteristics of a landscape in isolation and, still further, on their interior structure. Landscape in itself has in fact never concerned Hayter, but he is absorbed by aspects of nature in the deepest sense, as phenomena, and with its morphology.

A prime characteristic of modern art to be found throughout Hayter's work is the concern for close-up, the examination of structures, substances, and encounters of all kinds in close detail rather than from a distance. Hayter's parallel interest in morphology and the structure of movement itself—a wave, a crystal, a shell, the vortex and the ellipse, cross-currents in water, the action of tides, mirror images—finds itself most happily within this proximity. The space occupied by the central forms in his work is usually enclosed, like a harbour or an arena; or the action is set within an implicitly stated proscenium, like a theatrical event on a shallow stage.

Hayter is also a dissector, keen always to get beneath the surface of things and

to see beyond normal boundaries. His early training as a chemist and his interest in structure—including the interplay between one kind of movement and another and their interaction with space—is seen most clearly in his lifelong delineation of a kind of X-ray vision of objects so that one part of something is seen through another part with the object as a whole thus opened up, as if transparent. This approach to form has a sculptural, three-dimensional counterpart in the early wire sculptures of Calder, another close friend of Hayter's since student days in Paris.

I have referred to time, history, violence, mythology, and other themes which may seem to burden Hayter's art with literary connotations that an abstract artist concerned always with the image beyond the words, cannot properly support. But Hayter's potency as an artist was realized in its strongest terms through Surrealism which developed—on a broad front shared by many artists—the invention of personages, biomorphic, anthropomorphic, or mechanomorphic, to play out the disruptive dramas of the post-Freudian probings of the subconscious through free drawing or automatism. The latter produced new forms, often bird-like, insect-like, or crustacean, as well as anthropomorphic. Other forms have no exterior reference and spring to life from another kind of impulse in the subconscious: they exist only within their own energy.

Hayter's interest in mythology is lifelong, and indeed no artist in the twentieth century can remain ignorant of the fresh insights gained from Fraser's *The Golden Bough*, no matter how discredited this book may be now, or Jessie Weston's seminal study *From Ritual to Romance*, referred to by Eliot in his notes for *The Waste Land*. Eliot's poem first projected the possibility of bringing together incongruously dissimilar kinds of imagery, ancient history in conjunction with everyday life, the monumental and the trivial, a co-existence that was first described by Jules Laforgue in his *Complaintes*. In *The Waste Land* also are references to the emblems of the Tarot cards as well as to religion and mythology, and the violence and despair—left behind by the 1914–18 war—which flared into horrific reality again through Nazism and the Spanish Civil War. The titles of Hayter's paintings and prints, from *Combat* (1936 and differently in 1953) to *Cronos* (1944) and *The Hanged Man* (more properly entitled *Pendu*, of 1983), reflect these concerns. In the forties, a violent sexuality flickers in and out of many works, notably and most obviously in Hayter's praying mantis images, which seem also to have been used by Masson as part of the common currency of the period. Giacometti's abstractly dismembered female anatomy in *The Suicide* sculpture is also relevant—Giacometti was Hayter's first neighbour in Paris in 1926. Behind a few of Hayter's more violent images is a sense of menace or fatality also similar to the dread contained in Eliot's image of claws scuttling across silent sea floors.

The post-Bergson awareness of the relativity of time shows itself in the way in

which Hayter's imagery veers between trapped and isolated forms sharply and securely contoured and impermeable within their circumscribed space contained inside the pictorial boundaries, and a separate concern for the analysis of a transient aspect of natural phenomena, alive and moving according to exterior forces, like wind or tidal pressure, making its own space and seen as part of a greater action extending beyond the edge of the canvas or sheet of paper and therefore open and vulnerable in the time-flux. This difference can be found in almost any of the images of the thirties or forties, with their common air of dramatic confrontation trapped within a known and bounded space, and the flowing images of the fifties and sixties, when Hayter's early love for patterns or reflections made by rippling water in harbours or even in city street gutters, in wet sand, or on cobblestones found its fullest expression in the series of images of rushing water drawn largely from watching the nearby stream in his summer home (at that time) in the Ardêche. The two extremes of figuration are the polarities of Hayter's vision.

In *Poème* of 1957, Hayter coincidentally appears to at least adumbrate the principle of new colour achieved through two bands of two different colours traversing at intervals a third band of another colour which was explored later in the sixties by Bridget Riley. There is no trite question of 'influence' here, merely Hayter's inherent sense of *Zeitgeist* appearing ahead of time as it did with Abstract Expressionism.

To speak of Hayter's very physical nature, with his enjoyment of swimming and tennis, may seem irrelevant to the business of image making, but indirectly there is a real connection. Ben Nicolson spoke of his own lifelong delight in playing table tennis and billiards as highly relevant to the way in which he composed his famous painted reliefs, with their subtle disposition of circles and squares. He implied an element of play, and this is present in Hayter's work also. The sheer velocity and spinning energy of Hayter's line, lashing across and over a space or binding two forms together in a dynamic skein of intertwined lines, has some kind of analogy with fast tennis. Hayter's love of sailing—since he served as crew on friends' yachts in the Mediterranean from his twenties onwards, on brief occasions—is always relevant to his soaring and gliding sense of movement in space as well and it reflects his interest in air and water currents, densities, and buoyancies.

With so much energy detonated in Hayter's paintings and prints, it is unsurprising to find that in each case the overall image seems instantaneous, as if it were projected directly on to the canvas or paper like a colour slide. There is no sign of work or struggle: the image seems to have materialized effortlessly. Hayter does not build up his images in the usual additive way but sets great store in destroying or wholly transforming the image at each daily encounter during the execution of the work. I have watched it happen: the image certainly changes, at once more complex in some areas and greatly simplified in others. The process has a lot to do with the

old Surrealist approach of automatism but it appears also to be governed, however subconsciously, by a dominant drive toward at least the general characteristics of a specific shape—that is, a rising or a falling image, or an expanding or contracting composition, or the clarification of the tensions set up by opposing diagonals. What you see finally is a totality in terms of line, mass, space, colour, light, and darkness or shadow. You are unaware of brushwork or textural blandishments as a sideshow. The feast for the eye is all of a piece, indivisible.

For all the grimmer aspects or phases of Hayter's work, there is throughout an extraordinary sense also of festival, of firework display, of theatrical tableaux and celebration, a catharsis which redeems any reference to conflict, confrontation, or battle. The action is always spotlit and as glamorously 'presented' as a display of dancing or conjuring; the work has always an element of performance which effectively distances whatever might seem threatening, in a recreative sense, despite its more obvious immediacy. And in recent years, since the late seventies, the imagery—or at least its new arena—has derived quite often from Hayter's immediate studio surroundings in rue Cassini. The walls, floor, windows and skylights, plants, and objects appear in many paintings and prints and these references are in turn transformed in other parts of the canvas or the print. The references are mostly only partial and include a good many games with interior and exterior space, angle, perspective, and mirror image. Ambiguity takes on new dimensions, virtually, in nearly all Hayter's work.

If form is the muscle, bone and sinew of a painting or drawing, colour is its heart's blood. Hayter's colour has always been sharply resonant, often high-pitched, and invariably strong, blazing often in its brilliance and depth. All his colour is inhabited, never raw but lived-in, sieved and felt through experience, never arbitrary and never merely decorative but always psychologically and emotionally acute. His colour is consistently artificial and invented, with no true resemblance to anything seen in nature. Even the colour in those works which appear to reflect natural phenomena, like the print *Poisson rouge* (1957) or the painting *The Sea* (1957), is heightened to such a degree of blue/green or red/gold that it belongs to another realm.

Since the mid-fifties, Hayter's colour in his paintings and prints has also a fluorescent element which increases its brilliance through luminosity. In recent years, the simplified concentrations of form and space and the equally abrupt juxtapositions of edgily bright colour recall the emblematic and perspectival simplifications in the colour and form of Japanese art, notably in Japanese nineteenth-century prints, and it is not surprising that the largest retrospective exhibition of Hayter's paintings and prints was held at two museums in Japan in 1984. Since then, Hayter has painted through his own eighties with an extraordinary *éclat* not seen in any artist's late work since the glowing example of Matisse. In scale and

intensity, the work seems unfazed by the passage of time—like so much of the action itself in a Hayter canvas—and continuously brings in fresh discoveries. Hayter is not marking time, and says that he is busily unlearning everything in the best spirit of Zen.

8

Catalogue of the Retrospective Exhibition of the Prints of S. W. Hayter at the Ashmolean Museum, Oxford, 11 October–27 November 1988

The dimensions of the image or the platemark are given in mm., height before width. For technical details the editor is indebted to the forthcoming catalogue *raisonné* of Hayter's prints compiled by Désirée Moorhead.

1 FONTAINEBLEAU AQUEDUCT 1926
 The first print Hayter made in Paris.

 Copper plate 232 × 196
 Drypoint
 Intaglio black
 Edition of 10
 Illustrated (b/w)

2 PENSEUR (THINKER) 1926
 This small portrait is based on the features of Hayter's first wife.

 Woodcut 125 × 105
 Black
 Edition of 10

3 LA BOLLÉE 1926

La Bollée was a tavern frequented by Hayter and many artists in the 1920s. A *chansonnier* is visible in the background.

Woodcut 86 × 118
Black
Edition of 20

4 RUE DES PLANTES 1926

A street scene near Hayter's lodgings. The motive for this print was to capture the rain on the wet cobblestones and the water in the gutter. The converging vertical lines of the buildings impart a sense of height. Apropos of this early series of drypoints and engravings on urban themes, which began in 1926 and culminated with *Paysages urbains* (see Showcase 1), Jacob Kainen wrote: 'From the beginning he was a printmaker of great gifts, even before was was attracted to surrealist doctrine and technical venturesomeness. His "Rue des Plantes" (1926) and the album of six prints, "Paysages Urbains" (published in 1930), are ... already intense, spirited and original and compare favourably with the best graphic work of the period.' (*Stanley William Hayter: Paintings, Drawings and Prints 1930–50* (Corcoran Gallery of Art, Washington DC, 1973.)

Zinc plate 267 × 208
Drypoint
Intaglio black
Edition of 20
Illustrated (b/w)

5 RUE DU MOULIN VERT 1927

Rue du Moulin Vert was the street in which Hayter lived in 1927, and the first location of the workshop which later became Atelier 17. Giacometti (who made three prints with Hayter) was a neighbour and close friend. After 1927 Hayter made woodcuts only as greeting cards.

Woodcut 155 × 103
Black
Edition of 20

6 BISON 1927

One of the first pure engravings made by Hayter, showing the influence of Joseph Hecht, who taught Hayter the use of the burin.

Copper plate 158 × 197
Engraving
Intaglio black
Edition of 20
Illustrated (b/w)

7 PORT DES PÊCHEURS 1928

The little fishing port is St Tropez, where Hayter used to spend his summer holidays in the 1920s.

Tushe and crayon lithograph 223 × 305
Black
Edition of 10

8 CROQUIS AU BURIN (BURIN STUDIES) 1929–32

Free exercises in burin work, exemplifying the artist's characteristic burin line. Hayter has made such a print every decade, beginning with this study. Themes that preoccupied him at this time are evident here. The motif of horses arose out of a holiday in Newmarket, when he sketched horses for the owner of a stud farm there. The hand, represented sometimes as transparent, sometimes by spaces successively occupied during a rotation of the wrist, is a recurrent subject, culminating in the monumental hand in the *Apocalypse* portfolio (**105**). The idea of one figure seen through another, resulting from the superimposition of different spaces, is the dominating idea informing *Paysages urbains* (**101, 102**).

Copper plate 245 × 181
Engraving
Intaglio black
Edition of 20
Illustrated (b/w)

9 GRAND CHEVAL (BIG HORSE) 1931

The print is interestingly comparable with Dürer's print *The Big Horse*. The effects aimed at are diametrically opposite. Dürer aimed at brilliantly detailed portrayal of nature, conceiving of line engraving largely as a pictorial rather than a sculptural technique. He sought for, and found, the engraved equivalent of every device of pencil drawing to render tone, shadow, and texture. With great dexterity and virtuosity, his *Big Horse* faithfully depicts muscle, sinew, the hair of tail, mane, and fetlock, and demonstrates masterly naturalistic foreshortening. By contrast, Hayter's fierce flowing burin line is vibrant and alive in its own right. It is suggestive and expressive rather than descriptive, achieving a sculptural effect of bulk, movement, and vitality with minimal means. The suppression of one of the rear hooves emphasizes which feet are taking the weight and captures the trotting rhythm. The foreshortening is dramatic without being naturalistic. Hayter's massive virile stallion is less a picture of a horse than a picture-horse that seems about to step off the printed page.

Copper plate 255 × 196
Engraving and drypoint
Intaglio black
Edition of 30
Illustrated (b/w)

10 AMANTS (LOVERS) 1932

Copper plate 151 × 215
Engraving
Intaglio black
Edition of 30

11 MEURTRE (MURDER) 1933

An early example of Hayter's use of texturing by impressing crumpled paper, fabric, wood, his own fingerprint, etc. into a soft ground and etching. Here its use is still experimental and tentative. But it rapidly evolved into a decisive means of liberating the engraved or etched line from the traditional cross-hatching, line and dot, etc. that emulate or seek the effects of drawing. Anthony Gross wrote: 'S. W. Hayter is responsible for a much wider use of soft ground. He began by experimenting with it in the 1930s. He was endeavouring to create an illusion of space, in the same way as is often done on the stage by the use of backdrops. This illusion is created on the stage by the use of translucent curtains hung between the actors at different distances from the footlights. These curtains establish immediately at what distance the actors are standing, thus placing them accurately in a required or imagined space. This is why he invented this spatial use of soft ground.' *Etching, Engraving, and Intaglio Printing* (London, 1970), p. 79.

Copper plate 234 × 295
Engraving, soft-ground etching with texture, and aquatint
Intaglio black
Edition of 30
Illustrated (b/w)

12 ŒDIPE (OEDIPUS) 1934

This important print exemplifies Hayter's use of the raised white line, created by gouging deep into the plate with a scorper. It increases the range of planes within the print, accentuating the depth of the image and its sculptural qualities. The background texture is the palm print of the artist's hand. This is the first of a long series of prints on classical mythological themes. The circling, closed white line suggests the inescapability of Oedipus' fate no matter by what path he goes. The same motif was explored in a painting made in 1934 (*Composition*).

Copper plate 149 × 160
Engraving (and scorper), and soft-ground etching with texture
Intaglio black
Edition of 30
Illustrated (b/w)

13 ÉROTISME COMPENSÉ (EROTICISM COMPENSATED) 1934

Together with *Œdipe* (**12**) this marks an important turn in Hayter's development. It is the beginning of his automatism (or, better, 'unconscious drawing'), characteristic of Surrealist art. His idiosyncratic 'whiplash' burin line, evident here, is described by Anthony Gross: 'An engraved line by Hayter will be as taut as wire sculpture, or like a thrown lasso, the flick of a whip, or a suspension bridge' (*Etching, Engraving, and Intaglio Printing*, p. 53). His use of soft-ground texture here is well integrated in the composition and more confident than in *Meurtre* (**11**), and the cross-hatching has been dispensed with.

Copper plate 198 × 212
Engraving, and soft-ground etching with texture
Intaglio black
Edition of 30
Illustrated (b/w)

14 VIOL DE LUCRÈCE (RAPE OF LUCRETIA) 1934

Ideas first manifest in *Œdipe* (**12**) and *Érotisme compensé* (**13**) find their fullest expression here in a complex interplay of curving and receding spaces and bold effects derived from different levels within the plate. This print was much admired by Picasso, who owned a copy. The plate is in the collection of the Museum of Modern Art, New York.

Copper plate 292 × 350
Engraving (and scorper), and soft-ground etching with texture
Intaglio black
Edition of 30
Illustrated (b/w)

15 WOMAN IN A NET 1934

The net is marked by the far-flung deep black line. The contour of the female figure is the raised white line, holding the intaglio black only at the edges. The head and shoulders are turned inside out back into the figure (like a partly inside-out glove).

Copper plate 219 × 296
Engraving (and scorper), and soft-ground etching with texture
Intaglio black
Edition of 30

16 CHEIROMANCY 1935

Cheiromancy is palmistry. Embedded in the hand are elements of the internal anatomy of a human body, for example, kidney, bowels, rib-cage. The copper plate is exhibited in Showcase 8.

Copper plate 200 × 148
Engraving (and scorper)

Intaglio black.
First edition of 30, second edition (1974) of 100

17 COMBAT 1936

This print, the largest of Hayter's works to this date, manifests his forebodings of war (Picasso's *Guernica* was painted a year later). The fallen, foreshortened horse is perhaps a quotation from Uccello's *Rout of San Romano*. (Hayter acknowledges Uccello as one of the painters who has most influenced him.) The strange curved face of the horse on the far left is reminiscent of Dürer's *Four Horsemen of the Apocalypse*. But these echoes are overwhelmed by the ferocity of Hayter's idiosyncratic line, the distorted figures and twisted limbs of the battling warriors. H. W. Janson has pointed out the structural similarity between this print and Leonardo's *Battle of Anghiari* (with which Hayter was unfamiliar), suggesting a common solution to the problems of depicting combat. The print was made over a six-month period during which Hayter was travelling in Greece and Corfu. Many of the twenty states were printed on plaster during his travels and discarded. The plate, eight states, and drawings are in the collection of the Brooklyn Museum, New York.

Copper plate 400 × 495
Engraving (and scorper), soft-ground etching with texture, and burnisher
Intaglio black
Edition of 30
Illustrated (b/w)

18 PÂQUES (EASTER) 1936

The Surrealist figure of a pregnant woman seated on the ground is executed with great conviction. The title is as much a reference to the time at which the plate was made (April 1936) as it is to its theme of conception and fertility.

Copper plate 295 × 172
Engraving (and scorper), and soft-ground etching
Intaglio black
Edition of 30

19 MACULATE CONCEPTION 1936

The statuesque figure in flowing dress of Greek antiquity, holding a spear, is Pallas Athena. An embryo is visible in her womb. Behind her, a warrior, carrying a shield on which a foetus is engraved, is holding a falcon on his outstretched arm.

Copper plate 357 × 255
Engraving (and scorper), and soft-ground etching with texture
Intaglio black
Edition of 30
Illustrated (b/w)

20 ÉTREINTE (EMBRACE) 1937
Copper plate 215 × 185
Engraving (and scorper), and soft-ground etching with texture
Intaglio black
Edition of 30
Illustrated (b/w)

21 PAYSAGE ANTHROPOPHAGE (MAN-EATING LANDSCAPE) 1937
This and four other prints, three of which are here exhibited (**22–4**), were intended
to be included in a portfolio of prints, commissioned by Ambroise Vollard, with
Spanish and French texts of Cervantes's play *Numancia*, celebrating the heroic but
vain defence of a Spanish city against the Romans in 133 BC. Due to Vollard's death,
the project was never completed. These prints, expressing horror and indignation at
the Spanish Civil War, were published separately. *Paysage anthropophage* refers to the
cannibalism adopted by the defenders of the doomed city.

Copper plate 184 × 353
Engraving, and soft-ground etching
Intaglio black
Edition of 30
Illustrated (b/w)

22 VIOL (RAPE) 1938
One of the *Numancia* series (see **21**).

Copper plate 196 × 256
Engraving, and soft-ground etching with texture
Intaglio black
Edition of 30
Illustrated (b/w)

23 DÉFAITE (DEFEAT) 1938
One of the *Numancia* series (see **21**).

Copper plate 153 × 195
Engraving, and soft-ground etching with texture
Intaglio black
Edition of 30
Illustrated (b/w)

24 THE RUNNER 1939
One of the *Numancia* series (see **21**). The huge figure, with a wholly imaginary
anatomy and exaggerated foreshortening, conveys urgency and force. The curved
lines against the tilted latticework of the ground intimate the space traversed. Note
the subtle ambiguity in the representation of legs and feet. An uninked plaster print

was made from this plate; it is displayed here with the print in Showcase 5. The figure of the runner also appears in a painting with the same title made at this time.

Copper plate 265 × 205
Engraving
Intaglio black
Edition of 30
Illustrated (b/w)

25 MATERNITY 1940

This is the first print Hayter made in the USA, on the occasion of the birth of his son Augie. It is the first of the colour prints. Unlike the later ones, it is in effect a combination of screenprinting and engraving.

Copper plate 227 × 191
Engraving, and soft-ground etching with texture
Three colours, orange, sienna, and ultramarine, applied to paper through silkscreens, plate inked intaglio black, and paper then overprinted with engraving
Edition of 50
Illustrated (colour)

26 CLOTHO 1941

Clotho, in classical mythology, is the first of the Moirai, the three goddesses of Fate. Clotho spun the thread of life. The small format of Hayter's early American prints was necessitated by the scarcity of metal for plates in the early war years.

Zinc plate 178 × 78
Engraving (and scorper), etching and soft-ground etching with texture, and burnisher
Intaglio black
Edition of 30

27 MIRROR 1941

A coloured plasterprint of this plate is in the collection of the Virginia Museum of Art.

Zinc plate 190 × 118
Etching, soft-ground etching with texture, and engraving (and scorper)
Intaglio black
Edition of 30
Illustrated (b/w)

28 SOURCE (SPRING) 1941

Zinc plate 173 × 96
Etching, soft-ground etching with texture, and engraving
Intaglio black
Edition of 30

29 DEBRIS 1941

Zinc plate 95 × 209
Etching, soft-ground etching with texture, and engraving (and scorper)
Intaglio black
Edition of 30

30 ARCHIPELAGO 1941

Zinc plate 124 × 185
Etching, soft-ground etching with texture, and scorper, retouched with burin
Intaglio black
Edition of 30

31 LIMBS 1941

Zinc plate 129 × 151
Etching, soft-ground etching with texture, and engraving (and scorper)
Intaglio black
Edition of 30

32 SUBMERGED FIGURE 1941

Zinc plate 127 × 197
Etching, soft-ground etching with texture, and engraving (and scorper)
Intaglio black
Edition of 30

33 LA BÊCHE (THE SPADE) 1942

Copper plate 99 × 73
Engraving
Intaglio black
Edition of 25

34 MINOTAUR 1942

The idea of this gem-like print could doubtless have been realized on a larger scale
had circumstances permitted. The strange structure before which Theseus stands
intimates an entrance to subterranean labyrinths.

Copper plate 75 × 100
Etching, retouched with burin
Intaglio black
Edition of 25
Illustrated (b/w)

35 CRUELTY OF INSECTS 1942

The taut lines, angular insect joints, and strange mantis heads capture the indifference of insects as they tear and devour each other. Made during the war, the image also intimates the inhumanity of man to man. For cruelty is a prerogative of mankind. The form, transposed to the mythological domain, is echoed in *Cronos* (**42**) and recurs, almost forty years later, in the brilliantly coloured and frightening image of *Plexus* (not exhibited here). A painting with the same title was made at this time.

Copper plate 201 × 249
Engraving, soft-ground etching with texture, and scraper
Intaglio black
Edition of 30
Illustrated (b/w)

36 PRESTIGE OF THE INSECT 1943

When an insect, for example a scorpion, is alarmed, it takes up a characteristic menacing stance which is referred to as 'the prestige of the insect'.

Copper plate 226 × 226
Engraving (and scorper), and soft-ground etching with texture
Intaglio black
Edition of 30

37 LAOCOÖN 1943

The awful death of the priest of Troy in the coils of Poseidon's serpents is depicted here in a dramatic foreshortening, comparable to the central figure in El Greco's *Laocoön* in the National Gallery, Washington DC. The powerful projection of the burin work against the complex spatial planes of the soft-ground texturing captures the torment of the dying figure. *Laocoön* was awarded the Annual Prize by the Philadelphia Print Club in 1943. Two plaster prints of this plate were made, a coloured one of which is displayed here with the print in Showcase 1. The print and plaster print were both shown in the famous exhibition 'Hayter and Studio 17' at the Museum of Modern Art, New York, in 1944—an exhibition that changed the course of printmaking in the USA. The plate of *Laocoön* is in the National Gallery, Washington DC (given by Lessing Rosenwald).

Copper plate 310 × 550
Engraving (and scorper), and soft-ground etching with texture
Intaglio black
Edition of 30
Illustrated (b/w)

38 CENTAURESSE 1943

This delightful engraving of a female centaur is the first plate to be successfully printed with different coloured inks simultaneously applied by means of stencils to a

single plate and printed in one operation. See Hayter's *New Ways of Gravure* (rev. ed., New York, 1981), p. 134. However, he considers that certain of Hercules Seghers's prints, usually described as hand-coloured, were printed in this way (ibid. pp. 115 and 190).

Copper plate 150 × 102
Engraving, and soft-ground etching with texture
Intaglio violet-red; orange, blue, green, and yellow applied to plate through stencil
Edition of 35
Illustrated (colour)

39 TERROR 1943

Hayter utilizes the unusual format of this print to create a claustrophobic image of a terrified figure hemmed in by closing walls.

Copper plate 374 × 143
Engraving (and scorper), and soft-ground etching with texture
Intaglio black
Edition of 30
Illustrated (b/w)

40 TARANTELLE 1943

This, in Hayter's judgement, is one of the most important plates he made at this time. The soft-ground texturing here is the most refined to date, a moiré effect having been created by the 'interference' of two silk textures separately impressed into the ground. The swirling motion of the dancer is accentuated to the point at which the upper half of the body seems to become detached from the lower (a device borrowed from Tiepolo). The engraved hand, with the distinctive thumb, is Hayter's own. The plate is in the National Gallery, Washington DC (given by Lessing Rosenwald).

Copper plate 550 × 328
Engraving (and scorper), and soft-ground etching with texture
Intaglio black
Edition of 50
Illustrated (b/w)

41 TARANTELLE 1943 (SECOND STATE)

42 CRONOS 1944

Cronos (Saturn), son of Gaea (earth) and Uranus (heaven), dethroned and castrated his father. Gaea prophesied that one of his own offspring would usurp his throne. In an attempt to forestall this fate, Cronos devoured his children—as he is here depicted doing. The plate is in the collection of the Chicago Art Institute.

Copper plate 397 × 504
Engraving (and scorper), and soft-ground etching with texture

Intaglio black
Edition of 50
Illustrated (b/w)

43 AMAZON 1945

The ideas realized in *Tarantelle* (**40**) are further developed in this equally powerful print. The taut lines pulled together impart tension to the image. The distortion of the head echoes one of Picasso's portraits of Dora Maar. Spatial reversion is explored in the representation of the legs and feet. The figure has only one breast, as the Amazons, according to legend, removed one breast in order better to draw the bowstring. As in *Tarantelle*, the artist's hand is depicted. The plate is in the National Gallery, Washington DC, and a plaster print in the City Museum, St Louis.

Copper plate 622 × 402
Engraving (and scorper), and soft-ground etching with texture
Intaglio black
Edition of 50
Illustrated (b/w)

44 AMAZON 1945 (FIRST STATE)

45 AMAZON 1945 (SECOND STATE)

46 AMAZON 1945 (FIFTH STATE)

47 CINQ PERSONNAGES (FIVE CHARACTERS) 1946

Cinq Personnages is a requiem for the death of a son. David, Hayter's only son from his first marriage, died at the age of 16 from tuberculosis. The dying youth sprawls in agony on the bottom right in a posture related to the broken figure of Christ in the Villeneuve-les-Avignon *Pietà* by Enguerrand Quarton, a painting Hayter judges to be one of the greatest ever made. (Compare also the corpses in *Paysage anthropophage* (**21**).) Above, a male figure falls, mouth open in a cry of anguish. On the left, a standing woman raises her arms in grief, and next to her another falls in a spin. In the centre, a small, white, totemic figure of a child sits in a cold receding space. This is the first large print in the history of gravure successfully made by the method of applying successive layers of colour to the one plate and printing all simultaneously. The surface colours were applied by means of silkscreens instead of the stencils used in *Centauresse* (**38**). For a full description of the making of this print, see Hayter's *New Ways of Gravure*, pp. 132–5.

Copper plate 387 × 605
Engraving (and scorper), and soft-ground etching with texture
Intaglio black; orange, green, and red-violet applied through silkscreens on to plate
Edition of 50
Illustrated (colour)

48 SEA MYTH 1947

The archaic boat and strange figures seen through the water evoke the mythic forms of thought of antiquity. This print, begun in France in 1946 and completed in New York, was made while Hayter was reading Ernst Cassirer's *The Philosophy of Symbolic Forms*, whose discussion of mythical thought greatly interested him.

Copper plate 275 × 375
Engraving (and scorper), and soft-ground etching with texture
Intaglio black
Edition of 30

49 UNSTABLE WOMAN 1947

The instability of the woman (moving anticlockwise) is generated by the interplay of the figure and the complex spiral linear background. This print won the Purchase Prize, Brooklyn Museum Annual Print Exhibition, 1948.

Copper plate 377 × 500
Engraving (and scorper), and soft-ground etching with texture
Intaglio black; red, blue, yellow applied through silkscreens on to plate
Edition of 50
Illustrated (colour)

50 CERES 1948

Ceres (Demeter) was the goddess of agriculture, sometimes worshipped as the earth-mother, the prime source of fertility. The serpentine figures here may be references to the Delphic snakes, or earth symbols.

Copper plate 590 × 386
Engraving (and scorper), soft-ground etching with texture, roulette and burnisher
Intaglio black; yellow applied through silkscreen on to plate
Edition of 50
Illustrated (colour)

51 TROPIC OF CANCER 1949

The largest of all Hayter's prints, *Tropic of Cancer* brings together many of the forms that had preoccupied him during the decade in America. In his own unique Surrealist idiom, it evokes primeval marine life.

Copper plate 552 × 693
Engraving (and scorper), and soft-ground etching with texture (and scraper)
Intaglio black
Edition of 50
Illustrated (b/w)

52 PEGASUS 1951

Pegasus, a symbol of immortality, was the winged horse that sprang from the blood of Medusa when Perseus beheaded her. The horse is depicted throwing a female rider. The colours in the prints of the early fifties are softer and warmer than in the late forties.

Copper plate 198 × 302
Engraving, and soft-ground etching with texture
Intaglio black; orange to yellow in gradation, green, red-violet through stencils on to plate
Edition of 50
Illustrated (colour)

53 L'ESCOUTAY 1951

'L'Escoutay' is the name of the stream that flows through the grounds of a holiday house Hayter purchased in the Ardêche. Watching the waters of the stream has inspired Hayter to make numerous prints and paintings since the early 1950s. This print was the first to be commissioned by the International Graphic Arts Society (IGAS), New York, established at that time by Nelson Rockefeller and Lessing Rosenwald.

Copper plate 198 × 310
Engraving (and scorper), and soft-ground etching with texture
Intaglio black; orange-pink gradation offset from wood through stencil on to plate, blue-green
 gradation through stencil on to plate
Edition of 200
Illustrated (colour)

54 WINGED FIGURES 1952

Copper plate 399 × 329
Engraving (and scorper), and soft-ground etching with texture
Intaglio black; red-violet and orange through stencils on to plate, green-yellow in gradation
 offset from wood through stencil on to plate
Edition of 100
Illustrated (colour)

55 LE SORCIER (WIZARD) 1953

Copper plate 491 × 397
Engraving (and scorper), carborundum, and soft-ground etching with texture
Intaglio black
Edition of 50

56 JEUX D'EAU (WATER PLAY) 1953

Copper plate 397 × 321
Engraving, soft-ground etching with texture, and burnisher
Intaglio black; blue-green, orange, and yellow applied through stencils on to plate

Edition of 200
Illustrated (colour)

57 LA NOYÉE (DROWNED WOMAN) 1955

The raised white line, as if suspended before the image, increases the spatial depth and accentuates the drooping limbs of the dead figure floating submerged in the water. This is the first example in this exhibition of Hayter's use of a soft roller to lay colour of lower viscosity over colour already applied to the surface of the plate. He first used this technique in *Guerriers* (1953). It is, however, noteworthy (since misattributions of the invention of so-called 'viscosity printing' are rife) that Hayter and his associates in Atelier 17 had been conducting experiments in this technique since the early 1930s.

Copper plate 350 × 471
Engraving (and scorper), and soft-ground etching with texture
Intaglio black; orange through stencil on to plate, green offset through stencil on to plate, soft-roller violet
Edition of 175
Illustrated (colour)

58 POISSON ROUGE (GOLDFISH) 1957

This print was awarded the Lugano Purchase Prize 1958. It is the first of a long series of prints using Flowmaster pen (a type of felt-tip pen) to lay down an impermanent acid-resist, and spraying or spattering resin varnish to function as a permanent acid-resist. It is also the first time Hayter made a print by applying inks with a hard roller followed by a soft roller. *Poisson rouge* constitutes a decisive change in direction for Hayter. The new technique released a flood of ideas and opened a wide range of imaginative possibilities which he explored in the following years. It enabled him to give full expression to his fascination with the motion of water, the reflection of light on and the movement of creatures through water. When figurative components reappear in his prints, his imagination seems purged of the awesome female figures that dominate the prints of the decade prior to *Poisson rouge*.

Zinc plate 337 × 466
Deep etching with permanent and impermanent grounds (Flowmaster technique)
Intaglio red-black; hard-roller orange, soft-roller green
Edition of 50
Illustrated (colour)

59 WITCHES' SABBATH 1958

Copper plate 498 × 645
Engraving (and scorper), and soft-ground etching with texture
Intaglio black; hard-roller blue, soft-roller green
Edition of 50
Illustrated (colour)

60 POISSONS VOLANTS (FLYING FISH) 1958

As in *Poisson rouge* (**58**), and in later prints, Hayter's interest is not in the moving objects, which are not even depicted, but in the spatial path they trace.

Zinc plate 296 × 378
Deep etching with permanent and impermanent grounds (Flowmaster technique)
Intaglio red-black; hard-roller green, soft-roller blue
Edition of 50
Illustrated (colour)

61 LA RAIE (THE SKATE) 1958

Seeing the ripple movement of a skate (rayfish) while swimming underwater in the Red Sea inspired this print.

Zinc plate 294 × 376
Deep etching with permanent and impermanent grounds (Flowmaster technique), and scorper
Intaglio blue-black; hard-roller orange, soft-roller blue
Edition of 50

62 CASCADE 1959

Zinc plate 492 × 492
Deep etching with permanent and impermanent grounds (Flowmaster technique)
Intaglio black; hard-roller yellow, soft-roller green, soft-roller red-violet
Edition of 50

63 GULF STREAM 1959

Copper plate 515 × 485
Engraving, and deep etching with permanent and impermanent grounds (Flowmaster technique)
Intaglio black; hard-roller orange, hard-roller red-violet, soft-roller green
Edition of 50

64 NIGHT 1960

Zinc plate 298 × 492
Deep etching (using a water-soluble plastic as impermanent resist), and aquatint
Intaglio violet with black; contact yellow, soft-roller green, soft-roller blue
Edition of 50

65 NIGHT SEA 1962

Zinc plate 296 × 398
Deep etching with permanent and impermanent grounds (Flowmaster technique), and scraper
Intaglio black-red; soft-roller green
Edition of 50

66 RED SEA 1962

Hayter experimented here with deep etching on a steel plate, using extensive scraping to achieve new effects. The delicate web running across the image was obtained by means of a burnisher.

Steel plate 356 × 277
Deep etching (using resin varnish as permanent ground sprayed on to plate), scraper, and
 burnisher
Intaglio red-black; hard-roller orange, soft-roller red
Edition of 50
Illustrated (colour)

67 PELAGIC FORMS 1963

Pelagic forms are marine forms. This print was awarded the Giles Award, London, 1963. The plate and print are in the collection of the Victoria and Albert Museum.

Zinc plate 368 × 446
Deep etching with permanent and impermanent grounds (Flowmaster technique), scraper,
 and burnisher
Intaglio alkali blue; contact fluorescent yellow, hard-roller monacal blue
Edition of 50

68 CONFLUENCE 1964

Zinc plate 397 × 508
Deep etching with permanent and impermanent grounds (Flowmaster technique), scraper,
 scorper, and burnisher
Intaglio blue; soft-roller transparent yellow, hard-roller lumogen yellow
Edition of 50
Illustrated (colour)

69 ONDE VERTE (GREEN WAVE) 1965

This is the first of a series of some thirty prints Hayter made between 1965 and 1969, still largely on the theme of light and water. Like Op Art of the period, his interest was captured by the visual impact of multiple parallel lines. But, faithful to his principle that there is no sharp differentiation of abstract from figurative art, he exploited the effects of 'parallel' undulating lines to depict light on moving water, tides, waves, and flow. The patterns created are never static, but constantly being modified. In the case of *Onde verte* variations in the angle of vision further vary the apparent field.

Zinc plate 592 × 500
Soft-ground etching, deep etching, and scorper
Intaglio green; hard-roller orange, soft-roller blue-green
Edition of 50
Illustrated (colour)

70 PETREL 1965

Petrel and *Vague de fond* (71) are two of a series of six prints intended to be published together with six poems by John Montague entitled *Sea Change*. (The other four are *Filet*, *Boats*, *Remous*, and *Wine Dark Sea*.) The project had to be abandoned, and the prints were published separately. Montague's poems were published in his volume *Tides* (Dublin, 1970), with a cover design by Hayter. In *Petrel*, Hayter has varied the undulating stripes to create a field in continuous deformation—a feature typical of his imagery in this period, which so clearly differentiates it from the mechanical character of much Op Art. The raised white line suggests the flight of a petrel across the waves.

Zinc plate 295 × 494
Deep etching, soft-ground etching with texture, and scorper
Intaglio orange; hard-roller lumogen orange, soft-roller yellow
Edition of 100

71 VAGUE DE FOND (SWELL) 1965

By creating a web pattern of moiré interferences, Hayter achieves here the impression of smaller waves moving across the trough of a deep swell.

Zinc plate 395 × 493
Deep etching, soft-ground etching with texture, and scorper
Intaglio alkali blue; hard-roller yellow, soft-roller monacal blue
Edition of 100
Illustrated (colour)

72 DIPTYCH 1967

Note the subtle discontinuities and continuities between the two images, akin to the 'break' in the appearance of a stick in water. The wave motion partly conceals the figure of a female nude.

Two copper plates Image size 337 × 485
Engraving (and scorper)
Intaglio blue, hard-roller green
Edition of 50

73 CARIBBEAN SEA 1969

This is the first print in this exhibition of the large series, beginning in 1969, in which Hayter used venilia as acid-resist (for explanation of the technique, see pp. 36 f.; 125). The effect of the delicately undulating ghostly web is greatly to increase the depth of the image. One sees the sunlit shallow sea as if from a great height, or the seabed as if from the surface of the water. This is the only occasion Hayter experimented with distorting the actual plate, attaching a wire grid to the back and then passing it through the press. The expressive potentialities of the new techniques he invented in association with his use of venilia gave a fresh impetus to his water

studies, which continue through the early seventies, using novel forms and colours. His extensive use of fluorescent colours also dates from this year.

Zinc plate 647 × 486
Deep etching (using venilia), and soft-ground etching with texture, on modified plate
Intaglio fluorescent orange; contact yellow, soft-roller blue
Edition of 50

74 NAUTILUS 1969

A nautilus is a shellfish with a chambered shell and webbed sail-like arms.

Copper plate 536 × 446
Engraving (and scorper), and etching (using venilia)
Intaglio fluorescent orange; hard-roller blue, soft-roller green
Edition of 50
Illustrated (colour)

75 L'HARMAS 1969

'L'Harmas' is the name of the house of a friend of Hayter's in Aix-en-Provence, the swimming pool of which is here depicted.

Copper plate 495 × 439
Engraving, deep etching (using venilia), and soft-ground etching with texture
Intaglio fluorescent yellow; hard-roller blue through stencil, soft-roller fluorescent orange
 through stencil
Edition of 50

76 RIPPLE 1970

The idea, manifest in *L'Harmas*, of capturing the sunlight on the rippling surface of a swimming pool, is here explored afresh with greater scintillating and dramatic effect.

Zinc plate 470 × 594
Deep etching (using venilia), and soft-ground etching with texture
Intaglio fluorescent orange; soft-roller blue
Edition of 100
Illustrated (colour)

77 CALCULUS 1971

This print was reproduced as the cover for a mathematics textbook *Calculus* by Louis Leithhold (New York, 1972). In it Hayter combines circles, ellipses, helices, and parabolic and hyperbolic curves to create an image of complex and subtle counterpoint. The abstract beauty of mathematics is given concrete expression in an image constructed out of algebraic and transcendental curves.

Zinc plate 592 × 485
Deep etching (using venilia), and soft-ground etching with texture

Intaglio fluorescent orange; soft-roller blue
Edition of 100

78 CLADUÈGNE 1972

'Claduègne' is the name of a river not far from Hayter's holiday house in the Ardêche. The variation in the complex ripple effect is the theme of this, the most brilliantly coloured of all Hayter's images.

Zinc plate 486 × 598
Deep etching (using venilia), and soft-ground etching with texture
Intaglio fluorescent red; hard-roller green, soft-roller yellow
Edition of 50
Illustrated (colour)

79 CLAIREVOIE (LATTICEWORK) 1974

The first of a sequence of prints made in the mid-seventies exploring two spatial orders, one seen through the other. Also exhibited here are two further prints of this series, *Voiles* (**85**) and *Volet* (**90**).

Zinc plate 490 × 597
Etching (using venilia) and soft-ground texture
Intaglio black; hard-roller yellow in gradation, soft-roller blue in gradation
Edition of 75

80 FREE FALL 1974

The violence of the fall through space is accentuated by the billowing wake of the ruined object as it plunges downwards. The dark-blue inking in gradation creates the impression of bottomless void below, and the slivers of yellow shooting along the undulating bands increase the sensation of speed. Note the subtle progressive displacement of a variant layer of bands.

Zinc plate 592 × 490
Engraving, and etching (using venilia) with soft-ground texture
Intaglio fluorescent yellow; soft-roller blue in gradation
Edition of 75
Illustrated (colour)

81 WIND 1974

The swirling rhythms of rising gusts of air are set off against the stable vertical on the left, rather as a pennant flutters on its mast—from which this idea for depicting wind is derived. The irregularity of the progressive displacement of the second layer of bands animates the image.

Zinc plate 600 × 437
Etching (using venilia) with soft-ground texture. (First proof pulled, cut into strips, and an

impression offset from these strips back on to the plate which had been re-covered with venilia; venilia cut afresh, soft-ground texture applied and bitten.)
Intaglio fluorescent orange; soft-roller red in gradation
Edition of 75
Illustrated (colour)

82 CITY 1974

The second of a series of four prints made in 1973–4 in which Hayter explored the idea of partly reflecting the top half of the image on to the bottom half. The others are *Lake* (1973), *People* (see **84**) and *Caragh* (1974). The city by the sea began as Venice, and ended as Istanbul, some of the domes and minarets of which are depicted.

Zinc plate 492 × 600
Etching (using venilia), and soft-ground etching with texture. (Upper half of venilia cut and bitten. First proof pulled, counter-proof made, and this offset on to another paper, and then printed back from this on to lower half of venilia sheet, cut, soft-ground texture applied and bitten.)
Intaglio fluorescent red, blue-green, and black mixed; soft-roller blue-green, soft-roller green on lower half
Edition of 75
Illustrated (colour)

83 STYX 1974

'Styx' is the name of the infernal river separating the world of the living from Hades. This is the only image in which Hayter has used these distinctive shapes, suggesting slow-moving viscous flows, a fluorescent orange one moving from top left to bottom right, an interpenetrating blue-green flow moving from bottom left to top right, and a rippling of emerald green moving in concentric circles from bottom right to top left. The making of *Styx* featured in a film *Behind the Mirror*, produced and directed by Julian Hayter (Paris, 1974).

Zinc plate 485 × 592
Deep etching (using venilia), soft-ground etching with texture, and roulette
Intaglio fluorescent red; hard-roller blue-green, soft-roller yellow
Edition of 100

84 PEOPLE 1974

The idea of reflecting part of the top half of the plate is exploited here to create an overpowering image of mankind huddling at the edge of the land, reflected in the rippling water, under an awesome sky. No single figure in the crowd is actually delineated, yet the impression of a mass of people is most effectively conveyed.

Zinc plate 490 × 600
Etching (using venilia), soft-ground etching with texture, and scorper. (The 'reflection' was produced by treble offsetting, as in the case of *City* (**82**).)

Intaglio blue-green and fluorescent orange; hard-roller blue-green in gradation, soft-roller green in gradation
Edition of 75

85 VOILES (SAILS) 1975

Two spatial orders, one seen through the other, force the eye to change focus continually as now one space, now another, dominates the viewer's perception of the image. By progressively changing the width of the frontal bars, the ambiguity of dominant and subordinate plane is increased. The continuities and discontinuities in the pattern of white sails set up a series of rhythms and counter-rhythms within and between the two planes.

Zinc plate 596 × 492
Deep etching (using venilia), and soft-ground etching with texture
Intaglio blue; soft-roller blue-green in gradation
Edition of 50
Illustrated (colour)

86 CHUTE (FALL) 1975

A further exploration of the idea of plummeting through space, first studied in *Free fall* (see **80**). Whereas in *Free fall* the object is in the throes of destruction, here the fall is a triumphant swoop. The catenary curves (made by marking the plate with chains and drilling) define a spatial plane and emphasize the thrust and accelerating velocity of the object.

Zinc plate 599 × 490
Etching (using venilia), with soft-ground texture
Intaglio fluorescent orange to fluorescent red; soft-roller blue to green in gradation, soft-roller yellow in gradation
Edition of 75
Illustrated (colour)

87 RIDEAU (CURTAIN) 1976

Hayter has suggested 'that for any particular plate and individual artist there exists one, and only one, ideal system of colour, in comparison with which all other solutions appear inadequate ... when several alternate colour versions seem equally desirable, no one is convincing' (*New Ways of Gravure*, p. 144). *Rideau* is therefore particularly interesting, for it is a rare instance of Hayter's changing his mind about the colour scheme half way through an edition. The final version, by reducing the emphasis on the dancing figure, involves a more subtle equivocation between curtain and dancer, and accentuates the swirling motion.

Zinc plate 642 × 437
Deep etching (using venilia), soft-ground etching, and scraper
Intaglio fluorescent red; soft-roller red, soft-roller green
Edition of 75
Illustrated (colour)

88 RIDEAU (CURTAIN) 1976

This is the early colour variant of the previous print, before the plate was cut down, reworked, and the final version printed.

Zinc plate 642 × 485
Deep etching (using venilia), soft-ground etching, and scraper
Intaglio fluorescent red; soft-roller green and yellow
30 impressions were made of this version of *Rideau*
Illustrated (colour)

89 BOULEAU (BIRCH TREE) 1976

The idiosyncratic circular motion of the twigs of a birch tree blown by the wind is the inspiration for this image. The brilliant colours and harmonious movement of the branch dancing in the sunshine make this one of the most joyous of Hayter's prints.

Zinc plate 495 × 400
Deep etching (using venilia), and soft-ground etching with texture
Intaglio orange and fluorescent yellow; hard-roller green to red in gradation
Edition of 50

90 VOLET (SHUTTER) 1977

The inspiration for this print comes from the vertical swivel shutters on which theatrical backdrops were painted in the nineteenth century. Revolving alternate shutters produces two broken fields. Although one unavoidably sees the swirling bands of black and yellow as continuous, they are in fact two quite separate, alternating, series.

Zinc plate 640 × 490
Etching (using venilia), with soft-ground texture
Intaglio fluorescent yellow and black on alternate bands; soft-roller silver in gradation
Edition of 50

91 SERRE (GREENHOUSE) 1979

The subtle colouring and spacing of the parallel stripes magnify the recession of the diagonal etched stripes, while the hot colours on the left and yellowish-green on the right evoke the atmosphere of a hothouse. The convex mirror reflections create a play of in-folding spaces.

Zinc plate 640 × 490
Soft-ground etching with texture
Intaglio fluorescent red, fluorescent orange, black, and green; soft-roller blue to green to yellow
 to red in gradation through stencil
Edition of 75

92 CEILING 1980

This is the first of a series of prints showing Hayter's studio at his home. The great north-facing window is a recurrent motif in this series. The building visible upside down through the window (as if seen when lying on one's back and gazing backwards) is the adjacent house. The monstera leaf schematically depicted in the upper left quadrilateral is derived from the huge plant in the studio. The function of the white stripes, like the raised white line of earlier prints, is to create spatial depth as well as spatial ambiguity.

Zinc plate 490 × 595
Engraving (and multiple graver), etching (using venilia) and soft-ground texture
Intaglio fluorescent yellow-green and blue-violet; soft-roller blue through stencil, soft-roller blue in gradation
Edition of 75

93 FIGURE 1981

The silhouetted figure in an alcove of the studio is a self-portrait. On the right the studio window bars are depicted in concave distortion. The Ionic capital is a classical motif that recurs in a number of Hayter's paintings of this period, following a holiday in Vicenza, where he visited Palladio's Teatro Olympico. The five vertical stripes, because of their different colouring, appear situated at different depths within the image, and contribute an air of mystery to the poised, tense figure of the artist.

Zinc plate 590 × 490
Engraving (and multiple graver), etching (using venilia) with soft-ground texture
Intaglio fluorescent green, vertical bands on left and right green; soft-roller red through stencil, soft-roller red in gradation
Edition of 50
Illustrated (colour)

94 INDOOR SWIMMER 1981

The pool through which the figure is swimming is Hayter's studio. The adjacent building, depicted in *Ceiling* (**92**), is visible here through the great angled window on the left. The grid-like structure on the right is the other studio window. The partly inked stripes accentuate the recession of the swimmer and emphasize the articulation of waist and torso.

Zinc plate 585 × 490
Engraving (and multiple graver), etching (using venilia) with soft-ground texture
Intaglio fluorescent red in centre vertical band, red on both sides; soft-roller green through stencil, soft-roller blue in gradation
Edition of 50
Illustrated (colour)

95 MASQUE (MASK) 1981

The room depicted, with gallery and winding staircase, is Hayter's studio. The descending columns do not meet the ascending ones but merge with the spaces between them. The effect of this 'Disappearing Column Trick', as Hayter calls it, is to create a space. This effect is multiplied by the delicate inking in gradation. The African mask in the centre was the inspiration for the print. Hayter had seen this mask in a collection and was impressed by its forceful totemic power. The large floating figure, reminiscent of Hayter's work in the early 1930s, serves as a kind of autograph within the private space of the studio.

Zinc plate 485 × 595
Engraving (and multiple graver and scorper), deep etching (using venilia) and soft-ground
 etching with texture
Intaglio green and fluorescent yellow-green; soft-roller red to green in gradation
Edition of 100

96 APPARITION 1982

Copper plate 355 × 520
Engraving, and etching (using venilia) with soft-ground texture
Intaglio red; soft-roller green in gradation, soft-roller blue in gradation
Edition of 100

97 NORTH-WEST 1982

Zinc plate 495 × 595
Engraving (and multiple graver), and etching (using venilia) with soft-ground texture
Intaglio red; soft-roller yellow in gradation, soft-roller green in gradation
Edition of 100

98 PENDU (HANGED) 1983

The centre of the image conceals a precisely engraved figure of a hanged man, arms and wrists bound. The concave structure on the upper right is the window of Hayter's studio in concave distortion, as in *Figure* (93). The title contains a deliberate allusion to the Tarot 'Hanged Man' (a symbol of renunciation of personal interest in the name of an elevated cause; also of a Utopian dream world) as well as an allusion to François Villon's poem 'Ballade des pendus'. The subtle ripple effect on the left suggests the undulations of the seabed glinting in the sun, seen from a great height. This print is a rare instance of a contemporary *memento mori*.

Copper plate 575 × 522
Engraving (and multiple graver, and scorper), and soft-ground etching with texture
Intaglio fluorescent orange, and fluorescent green; soft-roller blue to red in gradation
Edition of 50
Illustrated (colour)

99 FASTNET 1985

This is the largest of Hayter's colour prints, made on the occasion of the 1985 Fastnet yacht race, which ran into a hurricane. The tilted horizon line, seen as if from the deck of a yacht tossing in a storm, destabilizes the spectator's viewpoint. The wild, deeply engraved burin lines float above the image in a plane that coincides with the top of the sails, suggesting the whip of the mast. Hayter also made three paintings on this theme.

Copper plate 705 × 525
Engraving (and multiple graver, and scorper), and soft-ground etching with texture
Intaglio fluorescent orange, fluorescent green, and red; soft-roller green to blue in gradation
Edition of 50
Illustrated (front cover)

100 CONSTELLATION 1987

The sweeping burin lines evoke the idea of planetary orbits and stellar paths. A constellation pattern is suggested by the points of intersection, and is picked out in brilliant fluorescent orange. The dark blue below prevents one from assuming an horizon line, and the space is immediately seen as extraterrestial.

Copper plate 600 × 500
Engraving (and multiple graver, and roulette); deep etching and soft-ground etching with texture
Intaglio fluorescent orange, and green; soft-roller blue to green in gradation
Edition of 50
Illustrated (back cover)

PORTFOLIOS AND LIVRES D'ARTISTE

PAYSAGES URBAINS (URBAN LANDSCAPES) 1930

Portfolio of six prints in an edition of 50 by Éditions Quatre Chemins, Paris, 1930. The unifying idea of these images is the superimposition of a landscape upon an urban scene, so that two different spaces are seen one through the other. Striking ambiguities are created as the spaces intermingle. Some figures are wittily located both in the urban setting and in the landscape.

101 PLACE FALGUIÈRE

Through the large building a cliff is visible, on which telegraph poles teeter and the gantry of an electric railway stands. The horse on the far left belongs to both scenes.

Copper plate 207 × 267
Engraving and drypoint
Intaglio black
Illustrated (b/w)

102 LA VILLETTE

Superimposed upon the townscape is a desert landscape with a large horse in the foreground and a minute horse on the horizon. The clouds above the desert lie across the windows of the left façade of the building.

Copper plate 181 × 243
Engraving and drypoint
Intaglio black
Illustrated (b/w)

FAUST'S METAMORPHOSES 1931

Six illustrations to a collection of poems by George Reavey, published in an edition of 100 by the New Review Editions, Fontenay-aux-Roses, France, 1932.

103 MY HEAD STRIKES THE LAMP

An amusing and ingenious illustration to Reavey's Surrealist poem.

Copper plate 150 × 110
Engraving and mezzotint
Intaglio black
Illustrated (b/w)

OMBRES PORTÉES (CAST SHADOWS) 1932

Five illustrations for a collection of poems by Georges Hugnet, published in an edition of 55 by Éditions de la Montagne, Paris, 1932.

104 LE PRISONNIER DES ÎLES

As in the *Paysages urbains* series, one space is seen through another. A female nude with a basket of figs at her feet is superimposed upon a seascape seen through a window. The shell on the bottom right belongs to both images.

Copper plate 155 × 95
Engraving
Intaglio black
Illustrated (b/w)

APOCALYPSE 1932

Six untitled prints with a text written about them by George Hugnet, published in an edition of 60 by Éditions Jeanne Bucher, Paris, 1932. The titles given here are derived from Hugnet's poem.

105 QUAND LA MAIN SE RETIRA

This projects on to a monumental scale the space enclosed by a gripping hand (**120, 121**). Hugnet's text for this print is:

> Cette main saisit la terre; et des chaînes de montagnes de glaise s'écraserènt entre ses doigts. Quand la main se retira, il ne demeura plus que ce monument dressé à la mémoire du poing fermé et du vide devenue statue.

Copper plate 322 × 248
Engraving, and carborundum
Intaglio black
Illustrated (b/w)

106 UN BRUIT DE CATACLYSME

Hugnet's text for this print is:

> Un bruit de cataclysme règne sur notre origine et sur notre fin . . .
> Les maisons s'ouvrirent comme des jeux de cartes . . .
> Il y a une fuite qui dessina dans l'air. Seuls, quelques bustes brisés s'enfonçaient dans le sable.

Copper plate 322 × 228
Engraving and drypoint
Intaglio black
Illustrated (b/w)

SOLIDARITÉ (SOLIDARITY) 1938

Portfolio of seven prints, initiated by Hayter, with a poem by Paul Éluard and translation by Brian Coffey, in an edition of 150, published by Atelier 17, and sold in aid of the Spanish Republican Children's Fund. The other prints are by Picasso, Miró, Tanguy, Masson, Buckland-Wright, and Husband.

107 SOLIDARITÉ (SOLIDARITY)

Copper plate 102 × 75
Engraving
Intaglio black
Illustrated (b/w)

FACILE PROIE (EASY PREY) 1938

Portfolio of eight untitled engravings and cover print with a poem by Paul Éluard dedicated to Hayter, published in an edition of 100 by Guy Levis Mano, Paris, 1939. The theme of the series is the horrors of the Spanish Civil War.

108 UNTITLED (TWO WARRIORS)

Copper plate 128 × 144
Engraving
Intaglio black

109 UNTITLED (MAN CARRYING DEAD WOMAN)

Copper plate 172 × 112
Engraving
Intaglio black
Illustrated (b/w)

110 LE DISTRAIT (DISTRAUGHT)

A copy of the print in the Library of Congress bears this title in Hayter's handwriting.
Copper plate 148 × 158
Engraving, and soft-ground etching
Intaglio black
Illustrated (b/w)

FRATERNITY 1939

Portfolio of nine prints, initiated by Hayter, with cover engraving by him, a poem 'Fall of a City' by Stephen Spender, and translation by Louis Aragon, published in an edition of 101 by Atelier 17 in 1939 (second edition of 100 published by Associated American Artists, New York, 1974). All proceeds from the sale of the portfolio were donated to the Spanish Republican Children's Fund. The other prints are by Buckland-Wright, Husband, Hecht, Kandinsky, Mead, Miró, Rieser, and Vargas.

111 ESPAÑA (SPAIN)

Copper plate 123 × 90
Engraving
Intaglio black
Illustrated (b/w)

STILL 1972/3

Portfolio of three prints and text of Samuel Beckett's 'Still' published in an edition of 160 by M'Arte, Milan, Italy, 1974.

112 STILL III

The caption for this print is: '... in this failing light impression dead still.... Legs side by side broken right angles.... Trunk likewise dead plumb.... Arms likewise broken right angles ...'

Copper plate 296 × 209
Engraving, and deep etching (using venilia), and soft-ground etching with texture; scraper
and scorper
Intaglio blue and fluorescent orange; soft-roller green, hard-roller blue

DEATH OF HEKTOR 1979

Portfolio of nine prints and the poem 'Death of Hektor' by Brian Coffey, published in an
edition of 300 by Circle Press, Surrey, 1979.

113 THE DEATH OF HEKTOR

Copper plate 295 × 215
Engraving, and soft-ground etching with texture
Intaglio black
Illustrated (b/w)

POÈMES D'AMOUR (LOVE POEMS) 1982–3

Nine prints and three lithographs loosely bound in a portfolio with Paul Éluard's poems,
and translations by Brian Coffey, published by 107 Workshop, Wiltshire, 1983, in an edition
of 100.

114 SUNDOWN

Four-colour lithograph 320 × 448

115 LA VOILE RESPIRE (THE SAIL BREATHES)

Copper plate 264 × 178
Engraving, and soft-ground etching
Intaglio black
Illustrated (b/w)

116 BÂTTISEURS DE RUINES (BUILDERS OF RUINS)

The opening line of the poem *Novembre 1936* which Éluard wrote for the portfolio
Solidarité is 'Regardez travailler les bâttiseurs de ruines'. In this print, made 45 years
later Hayter has re-created, with line of undiminished vigour and vitality, a variation
upon his *Solidarité* engraving of 1938 (see **107**).

Copper plate 258 × 178
Engraving
Intaglio black
Illustrated (b/w)

117 BLASON DES ARBRES (BLAZON OF TREES)

Copper plate 260 × 178
Engraving (and multiple graver), and soft-ground etching
Intaglio black
Illustrated (b/w)

PLASTER PRINTS

A method of making a print in plaster of Paris is described in *A Treatise on Etching* by Maxime Lalanne, translated from the second French edition by S. R. Koehler (Boston, 1880). Experiments with plaster casts have been conducted at Atelier 17 since 1931. A plaster print can be made, with or without inking, and a carved plaster print can be made by deepening the relief before the plaster is fully dry. Colour may be applied after carving. See *New Ways of Gravure*, pp. 126–31, 275–6.

118 THE RUNNER 1939

Uninked plaster print from the plate made for the unfinished *Numancia* series.

119 LAOCOÖN 1943

Carved plaster print with colour.

SCULPTURAL PIECES

120 HAND I

Plaster cast of the space enclosed by the artist's grip. Transposed to a monumental scale, this is the theme of the fourth print (**102**) in *Apocalypse* (1932).

121 HAND 2

Bronze cast of the same, made in 1965.

MEDAL

122 Commemorative medal in memory of H. Gaudier-Brzeska which Hayter made in the late 1960s. Cast in the french mint. The images are based on Gaudier-Brzeska's sculpture *Bird Swallowing a Fish* and (on the reverse) a self-portrait by Gaudier-Brzeska.

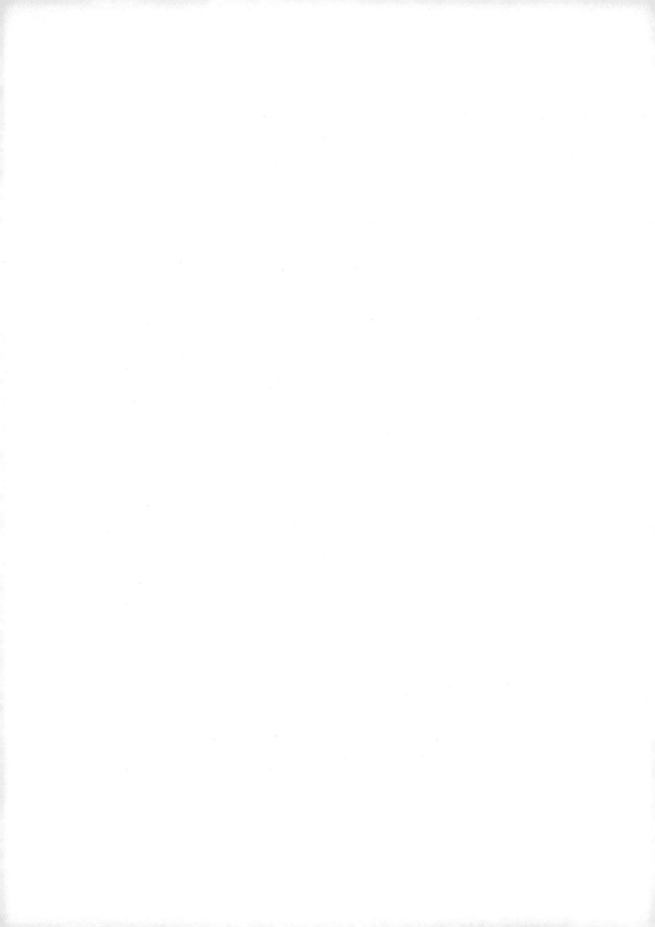

9
Biographical Notes

1901 Born in Hackney, London, on 27 December, third of four children of William Harry Hayter (1870–1936) and Ellen Mercy Palmer (1871–1959). His father was a painter whose family had produced artists in earlier generations, including Charles Hayter (1761–1828), a miniaturist, portrait draughtsman, and writer who published a treatise on perspective, Sir George Hayter (1792–1871), portrait and history painter to Queen Victoria, and John Hayter (1800–91), London portrait and genre painter.

1913 Won a scholarship to Whitgift Middle School, Croydon. In his teens frequently visited the National Gallery with his father, and was much impressed by Uccello, Zurbarán, and El Greco. Starting painting in his father's studio, producing impressionist studies in light and colour.

1917 Left school to work as an assistant research chemist in the laboratory of the Mond Nickel Company, while studying chemistry part time at King's College, London.

1918–21 After the armistice, enrolled as full-time student at King's College, studying chemistry and geology. After obtaining an Honours degree in 1921 did research into organic sulphur compounds under Professor Samuel Smiles at King's. Made his first etchings with friends at the Central School of Art.

1922–5 Worked as chemist/geologist for Anglo-Iranian Oil Company in Abadan. Travelled extensively in Middle East. Made a series of 150 pencil portraits of Anglo-Iranian personnel, and paintings of landscapes, boats, rivers, seascapes, and oil refinery. Also paintings in Cubist style.

1925 Returned to England.

1926 Exhibited paintings and drawings at Anglo-Iranian HQ in London. Most of these were sold. In April he went to Paris, obtaining a studio at 51 rue du Moulin Vert, XIVe. Attended Académie Julian for three months, studying under Paul-Albert Laurens. Made first drypoints, woodcuts, aquatints, and lithographs. Met Joseph Hecht, who taught him the use of the burin. Made friends with members of international group of avant-garde artists including Balthus, Alexander Calder, Anthony Gross, Joan Miró, Giacometti. Visited Spain and Corsica in the summer. Exhibited paintings and prints at the Salon d'Automne.

1927 Made *Bison*, one of his first engravings. At the request of Alice Carr de Creeft

(wife of the sculptor José de Creeft) and friends, he established a printmaking workshop at his studio. By the end of the year ten people were working there two days a week, and Hayter moved the workshop to a larger space at the Villa Chauvelot in the XV^e *arrondissement*. First one-man show at the Sacre du Printemps Gallery, Paris.

1929 Travelled in Italy. One-man show at Claridge Gallery in London, and group exhibition with the Surrealists at the Salon des Surindépendants in Paris. With Miró, Arp, and Tanguy, became interested in string constructions on flat surfaces, sometimes painted (this effect is a forerunner of his later experiments with white relief in engravings). Began to paint non-figurative works with transparent colours on gold or silver grounds.

1930s *Artists working in the Atelier included Miró, Tanguy, Masson, Ernst, Giacometti, Hecht, Peterdi, Ubac, Vieillard, Buckland-Wright, and Trevelyan. In 1934 Hayter first met Picasso, who became a frequent visitor to the Atelier in search of technical advice and made some prints there.*

 In 1932 Hayter, together with Anthony Gross, began experimenting with simultaneous colour printing, using both intaglio and the surface of the metal plate. In 1933 he began impressing textures in soft ground. In 1934 he first hollowed out areas of the plate with a scorper to print white in relief.

1930 Published a series of six prints entitled *Paysages urbains* (Éditions Quatres Chemins, Paris).

1931 Travelled in Venezuela, Trinidad and Barbados, Spain, and Majorca. Made six engravings for George Reavey's collection of poems *Faust's Metamorphoses*, published the following year (The New Review Editions, Fontenay-aux-Roses).

1932 Published six engravings entitled *Apocalypse* with a poem on the prints by Georges Hugnet (Éditions Jeanne Bucher, Paris). One-man show at Galerie Vignon, Paris. Visited Majorca and Spain.

1933 Moved the workshop to 17 rue Campagne-première, XIV^e, from which the name 'Atelier 17' (proposed by Julian Trevelyan) was derived; the name was retained despite changes of location after 1939. Exhibited with Surrealist group in Paris. Met Paul Éluard and began a friendship that lasted until the poet's death in 1952.

1934 First show of Atelier 17 artists (including Ernst, Masson, Miró, Hayter) at Galerie Pierre, Paris, and at Leicester Galleries, London. Visited Austria and Germany.

1936 Helped to organize the Surrealist exhibition in London, and exhibited in it. Exhibited in 'Fantastic Art, Dada, Surrealism' in Museum of Modern Art, New York. After a visit to Italy and Greece began to use a very clear, prismatic range of colours in his paintings.
 'Combat'—*one of the most important engravings of this period.*

1937 Travelled in Spain at invitation of the Ministry of Arts of the Republican Government. On his return, Hayter agreed with Vollard to produce a series of prints to

illustrate Cervantes's *Numancia*, a tragedy recording the heroic defence of a city in Spain which was annihilated by the Romans in 1 3 3 BC. The project was halted because of Vollard's death, but five plates which had been completed were published individually. Exhibited with Surrealists in Japan.

1938 Initiated portfolio entitled *Solidarité* in tribute to the Spanish people (published by Guy Levis-Mano). It consisted of seven etchings with a poem by Paul Éluard and translation by Brian Coffey. The other six artists were Buckland-Wright, Husband, Masson, Miró, Picasso, and Tanguy. Proceeds from this portfolio went to the Spanish Republican Children's Fund. Participated in International Surrealist Exhibition, Galerie des Beaux-Arts, Paris. Ceased his close association with Surrealist group over the Éluard affair.

1939 Initiated and published a second portfolio, entitled *Fraternity*, the proceeds of which went to the Spanish Republican Children's Fund. It consisted of nine prints and a poem by Stephen Spender called 'Fall of a City', with a French translation by Louis Aragon. The other artists were Buckland-Wright, Hecht, Husband, Kandinsky, Mead, Miró, Rieser, and Vargas.

 Published *Facile Proie*, eight etchings accompanied by Paul Éluard's poem dedicated to Hayter.

 Left Paris the day after the Second World War was declared. Worked in England on camouflage techniques.

1940 Left London for USA; arrived in New York on 31 May. Met Clara Meyer, dean of the New School for Social Research in New York, and arranged to open a print workshop at the New School, offering an intaglio printmaking course to be called 'Atelier 17' as part of the art curriculum. As this could not open until the autumn, Hayter accepted an invitation to teach a summer course at the California School of Fine Arts in San Francisco. First one-man show in USA at Museum of Fine Arts in San Francisco. Returned to New York in the autumn.

1940s *Artists working with Hayter in Atelier 17, New York, included Antreasian, Calder, Chagall, Le Corbusier, Dali, de Kooning, Fuller, Lasansky, Lipchitz, Masson, Matta, Miró, Motherwell, Peterdi, Pollock, Racz, Rothko, Schrag, Tamayo, Tanguy, Todd, Zanartu.*

 Together with Max Wertheimer and Ernst Kris, Hayter conducted experiments on the psychology of visual perception at the New School. He worked extensively on the development of colour printing from intaglio and surface simultaneously.

1941 One-man show of paintings at Marion Willard Gallery, New York, and of prints at Art Institute, Chicago.

1942 Moved to Connecticut. Illustrated Bullfinch's *The Age of Fable* (Heritage Press, New York; re-edited by Book of the Month Club, New York, 1950).

1943 Moved to New City, New York State. Directed a course in printmaking at the Philadelphia Print Club and was laureate of Annual Prize there for print entitled *Laocoön*. Exhibited at the Art Institute, Chicago.

'Centauresse'—*first print in which colour was printed simultaneously from the surface of a plate already inked in the intaglio.*

1944 Moved back to New York City. Exhibition of the work of Atelier 17 was organized by Monroe Wheeler at the Museum of Modern Art, New York. Its impact on American printmaking has been compared with that of the Armory Show on American painting. The Museum of Modern Art circulated the exhibition in major US museums for two years, and a duplicate show was circulated for a year throughout Latin America by the State Department. An entire issue of the *Museum of Modern Art Bulletin* (12/1, Aug. 1944) was devoted to this exhibition.

1945 Hayter established Atelier 17 as an independent workshop at 41 East 8th Street, Greenwich Village, New York, in a loft above the artists' supplies store Rosenthal's. Between twenty-five and thirty artists could work there simultaneously. Exhibited at Mortimer Brandt Gallery, New York. Atelier 17 exhibition at Willard Gallery, New York.

1946 Visited Paris, exhibiting drawings and prints at Jeane Bucher's Gallery. Éluard's poem 'Facile Proie' was republished with two new drawings by Hayter in *Voir* (Édition Trois Collines, Zurich), an anthology of Éluard's poems on various artists, including Hayter.
 'Cinq Personnages'—*first large print in the history of gravure combining intaglio with surface colours printed simultaneously from the plate.*

1947 One-man shows in New York and Los Angeles. Exhibited in Salon de Mai, Paris. Exhibition of Atelier 17 at Leicester Galleries, London.
 With Miró and Ruthven Todd, Hayter employed a method, devised in 1944, of printing in colours from a plate etched in relief. This was in part an experiment to recreate Blake's method of relief etching. Using poems by Todd, Hayter and Miró produced plates etched to different levels in the manner of Blake. It was found possible to ink both relief (as Blake had done) and the intaglio with contrasting colour, and to print them simultaneously.

1948 Invited to teach a special course in painting and theory at California School of Fine Art; students included Hultberg, Mullican, and Halpern. Exhibited in San Francisco and Museum of Fine Arts, Santa Barbara. *Unstable Woman* won the Purchase Prize at the Brooklyn Museum Annual Print Exhibition.

1949 Gave a course on printmaking at Art Institute, Chicago. Professor of Fine Arts in Design Department of Brooklyn College, New York. Published *New Ways of Gravure* (Pantheon Press, New York, and Routledge and Kegan Paul, London), the most important book on gravure this century. Exhibited paintings in New York. Exhibition of Atelier 17 at Laurel Gallery, New York.

1950 Returned to Paris and reopened Atelier 17 at 278 rue Vaugirard, XVe, on the premises of the printing house of Chassepot. Exhibited at Galerie La Hune, Paris.
 The New York branch of Atelier 17 continued to function under the successive directorships of Karl Schrag, Terry Haass, Harry Hoehn, James Kleege, Peter Grippe,

and Leo Katz. Hayter visited it in 1952 (by which time it had moved to 523 Sixth Avenue) and again in 1953. But without Hayter's continued presence, it lost impetus, and he closed it in 1955.

Artists working with Hayter in Atelier 17 since 1950 include Alechinsky, Ball, Breivik, Fröhlich, Gentilli, Haacke, Hamaguchi, Hasegawa, Hiasa, Kihara, Kohn, Lodge, Thien-Shih Long, Loo, Matsutani, Mead, Platiel, Reddy, Reinhold, Rothenstein, Saunier, de Silva, Singer, Tanguy, Thornton, Wirz, Yamamoto, Zanartu.

1951 One-man shows in Paris and Munich. Exhibited from this year onwards at the Salon de Mai. Awarded Légion d'honneur for services to French culture.

 Purchased a summer house in Alba in the Ardèche next to the stream L'Escoutay. Alba transformed Hayter's colours, which became increasingly brilliant, and L'Escoutay gave him a passionate preoccupation with moving water and the effects of light on and in water. Began using metallic colours again (as in 1929) to get alternative views of a picture according to the spectator's viewpoint. One of his first paintings at Alba, *Poissons de L'Escoutay*, was purchased the following year (1952) by the Tate Gallery and a later painting of L'Escoutay was subsequently obtained by the Fitzwilliam Museum.

1952 Exhibited in Basle, Lille, Berlin, and Düsseldorf.

1953 With artists from Atelier 17 exhibited in Amsterdam, Rotterdam, Brussels, Copenhagen, Florence, and Rome. Atelier 17 moved to rue Vandrezanne, XIIIe.

1954 Exhibited paintings at Kunsthalle, Berne, with École de Paris artists. Atelier 17 moved to the Académie Ranson on rue Joseph Bara, VIe.

1955 One-man shows of paintings in Paris and Munich. One-man show of prints at St George's Gallery, London.

1955–6 Invited by Norwegian government to hold exhibitions of Atelier 17 at Oslo National Gallery, Stavanger, and Bergen.

1956 One-man show of prints at National Gallery of Argentina, Buenos Aires. Exhibited prints with Helen Phillips at California Palace of the Legion of Honour. Participated in 'Bokugin Show', Tokyo, and 'World Contemporary Art', Tokyo.

1957 Exhibited prints at Museo de Arte Moderne, Rio de Janeiro, at Basle, and Baltimore. First retrospective exhibition of paintings, prints, and drawings at Whitechapel Art Gallery, London (organized by Bryan Robertson).

 With Poisson rouge *Hayter began a series of etched plates, primarily on aquatic themes, printed from intaglio and relief in a new style. Techniques characteristic of the series are the use of Flowmaster felt pen to give an impermanent acid-resist, the spraying and spattering of stopping-out varnish, and the scraping down of texture already in the metal. When printed in colours, using his system of alternating hard and soft rollers combined with intaglio ink, wholly novel effects are created with etched and engraved plates.*

1958 Represented Britain at Venice *Biennale* with William Scott and Kenneth Armitage. Won Venice Liturgic Prize for painting. Exhibition circulated to Museum of

Modern Art, Paris, and to Cologne, Brussels, and Zurich. Exhibited paintings in Los Angeles and Pasadena. *Poisson rouge* awarded Lugano Prize at International Print Biennale, Grenchen, Switzerland.

1959 Awarded OBE. Exhibition of 'Hayter and his Atelier 17' at Tokyo Metropolitan Art Museum.

1960 Won International Grand Prize at the Second Tokyo International Print Biennale. Exhibition of Atelier 17 at Institute of Contemporary Arts, London, selected by Herbert Read.

1961 Exhibited in New York; at print *biennale*, Ljubljana; at Museum of Contemporary Art, Dallas, Texas. Atelier 17 moved to 77 rue Daguerre, XIVe.

1962 Published *About Prints* (Oxford University Press, London). Exhibited at Museum of Fine Arts, Liège, Modern Art Museum, Kamakura, and in Tokyo.

1963 Exhibited paintings in New York. With Atelier 17, exhibited in Bologna and Tokyo. *Pelagic Forms*, a further print made with the Flowmaster pen technique, won the Giles Award, London.

1965 Exhibited paintings in New York and Caen. Also exhibitions in Bologna, Venice, Rome, and Ljubljana.

1966 Retrospective print exhibition at Musée Rath, Geneva, subsequently shown at Calcographia Nazionale, Rome, and Municipal Gallery, Dublin. Exhibited in Copenhagen and Osaka. Second edition of *New Ways of Gravure* (Oxford University Press, Oxford).

1967 Retrospective print exhibition at Victoria and Albert Museum, London. Exhibitions at Los Angeles; University of Oregon; Austin, Texas; Amsterdam; and London.

1968 Awarded CBE, and made Chevalier de l'Ordre des Arts et Lettres. Retrospective exhibition of prints and paintings at Musée de Dieppe. Retrospective print exhibition at Kunsthalle, Bielefeld, Germany. Shows at Amsterdam, Savannah, Bordeaux, Long Island.

1969 Retrospective print exhibition at Musée des Arts Décoratifs, Paris, subsequently shown at Smithsonian, Washington. Shows in Paris, Seattle, Washington, DC, New York, and Osaka. Atelier 17 moved to 63 rue Daguerre, XIVe.

　　　With 'Swimming Bird' (1969) Hayter began a series of plates in which venilia, an adhesive-backed plastic sheet, was used to cover the plate as an acid-resist. When it is cut with a knife a sharp refined area is etched. Where lines cross and recross, facets can be removed and later replaced so that parts of the design can be etched to different depths.

1970 Retrospective print exhibition at University Art Museum, Austin, Texas. Shows in Long Island, Kansas City, Chicago, Santa Monica, Amsterdam, and Hong Kong.

　　　From the early 1970s onwards Hayter began again to introduce directly figurative

elements into many of his prints. The burin line was again used in counterpoint with soft-ground etching over large areas. Fluorescent inks were used to create prints with unprecedentedly brilliant colours.

1972 Exhibition of paintings at Musée de la Ville de Paris. Received Grand Prix des Arts de la Ville de Paris. Shows in Toronto, Seattle, Santa Monica, Battle (England), Biennale de Rio de Janeiro.

1973 Exhibited in Belgium, Washington, DC, Boston, and London.

1974 Exhibited paintings in Santa Monica. Prints shown in Amsterdam, Houston, New York, and Milan.

1975 Exhibited paintings at École des Beaux-Arts, Angers, and in Boston. Prints shown at Malmö Museum, Landskrona Museum, and Jonköpings Museum in Sweden. Also in Seattle, Dublin, and Osaka. Drawings shown at Kunsthalle, Düsseldorf, and Kunsthalle, Baden-Baden.

1976 Paintings exhibited in Paris and Santa Monica. Prints shown in Kobe, Tokyo, Warwick, and Luxembourg. Exhibited in group exhibition of modern art, New York, and Centre Pompidou, Paris.

1977 'Atelier 17: A 50th Anniversary Retrospective Exhibition' at Elvehjem Art Centre, University of Wisconsin. Paintings exhibited in Houston and Amsterdam. Prints shown in Sydney; Museum of Modern Art, Houston; and Kobe. Atelier 17 moved to 10 rue Didot, XIVe.

1978 Participated in 'Dada and Surrealism Reviewed' at the Hayward Gallery, London. Retrospective print exhibition at Calcographia Nazionale, Rome. Elected Foreign Member of the American Academy of Arts and Sciences.

1979 Retrospective exhibition of prints at Honolulu Academy of Arts, Hawaii; prints and paintings at Kunstnernes Hus, Oslo; Museum of Modern Art, Reykjavik; Nice; and Kanagawa.

1980 Exhibited in Amsterdam, Bergen, Stavanger. Participated in 'The World in Contemporary Prints 1955–80', Tokyo Metropolitan Art Museum; Tochigi Prefectural Museum of Fine Arts; and Hiroshima Prefectural Museum of Art.

1981 Third and revised edition of *New Ways of Gravure* (Watson-Guptill Publications, New York). Exhibited in Stuttgart, Lima, Orkney, Caen, and at the Oxford Gallery, Oxford.

1982 Prints exhibited in Rome. Elected Honorary Foreign Member, Royal Academy, London. Henceforth exhibited regularly at Academy summer exhibitions.

1983 Paintings and prints in Adelaide, Dublin, Paris, Luxembourg. Prints in Paris. Received Doctorate of Fine Arts, New School for Social Research, New York, and Honorary Doctorate from Hamline University, Minnesota.

1984 Paintings exhibited at Limerick, Paris, Stuttgart. Prints exhibited at the Redfern Gallery, London.

1985 Retrospective exhibition of paintings, drawings, and prints at Kobe, subsequently shown in Tokyo. Paintings exhibited in New York and Paris.

1986 Promoted to Commandeur des Arts et Lettres.

1987 Prints exhibited in London at Robert Douwma's Gallery, paintings and prints in New York.

1988 Paintings exhibited at Riedel Gallery, Paris. The British Museum purchased 400 of his prints from Hayter—the largest purchase of prints from a living artist the Museum has ever made.

10
Selected Writings of S. W. Hayter

———

Based on the Select Bibliography of the Whitechapel Exhibition, 1957, the Musée d'Art et Histoire, 1966, and other sources.

'Exposition de l'Atelier 17', in *La Bête noire*, 3–4 (June 1935).

Statement in catalogue, exhibition of European artists teaching in America, Addison Gallery of American Art, Andover, Mass., 1941.

'Techniques of Line Engraving', in *Print* (1941).

'Line and Space of the Imagination', in *View*, 4 (1944).

'Techniques of Gravure', in *Hayter and Studio 17, Museum of Modern Art Bulletin*, 12/1 (Aug. 1944).

'Convention of Line', in *Magazine of Art*, 38/3 (1945).

'The Language of Kandinsky', in *Magazine of Art*, 38/5 (1945); also included in Wassily Kandinsky, *Concerning the Spiritual in Art*, Documents of Modern Art, no. 5 (New York, 1947).

'The Apostle of Empathy: Paul Klee', in *Magazine of Art*, 39/4 (1946).

'Les Bases de la réalité', in *Juin* (July 1946).

'Note on the Techniques used by Atelier 17', in *Atelier 17* (Leicester Galleries, London, Mar. 1947).

'The Image Makers', in *Magazine of Art*, 40/10 (1947).

'Of the Means', in *Possibilities*, 1 (1947–8); also published in *Transformation* (New York, 1950).

Introduction to *Jankel Adler* (London and Paris, 1948).

'The Pretension to Find New Expression . . .', in *Atelier 17* (Laurel Gallery, New York, 1949).

New Ways of Gravure (London and New York, 1949; 2nd edn, London and New York, 1966; revised edn, New York, 1981).

'Interdependence of Idea and Technique', in *Tiger's Eye*, 1/8 (1949); previously published as 'Les Relations entre l'idée et la technique', in *Juin* (Aug. 1946); also as 'Idea and Technique', in *Student Independent* (Chicago Institute of Design, Fall 1953).

'Note sur la gravure' in *Art-documents* (Geneva, Nov. 1951).

'Réponse à une enquête: Quel paysage avez-vous choisi?', in *Arts*, 368 (July 1952).

'The Lautrec Bite' in *Art News*, 54/11 (1955).

'La Gravure de Mantegna', in *L'Œil* (Nov. 1957).

'Atelier 17', in *Graphis*, 55 (Nov. 1955).

About Prints (London and New York, 1962).

'Orientation, Direction, Cheirality, Velocity and Rhythm', in Georgy Kepes (ed.), *The Nature and Art of Motion* (New York, 1965).

'The Making of a Painting', in *Leonardo*, 1/3 (1968/9); also published in catalogue *S. W. Hayter: Peintures 1940–75* (Galerie de Seine, Paris, 1976).

'Les Techniques de l'estampe', in catalogue *Hayter: L'Atelier 17* (Musée de Caen, 1981).

'Une certaine idée de l'éducation', in catalogue *Hayter: L'Atelier 17* (Musée de Caen, 1981).

II

On Hayter

―――――

Of his many qualities, perhaps the rarest was his power of transmuting some visual experience so that it was no longer specific but transformed into a general human experience, but, unlike most generalizing art, Hayter's was decisive, subtly arresting and exquisitely precise.

Hayter's complex and highly charged imagination, scientific knowledge (and where engraving was concerned, a technical command) unapproached by that of any other artist of his time, his capacity to learn continuously from nature, from the masters and even on occasion from relatively inexperienced students, combined to create an art which is an enthralling combination of the ambiguous with the elegantly lucid. It is alive with a rhythmic vitality of its own.

Sir John Rothenstein, *Modern English Painters*, (rev. edn, London, 1984), ii. 285–6.

Stanley William Hayter is known to artists and others in the world of creative achievement as one of the most remarkable men of this era. He is considered by many to be the most influential engraver alive, a peerless catalyst and innovator who has helped twentieth century printmaking reach remarkable heights ... a painter of high quality, a rare personality and wit.

Adrienne Farrell, 'A Half Century of Lasting Imprint' *Smithsonian* (Sept. 1978), p. 89.

Hayter has probably had more personal influence on the course of engraving than any artist in the history of art. In 1927 he set up a workshop in Paris called Atelier 17, after the number of the house in which it was situated, and artists of every nationality and category came there to learn, to practise and to pool their ideas. In 1940 the Atelier was transferred to New York and its influence has been directly responsible for the renaissance of print-making in the United States. Most of the well-known artists from Picasso downwards have at one time or another made plates under the inspiring impetus of its founder.

John Buckland-Wright, *Etching and Engraving* (London, 1953), p. 31.

Hayter was not interested in printmakers as such, but in artists who would employ and develop the print media as another means of creative expression. Max Ernst, Giacometti, Miró, Chagall, Lipchitz, Yves Tanguy and later Braque, Picasso, Léger and other distinguished artists came to the Paris Atelier 17 to participate in a new venture in graphic

art. For a time the individual artists were submerged into a concerted effort and under the demanding tutelage of Hayter, set a new course for twentieth century printing.

Una E. Johnson, *American Prints and Printmakers*, (New York, 1980), p. 71.

It was his intensity that was overwhelming. He was like a stretched bow or a coiled spring every minute, witty, swift, ebullient, sarcastic.... The group with him absorbed, intent, bent over under strong naked bulbs. He always moved about between the students, cyclonic, making Joycean puns, a caricature, a joke. He was always in motion. I wondered how he had ever spent hours bent over copper plates, delicate, demanding, exacting work. His lines were like projectiles thrown in space, sometimes tangled like antennae caught in a windstorm. I never saw him at low ebb.... A volcanic personality.

Anaïs Nin, *The Diary of Anaïs Nin*, vol. iii: *1939–44* (New York, 1969), pp. 125 f.

Through its work, *Studio 17* represents a cross-section of some of the most vital researches in twentieth century graphic art. Its story is the story of an artist who saw the widespread neglect into which engraving as a medium of creative expression had fallen during the last four centuries and who realized the possibilities it offered for the exploration of those pictorial interests which most attracted twentieth century artists. Its founder, Stanley William Hayter, combines in an unusual fashion a scientist's technical interests with a plastic artist's imagination and feeling for form. Through his enthusiasm and personal qualities, Hayter was able to bring together, during the thirteen years of the Atelier's activity in Paris, leaders in the most diversified expressions of painting and sculpture, from Chagall, Picasso and Lipchitz of one generation, to Miró, Ernst and Calder of another.... The result was not merely the revival of old techniques, but rather the adaptation of certain features of such techniques to essentially twentieth century pictorial interests. What we have first of all in the work of Hayter and his associates is the revival of engraving as a medium for original expression.

James Johnson Sweeney in *Museum of Modern Art Bulletin*, 12/1 (Aug. 1944), p. 3.

Few have been unaffected by Hayter's powerful argument that only when content and means of expression are inseparable and one conspires with a medium to realise its idiosyncratic possibilities rather than using it as a device to repeat previously formulated images, can there be true originality in printmaking. Without any doubt this attitude has led to a revaluation of printmaking as an artform capable of major statement.

Pat Gilmour in *For Stanley William Hayter on His 80th birthday* (Oxford Gallery, 1981).

Hayter, particularly after 1940, was an exponent of the free line. He relished long exploratory curves of classical purity, involuted and uninflected. Carried along by the sheer pleasure of intuitive engraving, the lines he incised have a life of their own, as if done under water or with closed eyes. And indeed Hayter's work after 1940 has a marine feeling, a sense of ocean depths (many of his prints are given water-related titles). As for the artist's preoccupation with line and with degrees of transparency, we must recognize these qualities

as unshakeably English. Roger Fry and Nikolaus Pevsner, among others, have pointed out that English pictorial art has a strong tendency towards the linear, or, conversely, a feeling for the atmospheric as against the concrete three-dimensional.

Jacob Kainen, *Stanley William Hayter: Paintings, Drawings and Prints 1930–50* (Corcoran Gallery of Art, Washington, DC, 1973).

The workshop was a hub, a centre for international artists to gather and work. Hayter himself had just returned from New York, where he lived during the war. It was extraordinary how the artists came.... Hayter is called the father of modern printmaking. Since his workshop started, over four thousand printmaking workshops have begun. His participation in education, especially in developing the graphic area in fine arts, is important. He is one of the giants in the field.

Krishna Reddy, interview in 1981, printed in *Krishna Reddy: A Retrospective* (Bronx Museum of the Arts, New York, 1981).

12

Hayter: Miscellaneous Remarks

Autobiographical

My brother was an engineer and I was a chemist at one time and a geologist. But, of course, I was painting all the time and in the end I came to the idea that this is what I had to do because my father had a very charming view of this. He said: 'Now, if you are willing to devote your life to this sort of thing and you are prepared towards the end of it to realise that you have not only had no success with the public, but you have had no success with yourself, you've not succeeded in doing anything you set out to do; if you then feel that you have passed your time very well and profitably then you should be a painter, and that's the only way. There is no other way of doing it.'
Talk given at Bankside Gallery, 1985, reported in *Journal of the Society of Painter-etchers and Engravers*, 7 (1985), p. 3.

I don't believe it was arrogance that made me start Atelier 17, it was that I was overwhelmed by the prevailing neglect of printmaking, the failure to be aware of its immense potentialities. In short, by the sense of *things to be done* with a new etching, a new engraving. In any case, there was no question of a master and pupils relationship, but of one harnessing talent in a collective venture, of 'Let's see what's going to happen.' I was convinced that in the course of working together new ideas would emerge.

In discussion with Sir John Rothenstein, reported in Rothenstein's *Modern English Painters* (rev. edn, London, 1984), ii. 280.

When I met Hecht in 1926 I was very strongly impressed with the latent possibilities of his manner of using a burin, and later, realizing the necessity of collective work in a group in order to develop these and other possibilities, I set up a workshop where all equipment was available for artists who wished to work in those media.

In *New Ways of Gravure* (rev. edn, New York, 1981), p. 200.

I was acquainted with members of the Surrealist group quite early, but did not actually exhibit with them until the second Surrealist Manifesto for the simple reason that the first one, which had to do with oneiric, or dream, material, did not appeal to me. Making literal projection of matters of dream did not impress me as being valid. My first view of any work

of art is: Is it a thing? Is it a thing of itself? Is it real? Because unless you are convinced of that you have got nothing.

Interview with David Cohen, 1987.

On Teaching

... the author has for many years shared the view of Ivan Illich that whereas learning is synonymous with living, teaching is absurd. I prefer to regard my activities over all these years as unteaching, diseducation, disintoxication—like the somewhat similar activity that brought Socrates to an untimely end. There is no way in which the experience of a teacher can be transferred to a pupil, and the warning given to all beginners in our workshop not to believe a word they are told is necessary in view of the verbal deformation of our current civilization. Only the action of the newcomer can give rise to knowledge, this understood as the extension of his own experience.

In *New Ways of Gravure*, p. 203.

On the Unconscious Roots of Creativity

Although, for personal reasons, I am no longer an active member of the Surrealist group, the source of the material in all my works is unconscious or automatic; that is to say, an image is made without deliberate intention or direction. The impulse to make an image is definite, but no particular image is sought consciously. This may give the impression of a completely formless and unplanned method; however ... the execution of a project in a very indirect method involves a great deal of forethought....

I will try to explain this apparent contradiction. In the first project, a drawing perhaps, no conscious selection of form is exercised, although, as with a print, the proportions of the plate selected and the sort of colour to be used had been present in a nebulous state in my mind for a year or more. The hand that made the first study was, however, trained by twenty years of practice in line engraving, the mind has assimilated all the mechanical processes involved in making the work until they became 'instinctive', and the areas of imagination that are provoked by the use of such means had been exercised for years.

Thus, if the source of material for such a work is irrational, its development and execution have to be strictly logical, not with the mechanical logic of imitation, but in accordance with a sort of system of consequences having its own logic. At the different stages of development of the work, a choice is exercised, but with extreme precaution against the application of pedestrian common sense when inspiration flags. As Paul Klee says, 'To continue *merely* automatically is as much a sin against the creative spirit as to start work without true inspiration.'

On the execution of *Cinq Personnages* (1946) from *New Ways of Gravure*, p. 132.

On 'Abstract' and 'Figurative' Art

The term 'abstract' is unfortunate, as it suggests the abstraction or removal of a part of experience—the attempt to show less of the phenomenon and not more: the 'non-figurative'

label again suggests a pretension to deny the observer the association or comparison of the work with latent images in his own brain—a pretension which it is impossible to sustain. . . . I would suggest that to replace the opposition of 'figurative' and 'abstract', it would be wiser to employ the contrast of 'specific' and 'general'.

New Ways of Gravure, p. 282.

On Technique

. . . the interdependence of technique and idea is a condition without which idea is lost and technique is a sterile, mechanical operation.

New Ways of Gravure, preface to rev. edn, pp. 75 f.

. . . awareness of means should stimulate areas of imagination not otherwise accessible.

'Orientation, Direction, Cheirality, Velocity, and Rhythm', in G. Kepes (ed.), *The Nature and Art of Motion* (New York, 1965), p. 71.

. . . a technique is an action in which the imagination of the user is excited, whereby an order of image otherwise latent becomes visible: and not merely a series of mechanical devices to produce or repeat a previously formed image on paper.

About Prints (London and New York, 1962), p. 94.

On a Major Work of Gravure

Speech must be audible; a gesture must be perceptible; and the order of importance of the gesture must be such as to hold our attention. And to warrant the gesture reaching the permanence of a print, it must be a matter of significance and ultimately be recognized.

About Prints, p. 160.

. . . where the operations on the plate, block or stone have been used to repeat or translate an image actually existing in another medium, as drawing, sculpture or painting—or if not actually existing, readily conceivable as such—it is hardly possible that in the work we are seeing an idea itself coming into being: we are not in the presence of an original work.

About Prints, p. 128.

[A major work] must possess one quality, variously described as spontaneity, authority—in fact the ability to convince . . . to carry such conviction it is essential that the artist at the moment of creation should be himself convinced: that quite apart from his virtuosity of execution (the cumulative effect of a deep knowledge of the mechanics of his craft) and means of projection of his idea, his action, by which the work becomes visible, shall absolutely convince him at the time or it cannot convince an observer and hence is not a major work.

About Prints, p. 128.

If, in a pure line engraving, the situation of the artist in his progress at various speeds through the convolutions of a burin cut compels the observer to retrace the path he has laid out, one at least of the conditions for a major work has been realized. If again the interference of textures, the web of space, the conflict or harmony between figured space and colour space, the ambiguity of convex/concave,tension, torsion or flow, if all or any of these factors have involved the observer inevitably in their play, we have this condition.

About Prints, p. 129.

On the Nature of Art

My approach to art is fundamentally experimental. I consider that art—painting, print-making, sculpture, etc./is a means of research or a pursuit of knowledge, rather than a method of producing objects for pleasure, decoration or entertainment. Together with disciplines such as physics or mathematics, as with music or poetry, art is an attempt to extend and deepen our knowledge of life and our relations with our world. Furthermore, it is a way of seeking means of transmitting and sharing such experience with others.

What is the enjoyment of this art? The source of the joy of working in this field may be the participation in a process leading to the unknown, the opening of the mind, the surprise of discovery and the breakthrough of revelations.

What is the intention of art? Perhaps it is to lead man toward a fuller understanding of his terms of existence; to aid all people to live more completely and escape from the history of human error; to demonstrate by example that the human mind has unlimited capacity to go further and further the more one demands of it.

Hayter, Paris, October 1969.

On the Life of Value

... the practical organisation of our frame of living is based on material values and the pursuit of immediate material gain ... in many countries the failure to react to elementary greed is considered to be evidence of insanity. An artist who does not demonstrate daily this order of insanity is unlikely to produce works of serious importance. Actually he illustrates a point made by Einstein ... that success in our time is generally considered in terms of receiving more than one gives; whereas a man of value is honoured in giving to his world more than he receives. This point of view, by no means restricted to the artist alone, can be seen to be very much more 'practical' than it may appear. It is not only a question of the means of living but of the self with which one has to live.

About Prints, p. 114.

13
Glossary of Terms

burin (graver): A short steel rod the section of which is usually triangular or lozenge-shaped and sharpened obliquely to a point, fitted into a half-round wooden handle. The engraver uses the burin, held in the palm of the hand, the stem between the second finger and thumb, the index finger resting lightly on the upper edge, to cut lines by driving it ahead of him across the copper plate.

burnisher: An instrument of oval section with rounded and highly polished edges, used by the engraver to smoothe and reduce work already in the plate.

carborundum: The stone traditionally used for sharpening the burin. It can also be used to rub the surface of the plate. The effect is like that of drypoint in that the plate surface retains ink around the parts which have been abraded as part of the design. Carborundum allows whole areas of a plate to be covered with a tone.

deep etching: The term deep etching is used to indicate that open areas of plate were removed by the action of acid. It is a convenient way of establishing a considerable difference of relief between some areas of the design and the original plate surface. Intaglio elements can be present at different levels of a plate etched in this way. When printed, a tone dependent on the crystallization of the metal or the bubbling of the acid will appear, surrounded by strong black borders where ink is retained around the margins of the area eaten away.

drypoint: A sharp steel or other metal rod with a point harder than the metal of the plate to be worked. Lines or other marks can be made directly on the plate surface by drawing the tool across it. The drypoint effectively tears open the plate surface. As with an etching or engraving the ink is held within the lines thus cut into the plate. It is also retained on its surface around the edges of the rough lines of the design.

engraving: The most straightforward of the intaglio printmaking processes, line engraving is the incising of grooves into a metal plate (usually copper) by means of a burin (see above). The direction of the line is varied by rotating the plate.

etching: An intaglio technique. Etchings are prints made from plates having grooves or hollows eaten out with acid in which ink is retained and transferred by pressure to damp paper. In the simplest case a clean polished plate of copper or zinc is coated with an acid-resistant ground composed of bitumen, resin, and beeswax either melted or in solution. Lines are drawn through this coating with a point and the plate is exposed to acid—either in a bath, or by dropping acid on to it.

Flowmaster pen: Flowmaster is the trade name of a particular felt-tipped pen that Hayter and others have used to draw directly on to the plate without an etching ground. This pen has interesting properties: when exposed to acid, the ink lines made with it protect the plate surface to a degree which varies according to the speed and pressure with which the line was drawn. Where the design is drawn more rapidly and the ink is consequently thinner, it breaks down with the action of the acid and acts only as an impermanent resist. A line which begins slowly and firmly then continues rapidly and lightly will, when etched and printed, result in a line which passes from white to a dark grey.

gradation: see **inking**

graver: see **burin**

hard roller: see **inking**

inking: Hayter's colour prints make use of simultaneous inking of intaglio—that is, the grooves or indentations which hold ink—and surface of a plate so that a number of colours can be applied in layers and printed in a single impression. Thus, after a plate has been prepared for intaglio printing, the unworked surface is free to carry another colour so long as its viscosity is lower than the intaglio ink already present, and the layer of ink sufficiently thin to permit damp paper to make contact with the intaglio ink. Using a number of depths of relief and gelatin rollers of different hardness and diameter, different colours can be deposited according to the varying depths of penetration of the roller. The colours are separated by a contrast of viscosity, so that a more liquid film rejects a more viscous colour on the roller while a more viscous colour on the plate accepts the more liquid one. The most liquid ink must be above the viscosity of water, present in the paper, and the most viscous one must be below the viscosity of the intaglio colour, otherwise the roller will lift the intaglio instead of depositing colour upon it. Thus all the permutations of opaque intaglio and transparent surface colour can appear on the print in a single passage through the press. *hard roller:* A hard roller describes a continuous band of relief across the plate surface and will deposit ink only on the topmost parts. *soft roller:* A soft roller can be used to deposit ink all over a plate which has been etched to a considerable depth, both on the surface and on the deeper parts that would be left untouched by a hard roller. Hard and soft rollers are often used in combination for the inking of a single plate. *gradations:* When the ink is rolled out on the slab before being applied to the plate surface, it can be rolled evenly or it can be arranged in a gradation from maximum to minimum saturation of pigment. This can be transferred to the plate by means of the roller, hard or soft.

intaglio printing: The method of printing known as intaglio is so called because the printing ink is carried in incisions made into the plate; consequently the line on the print is in relief above the print. The images of intaglio plates are printed on a roller press. The plate to be printed is placed on a heated slab and a viscous ink forced into its crevices with a roller or a dabber. Excess ink is wiped away from the surface; the plate is laid on the bed of the press, and paper (which has been dampened many hours before) laid over it, and closely woven blankets over all. As the upper roller of the press is turned the bed is drawn through; a

pressure of several tons transmitted through the blankets moulds the wet paper into the ink-filled crevices, producing a cast of the plate in ink upon the paper.

relief printing: Relief refers to the original surface of the block on which the image has been produced. The ink, of oil- or water-based pigment, is carried on those areas of the original surface of the block not cut away or otherwise removed in the making of the image. Printing is carried out by depositing ink on the block surface, often using a gelatin roller, so as to leave the hollows uninked, placing a sheet of paper over the block, and applying pressure. Careful examination of the surface of any print made in this way will show some degree of indentation of the printed form.

roulette: A spiked wheel fitted with a handle used to make a row or rows of tiny indentations in the plate surface. These dots can be built up into an area of tone.

scorper: A gouge used to remove sections or areas of a metal plate. Hayter's principal use of the scorper is in the hollowing of areas to print as raised whites.

scraper: A sharp flat-edged tool used by the engraver to remove the rough burr thrown up along the edge of lines made with the burin. It is used mainly for reducing work already in the plate.

silkscreen printing: A silkscreen consists of a solid wooden frame across which is stretched a piece of fine silk of fairly open weave. The apparatus resembles a tray of which the silk is the bottom. Different products are used to paint on this silk to fill its pores. In the simplest case, where oil-based inks are to be used, the stopping-out material is simply glue, sufficiently diluted with water to make it easy to handle and yet capable, when dry, of filling the screen effectively. The screen thus prepared is a stencil through which ink can be forced with a squeegee or scraper so that a print of the stopped-out image appears on the paper.

soft-ground etching: The process of etching the areas of a plate left exposed by the artist's work on a soft ground made of a substance which never dries out. Any object impressed into the ground will pull it away and expose the surface of the plate. The traditional way in which the technique was used consisted in placing a sheet of paper over the ground and then drawing the design on to the paper. When the paper is removed it takes with it those parts of the ground which have been impressed by the action of drawing. In fact the texture of almost any material, fabric, or suitably flexible surface can be pressed into a soft ground so that the impression can be etched into the metal surface. Since about 1934 Hayter has taken advantage of this discovery to apply textures, often from textiles, but also crumpled paper, leaves, or even a palm print, usually with the aim of providing a neutral transparent tone to contrast with the engraved line on the plate.

soft roller: see **inking**

sprayed varnish: A varnish which protects the plate from the action of acid has always been a part of the technical repertoire of etchers and aquatinters. The whole plate can be covered with it, or parts can be painted with it to protect them from further biting by the acid. Such protected areas can be produced by the chance spilling or spraying of the varnish on to the plate. Hayter found this a useful technique for a number of images of splashing water.

stencils: Stencils cut from thin plastic are used to mask areas of the plate while inking the surface with one or more colour. An important part of the image-making process in many of Hayter's colour prints.

textures: see **soft-ground etching**

venilia: French trade name for a self-adhesive plastic sheet with which a plate can be faced as an alternative to the traditional resin etching ground. If a knife is used to cut the plastic a thin line will result when etched. Where lines cross and recross facets can be removed, preserved, and later replaced so that other areas can be etched.

viscosity: A term used to describe a liquid: the viscosity of a liquid is the reciprocal of its rate of flow. A contrast of viscosity is used to separate different coloured inks in the method of simultaneous colour printing. It is helpful to think of the inks being more or less sticky than one another.

woodcut: A relief printing process. The design is cut into the plank of a piece of wood or other relatively soft material with gouges or knives. The design which prints black consists of the untouched areas of the original surface of the block.

wood engraving: A relief printing process like woodcut only using the harder end grain of the wood. The design, usually in white line, is incised with a burin.

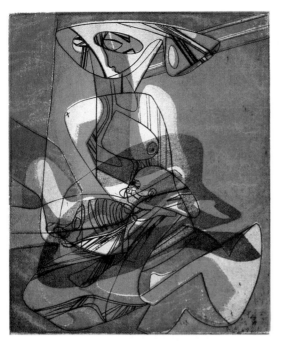

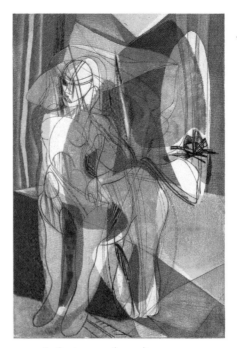

25 *Maternity* (1940), 227 × 191

38 *Centauresse* (1943), 150 × 102

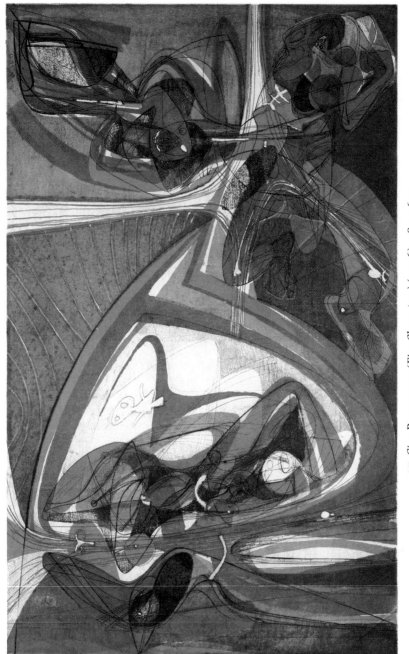

47 *Cinq Personnages (Five Characters)* (1946), 387 × 605

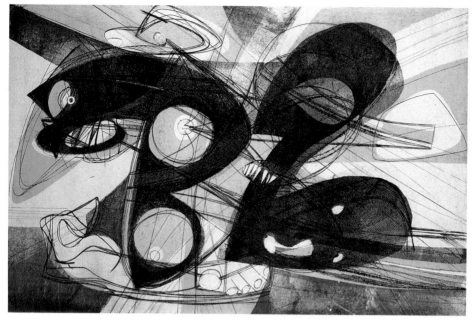

50 *Ceres* (1948), 590 × 386

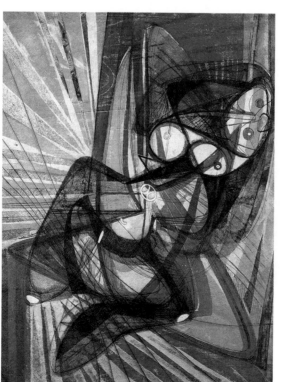

49 *Unstable Woman* (1947), 377 × 500

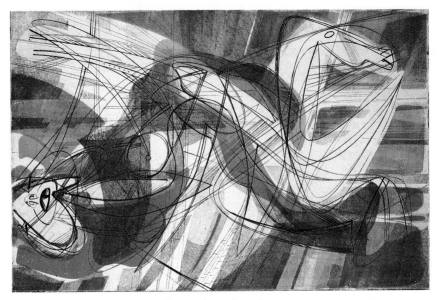

52 *Pegasus* (1951), 198 × 302

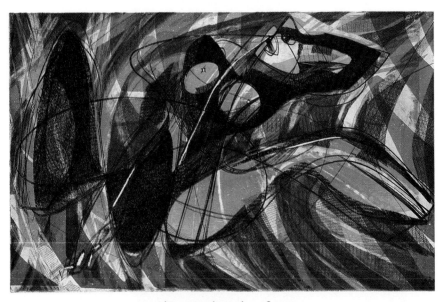

53 *L'Escoutay* (1951), 198 × 310

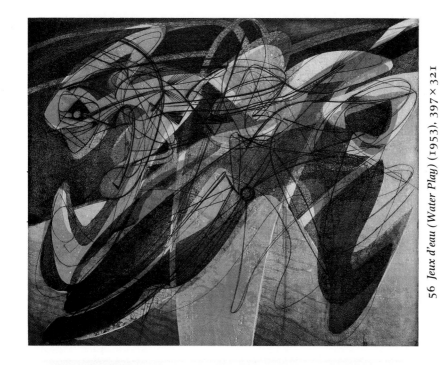

56 *Jeux d'eau (Water Play)* (1953). 397 × 321

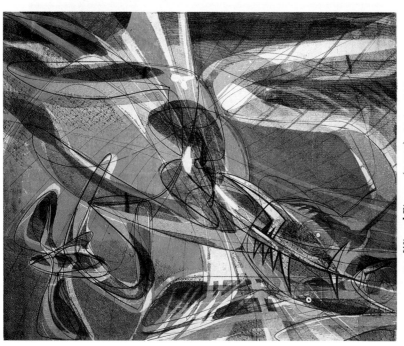

54 *Winged Figures* (1952). 399 × 329

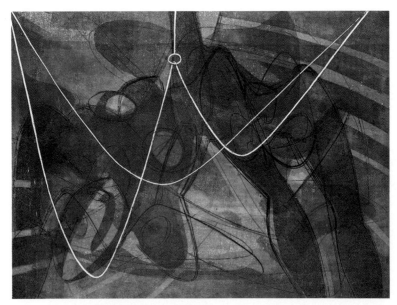

57 *La Noyée (Drowned Woman)* (1955), 350 × 471

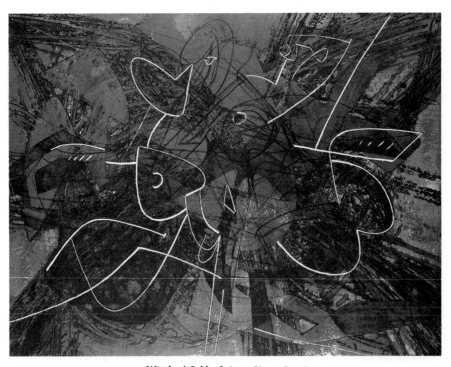

59 *Witches' Sabbath* (1958), 498 × 645

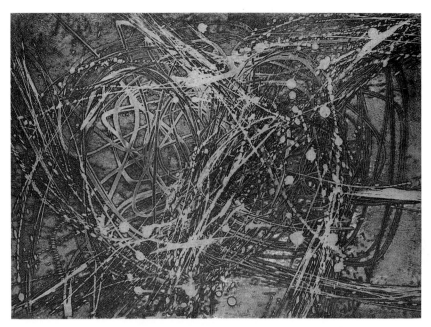

58 *Poisson rouge (Goldfish)* (1957), 337 × 466

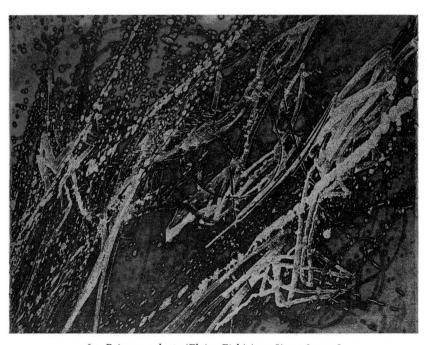

60 *Poissons volants (Flying Fish)* (1958), 296 × 378

66 *Red Sea* (1962), 356 × 277

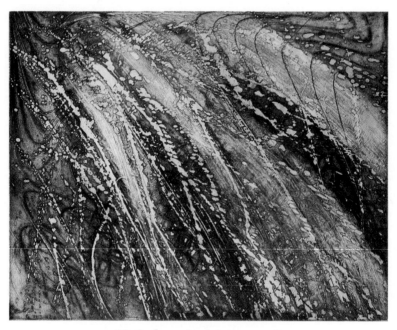

68 *Confluence* (1964), 397 × 508

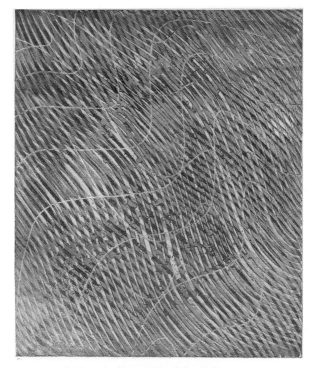

69 *Onde verte (Green Wave)* (1965), 592 × 500

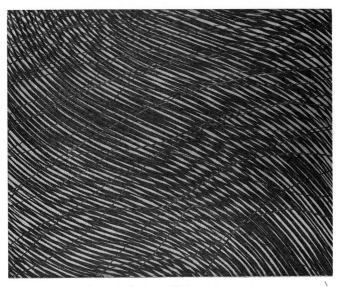

71 *Vague de fond (Swell)* (1965), 395 × 493

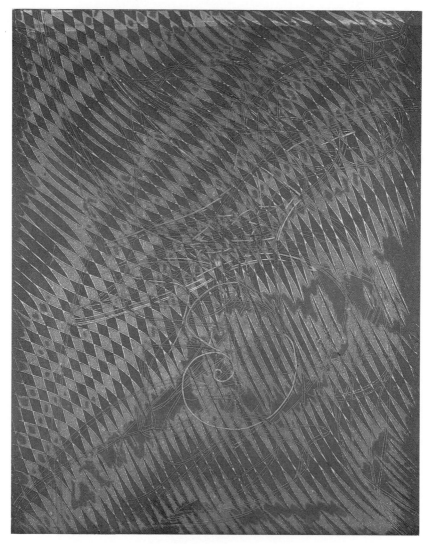

74 *Nautilus* (1969), 536 × 446

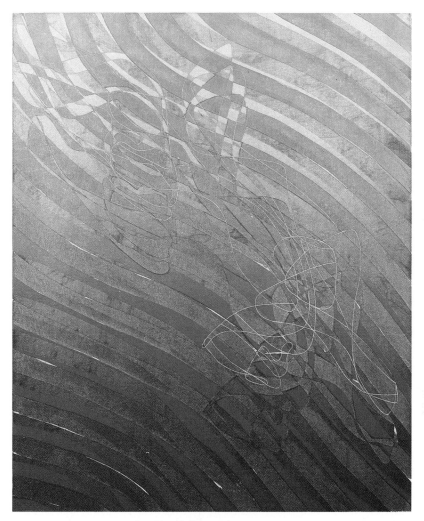

80 *Free Fall* (1974), 592 × 490

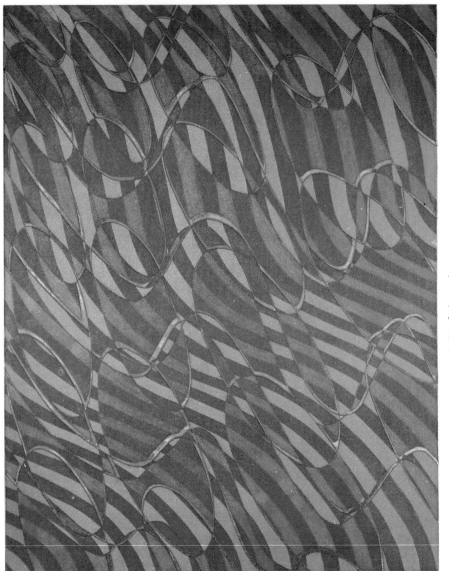

76 *Ripple* (1970). 470 × 594

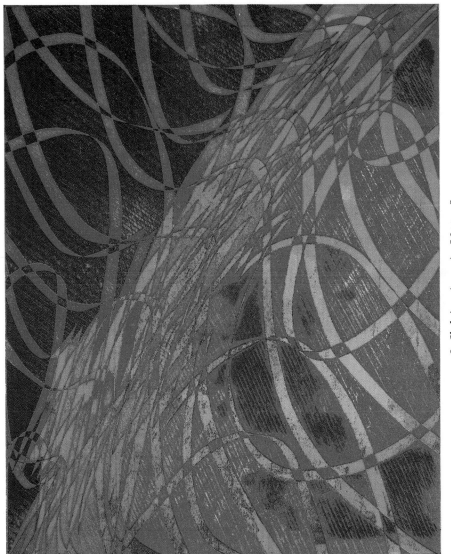

78 *Claduègne* (1972) 486 × 598

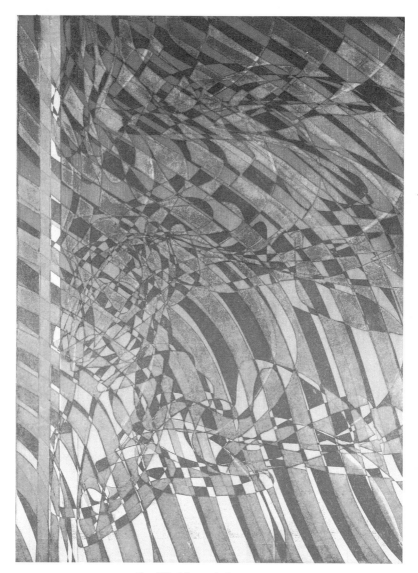

81 *Wind* (1974), 600 × 437

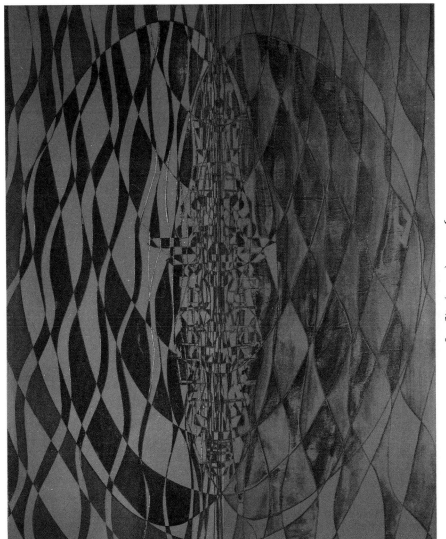

82 *City* (1974). 492 × 600

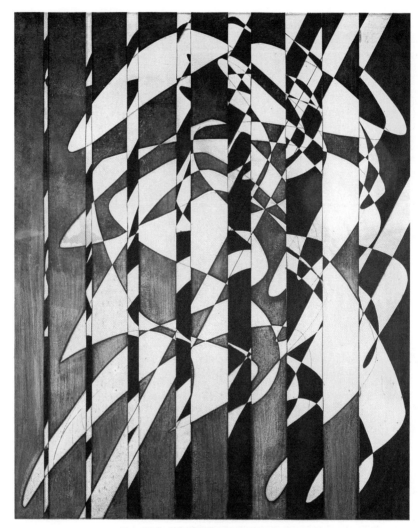

85 *Voiles (Sails)* (1975), 596 × 492

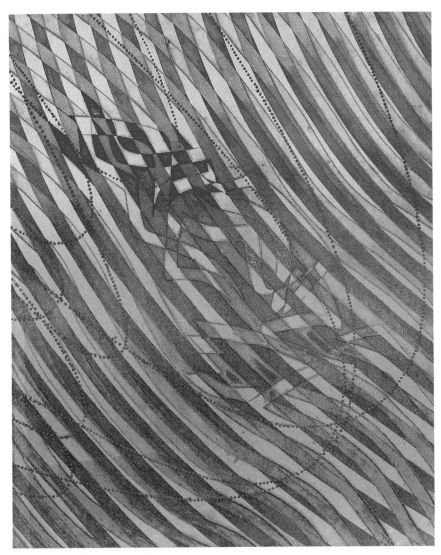

86 *Chute (Fall)* (1975), 599 × 490

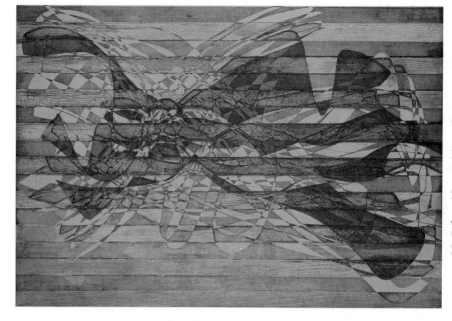

88 *Rideau (Curtain)* (1976), 642 × 485

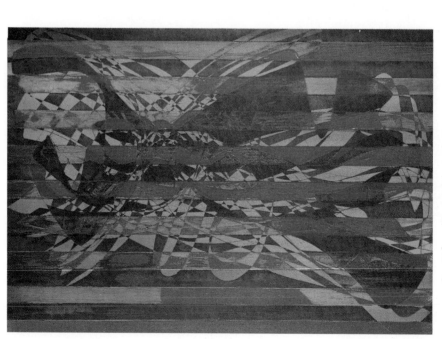

87 *Rideau (Curtain)* (1976), 642 × 437

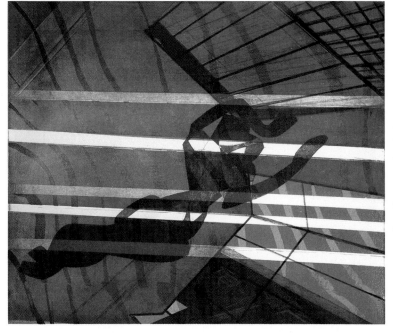

94 *Indoor Swimmer* (1981), 585 × 490

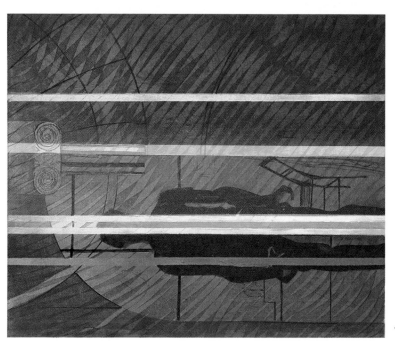

93 *Figure* (1981), 590 × 490

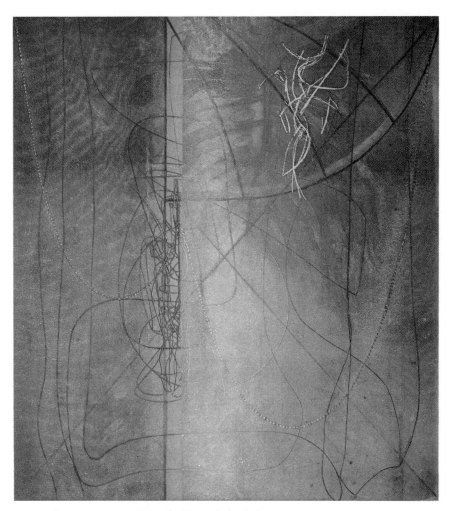

98 *Pendu (Hanged)* (1983), 575 × 522

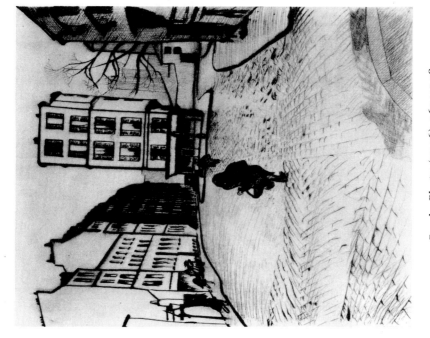

4 *Rue des Plantes* (1926), 267 × 208

1 *Fontainebleau Aqueduct* (1926), 232 × 196

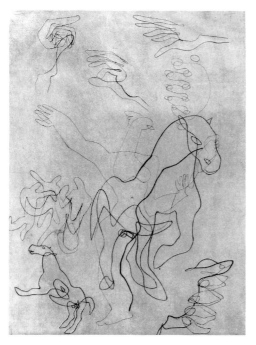 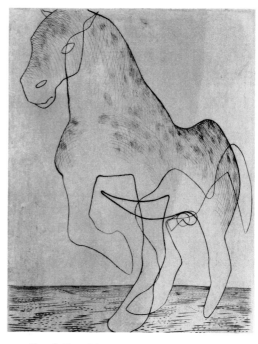

8 *Croquis au burin (Burin Studies)* (1929–32), 245 × 181 9 *Grand Cheval (Big Horse)* (1931), 255 × 196

6 *Bison* (1927), 158 × 197

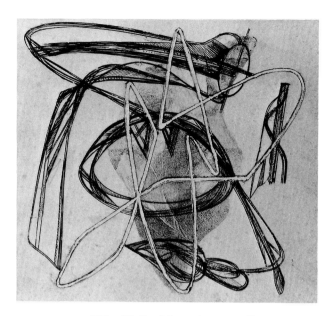

12 *Œdipe (Oedipus)* (1934), 149 × 160

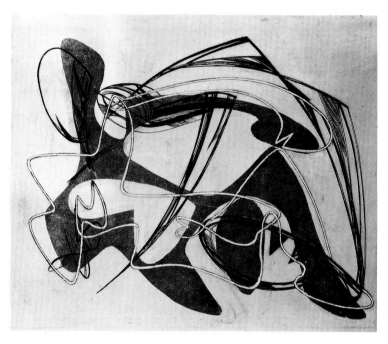

14 *Viol de Lucrèce (Rape of Lucretia)* (1934), 292 × 350

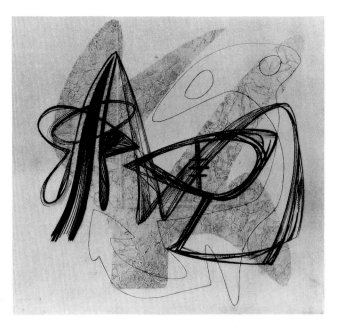

13 *Érotisme compensé (Eroticism Compensated)* (1934), 198 × 212

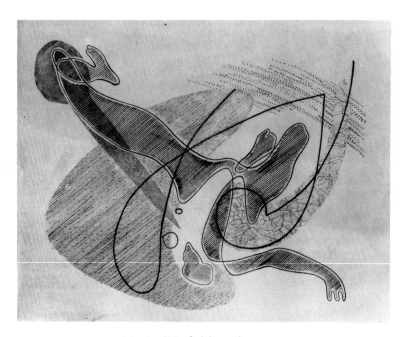

11 *Meurtre (Murder)* (1933), 234 × 295

17 *Combat* (1936). 400 × 495

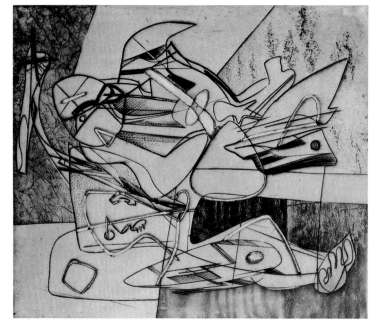

20 *Étreinte (Embrace)* (1937). 215 × 185

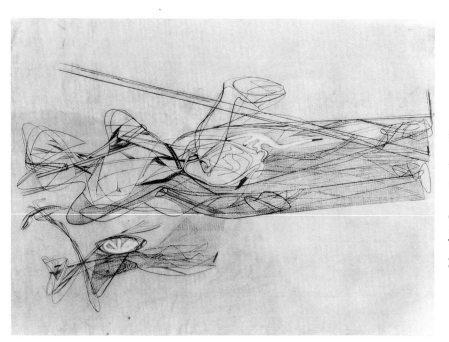

19 *Maculate Conception* (1936). 357 × 255

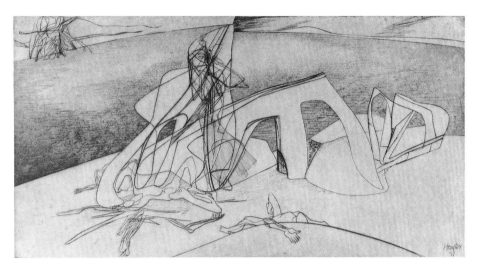

21 *Paysage anthropophage (Man-eating Landscape)* (1937), 184 × 353

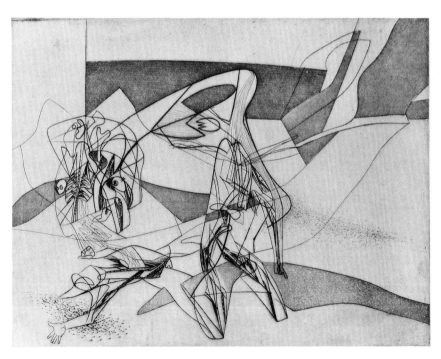

22 *Viol (Rape)* (1938), 196 × 256

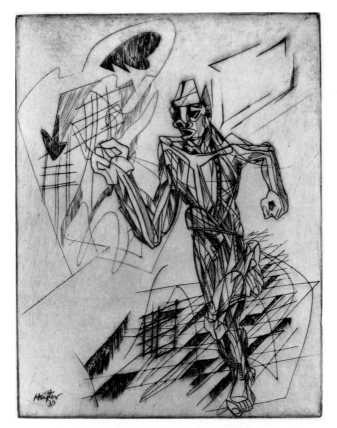

24 *The Runner* (1939),
265 × 205

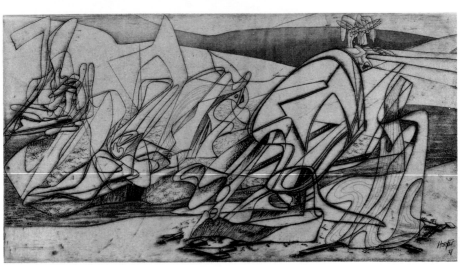

23 *Défaite (Defeat)* (1938), 153 × 195

27 *Mirror* (1941), 190 × 118

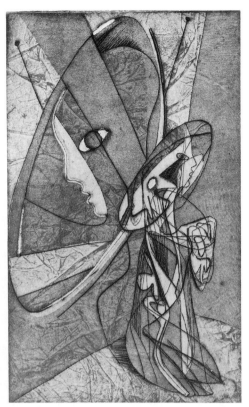

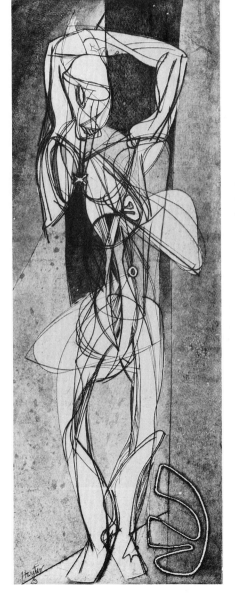

39 *Terror* (1943), 374 × 143

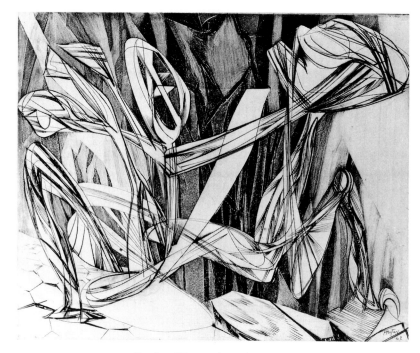

35 *Cruelty of Insects* (1942), 201 × 249

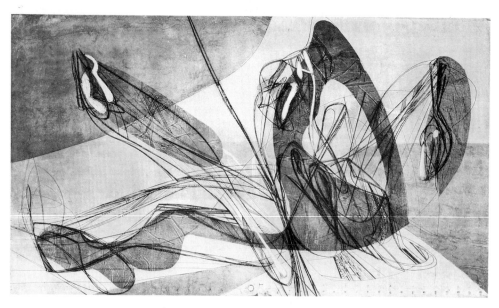

37 *Laocoön* (1943), 310 × 550

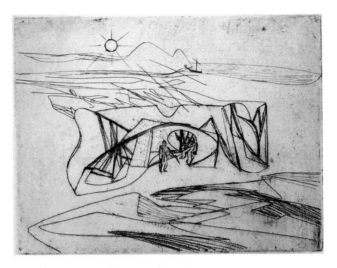

34 *Minotaur* (1942), 75 × 100

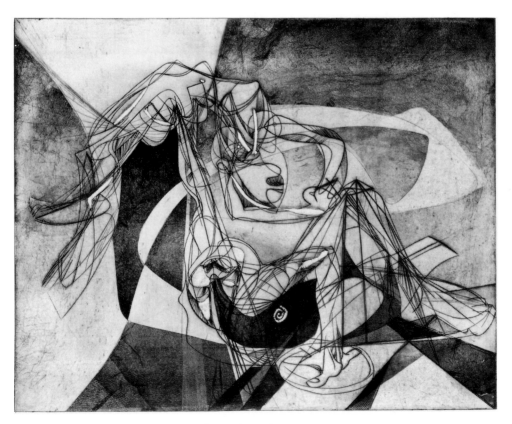

42 *Cronos* (1944), 397 × 504

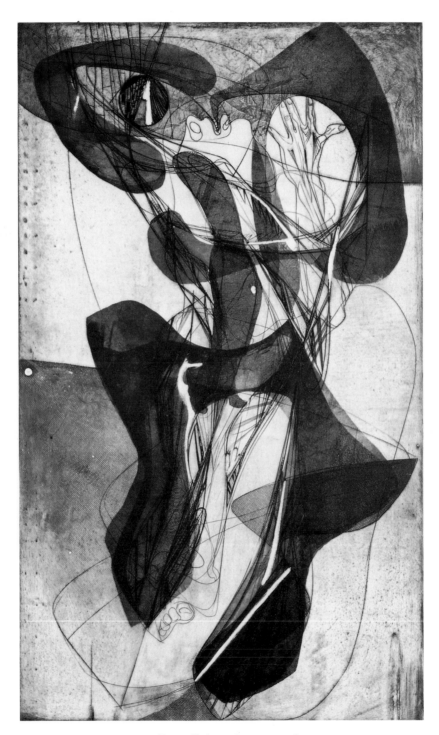

40 *Tarantelle* (1943), 550 × 328

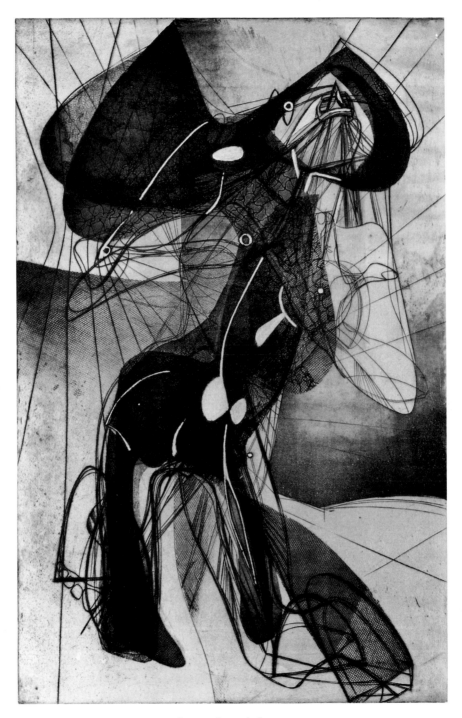

43 *Amazon* (1945), 622 × 402

51 *Tropic of Cancer* (1949). 552 × 693

101 *Place Falguière* (1930), 207 × 267

102 *La Villette* (1930), 181 × 243

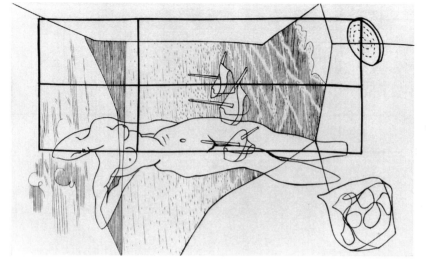

104 *Le Prisonnier des Îles* (1932), 155 × 95

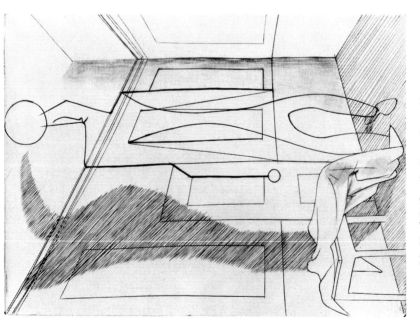

103 *My Head Strikes the Lamp* (1931), 150 × 110

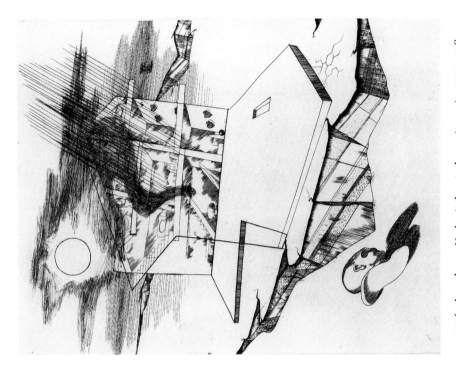

106 *Apocalypse: Un bruit de cataclysme* (1932). 322 × 248

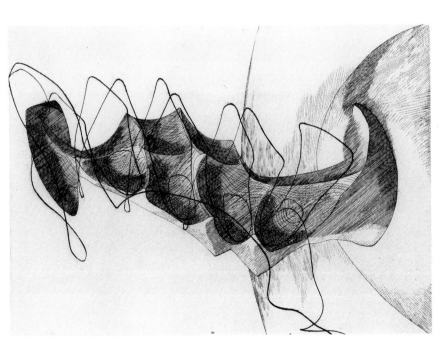

105 *Apocalypse: Quand la main se retira* (1932). 322 × 228

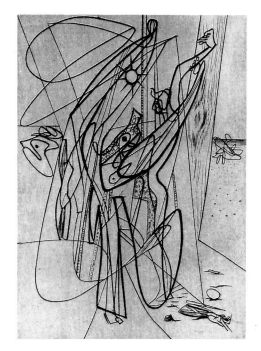

107 *Solidarité (Solidarity)* (1938), 102 × 75

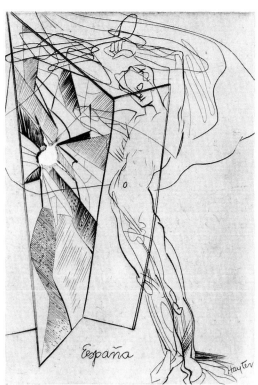

111 *España (Spain)* (1939), 123 × 90

109 *Untitled (man carrying dead woman)* (1938), 172 × 112

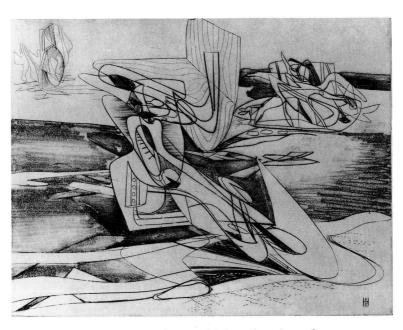

110 *Le Distrait (Distraught)* (1938), 148 × 158

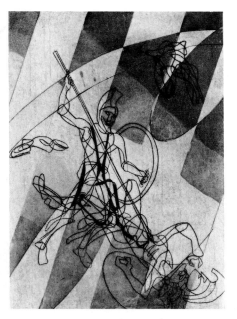

113 *The Death of Hektor* (1979),
295 × 215

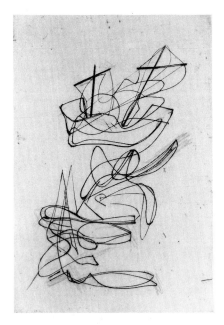

115 *La Voile respire* (*The Sail
Breathes*) (1982–3), 264 × 178

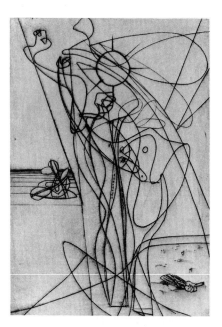

116 *Bâttiseurs de ruines* (*Builders of
Ruins*) (1982–3), 258 × 178

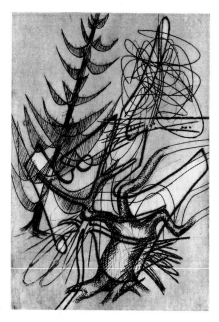

117 *Blason des arbres* (*Blazon of Trees*)
(1982–3), 260 × 178